Lighting for Digital Photography:
From
Snapshots to
Great Shots

Syl Arena

Peachpit Press

Lighting for Digital Photography: From Snapshots to Great Shots
Syl Arena

Peachpit Press
www.peachpit.com

To report errors, please send a note to errata@peachpit.com
Peachpit Press is a division of Pearson Education

Editor: Ted Waitt
Production Editor: Lisa Brazieal
Interior Design: Riezebos Holzbaur Design Group
Compositor: WolfsonDesign
Indexer: James Minkin
Proofreader: Stephanie Provines
Cover Design: Aren Straiger
Cover Image: Syl Arena
Cover Image Color Production Specialist: Marco Ugolini
Back Cover Author Photo: Vera Franceschi

ISBN-13 978-0-321-83275-7
ISBN-10 0-321-83275-2

3 16

Printed and bound in the United States of America

DEDICATION

For Amy, the proverbial girl-across-the-street.

ACKNOWLEDGMENTS

No book is written or photographed in a vacuum—especially this one. Thanks are owed to many.

First, to Amy and our three lads, Tom, Vin, and Tony—heartfelt thanks for accommodating my uncountable requests for you to serve as impromptu models, grips, fixers, etc. You may not have felt like you had a choice every time I asked, but you did.

Sincere thanks are also owed to my many friends at Maine Media Workshops. Most of the second half of this book was written and shot during my extended stay in Rockport. Thank you for providing a beautiful house in which to write, a studio in which to shoot, and lobster dinner every Friday night. Without the support of MMW, I likely would still be finishing Chapter 5.

Teaching is a privilege and an invaluable opportunity to learn from those I teach. So, thanks are owed to the workshop programs that invited me to teach during the past year—Maine Media, Santa Fe, and Gulf Photo Plus in Dubai—as well as to the amazing team at B&H Photo, who let me teach in their NYC Event Space every time I asked.

Thanks are also owed to every student I've met in a workshop, seminar, or random meet-up, as well as to those who got in touch after watching me on Kelby Training or listening to me on *This Week in Photo*. Your questions and comments formed the foundation on which this book was written.

Finally, every word in this book was first read, considered, and sometimes polished by my editor—Ted Waitt. Despite my affection for the sounds that deadlines make as they go whizzing by, Ted patiently coaxed me along as the vision for this book came into sharp focus. So thanks, Ted, for shepherding me through the creation of *Lighting for Digital Photography*.

Syl Arena

Paso Robles, California
October, 2012

Contents

CHAPTER 1: THE FIVE CHARACTERISTICS OF LIGHT 1

Photography Begins with Looking at Light

Poring Over the Picture 2

Poring Over the Picture 4

Start Your Obsession with Light 6

DICCH—That's a Curious Word 7

Direction 7

Intensity 13

Color 15

Contrast 21

Hardness 24

Lighting Lessons Are Everywhere 26

Chapter 1 Assignments 27

CHAPTER 2: YOUR LIGHT-CAPTURING MACHINE 29

Using Camera Settings Smartly and Creatively

Poring Over the Picture 30

Poring Over the Picture 32

Whole-Stop Increments 34

Shutter Speed: Slicing Time Thick or Thin 35

Aperture: Controlling Depth of Field 37

ISO: Keeping Shutter and Aperture in a Desired Range 40

Equivalent Exposures—Tying Shutter, Aperture, and ISO Together 43

Camera Modes—Who Sets What 46

White Balance 48

RAW vs. JPEG 49

Post-Processing 51

Chapter 2 Assignments 53

CHAPTER 3: USING THE LIGHT AROUND YOU 55
Getting Started with Natural Light
Poring Over the Picture 56
Poring Over the Picture 58
Light: Natural, Artificial, Available, and Ambient 60
Deal with the Ambient Light First 60
The Daily Cycle of Sunlight 61
Shooting in Direct Sunlight 66
Skylight—Shooting in Open Shade 73
Deep Shade—Shooting Under Trees 75
Clouds—Nature's Diffusion Panels 76
Windowlight 77
Chapter 3 Assignments 79

CHAPTER 4: CREATING YOUR OWN LIGHT 81
Getting Started with Artificial Light
Poring Over the Picture 82
Poring Over the Picture 84
Shooting Under Home and Office Light 86
Photographic Lights: Continuous 91
Photographic Lights: Flash and Strobes 94
Flash Basics 99
Moving Your Flash Off-Camera 112
Chapter 4 Assignments 116

CHAPTER 5: LIGHTING FOR TABLETOP AND MACRO PHOTOGRAPHY 119
Learn to Light by Starting with Objects
Poring Over the Picture 120
Poring Over the Picture 122
Quick Look—Shoots and Concepts 124
Getting Started with Lighting on a Small Scale 125
Make It Look Like Cloudy Weather 125
You Don't Have to Light Everything 127
Define Shape with Rim Light 130
Embrace the Power of Backlight 132
Throw Light Everywhere 135
If It's Shiny, Light What It Sees 140
Chapter 5 Assignments 143

CHAPTER 6: LIGHTING FUNDAMENTALS FOR PORTRAITS 145

Getting Started with Portraits

Poring Over the Picture	146
Poring Over the Picture	148
Quick Look—Shoots and Concepts	150
Think About the Ambient First	151
Be Lazy, When You Can	156
Open Light	159
Big Equals Soft	164
Shutter and Flash Synergy	173
Finding Light in the Shadows	178
Dancing with the Sun	182
Accuracy Matters	188
Over Under for Beauty	194
Sync About It	198
Chapter 6 Assignments	203

CHAPTER 7: ADVANCED LIGHTING FOR PORTRAITS 205

Adding Depth and Drama to Your Portraits

Poring Over the Picture	206
Poring Over the Picture	208
Quick Look—Shoots and Concepts	210
Concealing and Revealing	211
The Firing Line	218
Three Heads Are Better Than One	224
Syncing in Broad Daylight	229
Family, Friends, and Strangers	235
A Circus of Color	238
Creating Sunset	242
A Field of White	248
Chapter 7 Assignments	257

APPENDIX: THE GEAR I USE 259

Kit Recommendations	260
Camera Gear	261
Flash Gear	263
Strobe Gear	267

INDEX 269

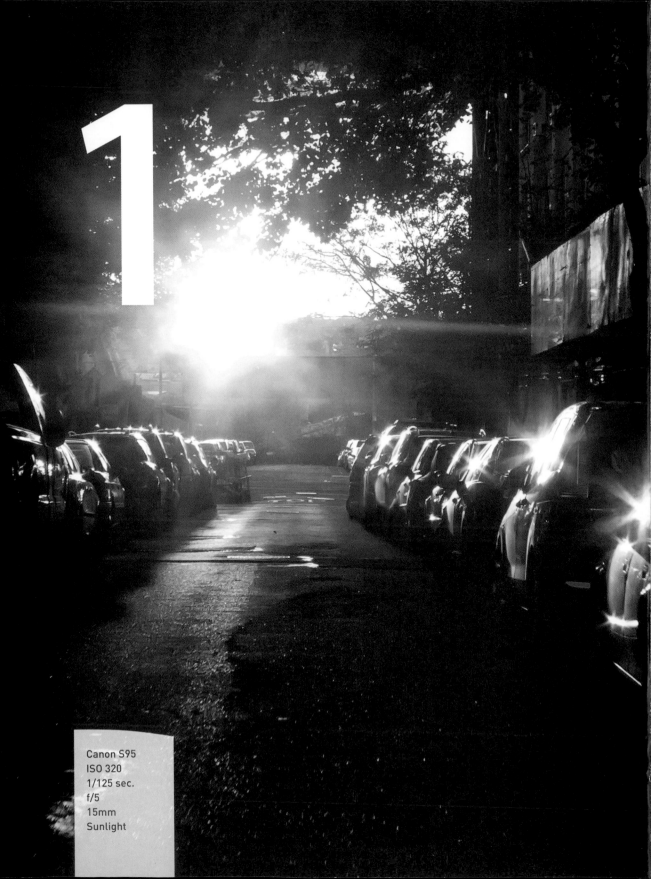

1

Canon S95
ISO 320
1/125 sec.
f/5
15mm
Sunlight

The Five Characteristics of Light

PHOTOGRAPHY BEGINS WITH LOOKING AT LIGHT

Allow yourself to become obsessed with light. This is the best advice that I can give any photographer. Many shooters are more concerned with learning buttons, dials, and software than with learning to truly see light. Yet, if you become a connoisseur of light, you'll see opportunities for great shots that you did not see before. You'll also recognize when there's no pizzazz to the light and, most likely, you will not make so many disappointing images.

Photography is "writing with light." So, let's build our conversation about lighting on five fundamental characteristics of light: Direction, Intensity, Color, Contrast, and Hardness.

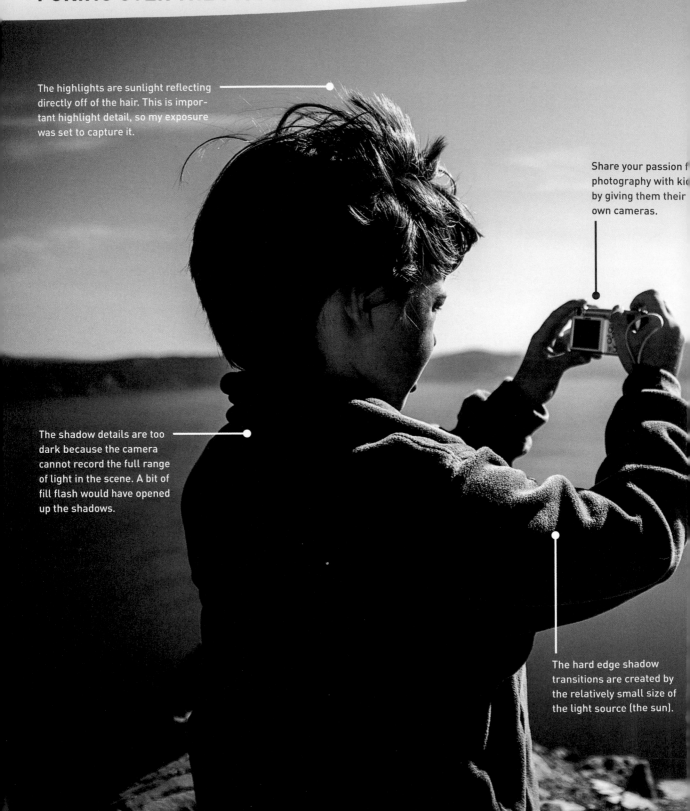

PORING OVER THE PICTURE

The highlights are sunlight reflecting directly off of the hair. This is important highlight detail, so my exposure was set to capture it.

Share your passion f photography with ki by giving them their own cameras.

The shadow details are too dark because the camera cannot record the full range of light in the scene. A bit of fill flash would have opened up the shadows.

The hard edge shadow transitions are created by the relatively small size of the light source (the sun).

The vignette in the corners is created in camera by using a wide-angle lens.

Shooting in bright sun can be a challenge for your camera because of the extreme range between highlight and shadow. In this shot, using a bit of fill flash would have helped reveal details in the shadows. Still, I love this snapshot of my son Tony at Crater Lake, Oregon. Remember, it is better to get a less-than-perfect shot than to miss it because you were grabbing another piece of gear.

The blurred background (shallow depth of field) is created by using a wide aperture and focusing on a subject close to the lens.

Canon 5D
ISO 100
1/4000 sec.
f/2.8
24mm
Sunlight

PORING OVER THE PICTURE

My mantra about lighting is this: "To create interesting light, you have to create interesting shadows. So look at the light and think about the shadows." In this shot of a lacquered ball, the shadows tell you everything about the lighting: the number of lights, their locations, and their size relative to the subject.

The soft edges of this shadow reveal that this light source was much larger than the ball. I used a Westcott Apollo softbox (with a Speedlite inside) to allow the light to wrap around the ball.

Canon 60D
ISO 200
1/200 sec.
f/16
47mm
Two Speedlites
and Apollo softbox

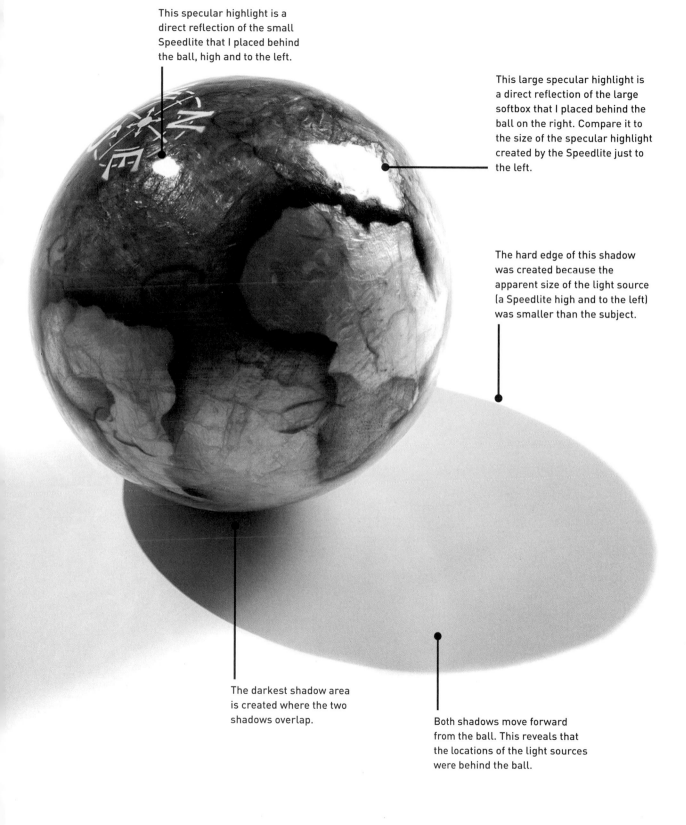

This specular highlight is a direct reflection of the small Speedlite that I placed behind the ball, high and to the left.

This large specular highlight is a direct reflection of the large softbox that I placed behind the ball on the right. Compare it to the size of the specular highlight created by the Speedlite just to the left.

The hard edge of this shadow was created because the apparent size of the light source (a Speedlite high and to the left) was smaller than the subject.

The darkest shadow area is created where the two shadows overlap.

Both shadows move forward from the ball. This reveals that the locations of the light sources were behind the ball.

START YOUR OBSESSION WITH LIGHT

The best photographers in any genre are the ones who are obsessed with light. I hope that you will join their ranks—both in terms of skill and in terms of how you look at light. To start you down the path, I encourage you to study the light around you throughout each day.

Here is a sample of observations about light I've made in a single day:

- In the morning, as I'm waking up, I study the color of a patch of golden sunlight on the wall of my bedroom.

- At breakfast, I examine the shape of the shadows around my coffee cup and solve the riddle, "Why are there three shadows?"

- At noon, I notice how sharp and small the shadows of pedestrians on the sidewalk have become since the sun is now straight overhead.

- On my way home, I enjoy the glare of sunlight as it skips off the asphalt and onto the metal siding of a warehouse.

- A half-hour after sunset, I call my wife, Amy, and our boys outside to see how the western clouds have turned salmon-orange and how the sky transitions from indigo high above down to turquoise at the horizon.

Yes, it's obvious that I'm obsessed with light. I hope that you'll start your own obsession today!

SAY "CLICK!" AND MAKE MENTAL PHOTOS

I make mental photographs all the time. I'm walking down the sidewalk and see a beautiful patch of sunlight in a park. "Click." At a restaurant, I notice that the candlelight flies through a water bottle and creates an interesting pattern on the table. "Click." At a stoplight, I glance over and see beautiful light bouncing off a silver van and onto the face of another driver. "Click."

Don't just look for photo opportunities when you have a camera in your hands. Look for them all the time.

DICCH—THAT'S A CURIOUS WORD

Of course, DICCH is not really a word. Rather it's a mnemonic (memory aide) that will help you remember the five ways I evaluate light: Direction, Intensity, Color, Contrast, and Hardness.

- **Direction:** Where is the light coming from—the front, the side, or behind?
- **Intensity:** How bright is each light source?
- **Color:** What color is the light—white, red, blue…?
- **Contrast:** Is the transition from the highlights to the shadows subtle or sudden?
- **Hardness:** What do the edges of the shadows look like?

As I said above, the best photographers I know are all obsessed with light. You should become obsessed with light, too. I guarantee you that if you learn to see light—I mean truly learn to see light—then your photography will improve automatically.

Truly seeing light is not just a matter of looking. Rather, to truly see light, you have to think about light. Think about the reasons the light looks the way it does. You know, think about DICCH.

DIRECTION

Where is the light coming from—the front, the side, or behind?

The direction of light has a tremendous amount to do with creating a sense of shape and texture in your images. To be a bit more precise, the direction of light controls the width of the shadows. And it's the shadows that create a sense of shape and texture in your photographs.

I tell all of my students, every time I start a workshop:

"If you want to create interesting light, you have to create interesting shadows. So, look at the light and think about the shadows."

Why are shadows important? When we look at a scene, we see depth because the separation between our eyes gives us the ability to see stereoscopically. We see in three dimensions: height, width, and depth. Yet, when your photograph of that scene appears onscreen or is printed on paper, the image only has two dimensions: height and width. Since the screen or paper is flat, the sense of depth in your photographs is created by geometry and shadows. In terms of geometry, we assume that larger objects are closer and smaller objects are farther away. In terms of shadow, the shapes of the shadows go a long way to informing the viewer about the shape of the objects.

THE LIGHTING COMPASS

The placement and width of shadows in a photograph is created by the angle between the camera and the light source. To keep the discussion simple, we'll only consider what happens as the light moves in a circle around the subject.

You, the photographer, control how the camera sees the direction of light through the framing of the shot. If you move your camera in a circle around your subject, you will see that the direction of the light changes as you move. For now, as shown in **Figure 1.1**, let's think of direction as being one of four possibilities:

- **On-Camera or Aligned with the Camera (red):** This means that the sun is coming straight over your shoulders or the flash is parked right on top of your camera. Typically, you will have *flat light* that lacks significant shadows. Photos with flat light often fall short of capturing a scene as you experience it because they lack depth.

- **Angled Towards the Subject (green):** When the light approaches the subject from either side of the camera, shadows are created, and shape/texture become more apparent. The width of the shadows increases as the direction of the light moves from the camera out to the side. You'll find that 45° is a great angle for many lighting situations.

- **To the Side of the Subject (orange):** When the main light comes at the subject directly from the side, you'll have very dramatic light—perhaps too dramatic. Unless there is a fill light or reflector on the other side of the subject, the camera will record the subject as being lit on one side with a dark shadow on the other side. This can be good if you want to create a headshot that conveys mystery, but not so good if you want to convey glamour.

- **Behind the Subject (blue):** Unless you want to create a silhouette shot, light coming from behind the subject should be considered a secondary light. I love shooting with the sun angled from behind my subjects, but I always have to add a source of fill light (either a reflector or a flash) on the front side of the subject. As you will see in Chapter 3, *Using the Light Around You,* a light coming from behind can help create a thin edge of brightness that will separate your subject from a dark background.

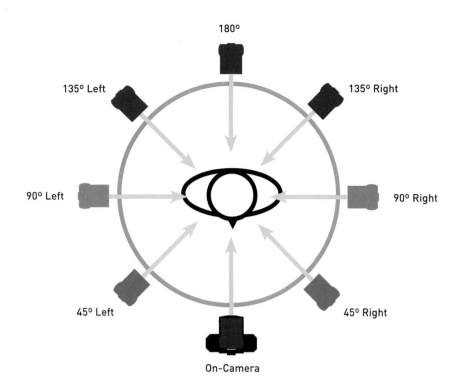

180°

135° Left

135° Right

90° Left

90° Right

45° Left

45° Right

On-Camera

FIGURE 1.1
The lighting compass is a view seen directly above the subject. It shows the angle between the camera and the light source. As you move the light from on-camera out to 90°, the shadows become more pronounced because they become wider. When you move the light behind the subject, you are creating an edge of light that will separate the subject from the background.

FILLING SHADOWS

As good as our cameras are, they cannot record the full range of human vision. If the difference in your scene between the brightest brights and the darkest darks is too much, then some of the details in either the highlights or the shadows (or both) will be beyond the range of the camera. To show details in the dark areas, you can bounce light in with a reflector or add a *fill light*.

LIGHTING LINGO

Key light: The main light hitting the subject, typically coming from the front, often angled in from one side.

Fill light: Light that is added to the shadows, can be created by bouncing light off a reflector or by adding a secondary light, such as a flash.

Rim or hair light: A light that comes from behind the subject and is seen by the camera as a thin outline of light along the edge of the subject.

Let's put these concepts into action. Compare the headshots in **Figures 1.2** and **1.3**. On the left, see how the texture of the shirt is flat? You really cannot see the folds in the fabric. Likewise, the face lacks depth. Now, as shown in Figure 1.3, by moving the light 45° to the right on a small lightstand, I created shadows that add shape to the face and texture to the fabric.

Sometimes you have no control over the location of the light source, such as when shooting outdoors under the sun. In this instance, try circling around the subject so that the camera sees the light falling on the subject from a different angle.

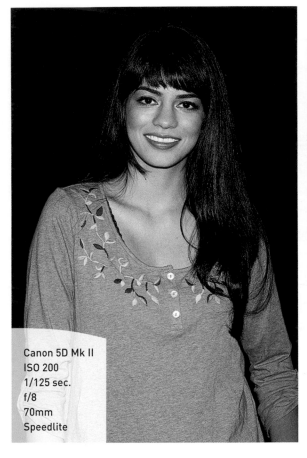

Canon 5D Mk II
ISO 200
1/125 sec.
f/8
70mm
Speedlite

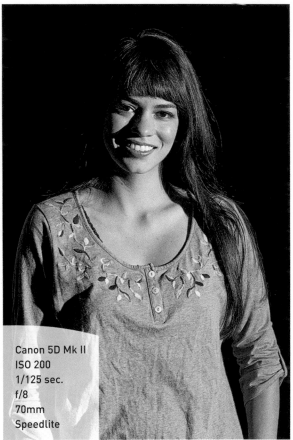

Canon 5D Mk II
ISO 200
1/125 sec.
f/8
70mm
Speedlite

FIGURE 1.2
With the flash sitting in the camera's hotshoe, the lighting appears flat because it lights both sides of Mallory equally.

FIGURE 1.3
Moving the flash off-camera on a lightstand 45° to the right adds depth and texture to the shot because the camera now sees shadows.

DIRECT, DIFFUSED, AND REFLECTED LIGHT

We've just reviewed how the angle between the camera and light affects the shadows in the image. During that discussion, I did not distinguish between *direct*, *diffused*, and *reflected* light. So, now, let's expand the discussion a bit. We need to consider whether the light goes straight from the source to the subject or changes direction along the way.

Direct light flies straight from the light source to the subject (**Figure 1.4**). As we'll discuss later in this chapter, direct light typically creates shadows with high contrast and hard edges. Sunlight on a clear day is direct light. Light from an on-camera flash can also be direct light. While direct light has many uses, photographers often prefer the softer look of diffused and reflected light.

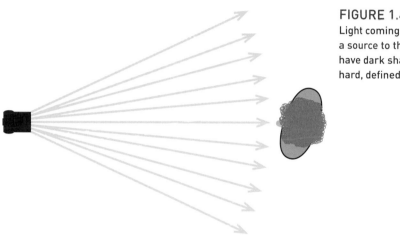

FIGURE 1.4
Light coming directly from a source to the subject will have dark shadows with a hard, defined edge.

Diffused light passes through a semi-transparent material on the way from the source to the subject (**Figure 1.5**). Diffused light creates shadows with lower contrast and softer edges than direct light. Depending upon the amount of diffusion, it is possible that the shadows will be so light that you can barely see them. Clouds are a great example of how sunlight can be diffused. The water vapor causes the light to bounce around and come at the subject from many angles rather than directly from the sun. A sheer curtain over a window is another example of a light diffuser.

FIGURE 1.5

Light that passes through a semi-transparent material, like a cloud bank or diffuser panel, will come at the subject from many angles. This light will have soft shadows.

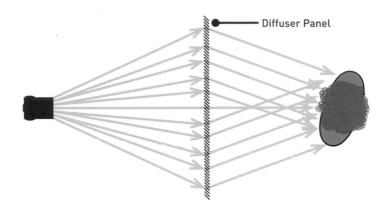

Diffuser Panel

Reflected light bounces off of an opaque surface before it hits the subject (**Figure 1.6**). Sunlight bouncing off the concrete wall of a building is reflected light. Sunlight bouncing off of clouds can create reflected light. Photographers can use white *foam core* panels or fabric *reflectors* in a variety of colors to bounce light. Hotshoe-mounted flashes often have the ability to tilt and pan so that the flash can be bounced off a nearby wall or ceiling. Like diffused light, reflected light is softer than direct light.

FIGURE 1.6

Light that bounces off a surface, like a white wall or ceiling, will also come at the subject from many angles and have soft shadows.

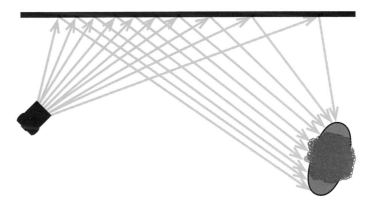

The difference between diffused and reflected light comes from the location of the diffuser and reflector. With diffused light, the diffuser is between the light source and the subject. With reflected light, the light hits a nearby surface and then bounces onto the subject. This is why clouds can be both diffusers and reflectors. When the sun's light goes through the clouds, they are a diffuser. When the light reflects off of the clouds—such as when the sun is setting low in the sky—then the clouds serve as reflectors.

As you will shortly read in the section on Hardness, diffused and reflected light is *softer* because the diffusion or bounce increases the *apparent size* of the light source. I know that this does not make sense to you now, but it will soon. The point to remember is that you should think about whether the light is direct, diffused, or reflected. If it is direct, then you may have options to create softer light by using a diffuser or reflector.

INTENSITY

How bright is each light source?

Of the five elements of DICCH, intensity is the easiest to understand and, I'll wager, the one given the least creative consideration. So, rather than think of a light source as being just bright or dim, think of it in terms of the many ways that its intensity can affect your shot.

A camera's exposure settings (shutter speed, aperture, and ISO) are based largely on the overall intensity of the light in the scene. For any given amount of light, there are many combinations of shutter speed, aperture, and ISO that can be used (these are called *equivalent exposures*). These three camera settings work in opposite directions—meaning that if you change one to be bigger/faster, then you have to change another to be smaller/slower to keep the overall exposure the same. Once you know the basics, you'll start to see the creative opportunities.

For instance, *depth of field* describes how much of your image appears to be in focus from front to back in the scene. A wide aperture, such as f/2.8, lets in lots of light and creates shallow depth of field. Conversely, a narrow aperture, such as f/22, only lets in a small amount of light and creates deep depth of field. So, if you don't have much light intensity and you want to create deep depth of field, then you'll have to use a slow shutter speed (which might cause camera shake) or a high ISO (which might cause digital noise in the image). If neither of these options works, then you'll need to increase the intensity of the light.

FINE-TUNING SHADOWS

If you have multiple light sources, then their intensities will affect the *contrast* in your image—which, as we'll discuss in just a bit, is the difference between the bright and dark areas of your shot. Typically, contrast is created because the intensity of light is greater on one side of the subject than another. Put another way, if your image appears flat, then you can either reduce the intensity of light on one side

or increase the intensity of light on the other to increase contrast. The contrast is increased because you are creating more shadows.

In **Figure 1.7**, I've arranged two lights, each placed at 45° to the left and right of Mallory, and set them so that they have the same power. As you can see, her face lacks shape—because it lacks shadows that reveal shape. Then, in **Figure 1.8**, I reduced the power on the left light so that it is one quarter as bright (i.e., I reduced it by two stops). Now, the lower intensity allows more shadowing and thereby shows more shape.

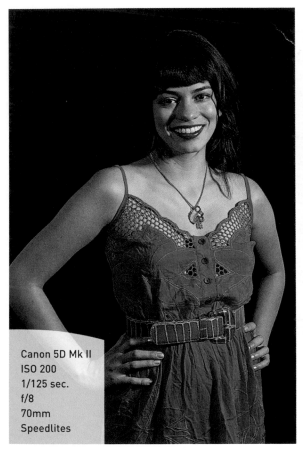

Canon 5D Mk II
ISO 200
1/125 sec.
f/8
70mm
Speedlites

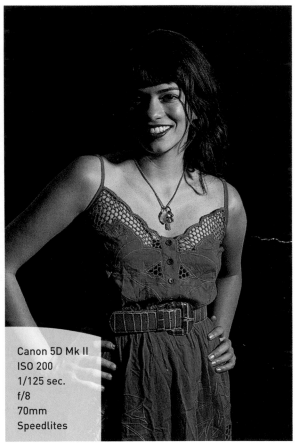

Canon 5D Mk II
ISO 200
1/125 sec.
f/8
70mm
Speedlites

FIGURE 1.7
Here I have set two lights angled towards the subject from 45° on the right and left. They are the same distance away and set at the same power. The shot lacks shadows and depth because both sides of the model are lit equally. This is basically the same as shooting with your on-camera flash.

FIGURE 1.8
Dimming the light on the left by two stops allows more shadows to be created by the light on the right. Actually the shadows were there before. The camera could not see them because of the intensity of the light on the left.

If you are wondering how this is different than the photos in Figures 1.2 and 1.3, here I have used two lights. In Figures 1.2 and 1.3, I used a single light. What I want you to learn is that, when you are crafting shadows, the intensity of a light is as important as its position.

DISTANCE AND INTENSITY

The simple truth is that as light travels farther, it spreads out. As it spreads out, it gets dimmer. This is what the mathematics of the *Inverse Square Law* describes. So, even if you're not a math whiz, remember this: one way to make a light appear brighter is to move it in closer. Likewise, to make it dimmer, you can move it farther away. As we'll discuss in the section on Hardness, moving a light in or out also affects the edges of the shadows.

COLOR

What color is the light—white, red, blue…?

The color of light in your photographs provides significant clues to your viewers about the shot. You were there. You experienced the moment as you pushed the shutter button. The viewer only has the details and information within the frame. So, know that color can go a long way to affect the mood of your images. Sometimes you can change the color of light in your shot for creative effect. Other times, you have to capture the light as you see it.

COOL LIGHT/WARM LIGHT

A basic way to describe color is to say that it is either cool or warm. Cool colors include green, blue, and purple. While cool light can be perceived as calming, it can also be perceived as cold or depressing. Likewise, green can suggest a pastoral setting, but it can also suggest immense wealth.

Warm colors live on the other side of the color wheel. They are red, orange, and yellow. Warm light is perceived as being comforting. Warm skin tones are seen as a sign of health. However, intense red can be seen as the color of anger and also passion.

When we speak of light as being either cool or warm, usually we are describing a slight tint to the light and not saying that the light is strongly blue or orange. As shown in **Figures 1.9** and **1.10**, the same scene can have two completely different looks based on the time of day that it was shot. In Figure 1.9, the photo has a cool

tint because it was shot with the sun just below the horizon. Figure 1.10 was shot a few minutes after the sun rose above the horizon. In the following chapter, we will talk in detail about how the time of day influences the color of light.

FIGURE 1.9
Shooting just before sunrise (during the blue hour) creates a cool tint to the image because the sunlight is reflecting off of the upper atmosphere.

Canon 20D
ISO 100
2.5 sec.
f/16
45mm
Sunlight (blue hour)

FIGURE 1.10
A few minutes later, when the sun crests above the horizon, the light takes on a golden glow—which is why photographers call this time the golden hour.

Canon 20D
ISO 100
1/4 sec.
f/16
70mm
Sunlight (golden hour)

COLOR TEMPERATURE OF LIGHT SOURCES

Color temperature refers to how blue or yellow a light source appears. The surprising thing is that low color temperatures describe yellowish light, and high color temperatures describe bluish light (**Figure 1.11**). Yet, we talk about yellow as being a warm color and blue as being a cool color. This is one of those photo-opposites—just like it's surprising when you first learn that an f-stop with a small number is actually a large aperture opening. Scientists and lighting designers have very precise reasons for why this is so. I just accept it as stated. My mnemonic is that somewhere in my youth I learned that the blue part of a flame is hotter than the yellow part. So, light with a high color temperature is bluer than light with a low color temperature.

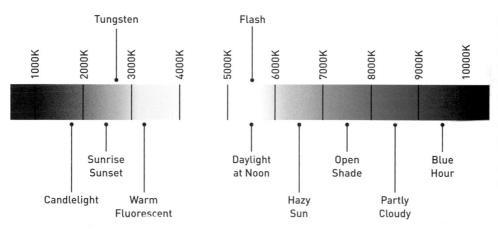

FIGURE 1.11
Color temperature describes how yellow or blue a light source appears. The unit of measurement for color temperature is "Kelvin" (not "degrees Kelvin," as you may hear some say).

In a practical sense, you know that candlelight has a very warm (yellowish) color. What you might not know is that the color of open shade is very blue. Our eyes and brain work together to turn the brightest part of a scene to white. This is why, when you look at a white shirt or a piece of white paper under an old-school incandescent bulb, they look white rather than yellow-orange. Then, when you walk outside into the open shade on the north side of your house, the paper and shirt still look white. In this sense, our eyes and brain are much smarter than our digital cameras.

White balance is the camera setting that overcomes the color cast of a particular light source. As we will discuss in detail in Chapter 2, matching the camera's white balance to the light source will mean that whites are captured as white rather than as lightly amber or slightly blue.

COLOR GAMUTS

Any range of colors can be described as a *gamut*. There is a gamut of colors that you can see, a gamut of colors that your camera can record, a gamut that your monitor can display, and a gamut that your printer can print. To paint a simpler picture, I like to think of each of these gamuts as a box of crayons. As you'll see below, the box of crayons gets smaller as you move through the image-making process. This is one of the reasons why a photograph of a richly colored sunset did not look as beautiful as the actual sunset.

Without getting too technical, I want you to understand the limitations imposed by our gear. So, in **Figure 1.12**, I've made a graph that compares the range of human vision to three key pieces of gear used to create the images in this book. The yellow line shows the range of colors that my camera can record. The white line shows the colors that my monitor can display. The orange line shows the gamut of CMYK commercial printing used to print books and magazines.

FIGURE 1.12
This gamut graph shows how human vision (the entire box) compares to the range of colors that can be captured by my Canon 5D Mark III camera (yellow), displayed on my Apple iMac monitor (white), and then printed in this book through CMYK printing (orange).

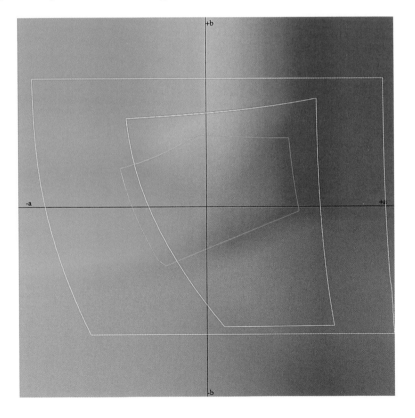

Now, take a look at the flowers in **Figure 1.13**. When I made this photograph, I was impressed by the super-saturated magenta of the petals. Take my word for it, the gamut of CMYK printing used to print this book falls far short of the vibrancy that I experienced in the garden. They screamed "PINK!"

Canon 5D
ISO 100
1/200 sec.
f/5.6
70mm
580EX II Speedlite as fill

FIGURE 1.13
The super-saturated magenta of these landscape roses is beyond the gamut of the CMYK inks used to print books, magazines, and catalogs. So, the color and texture of the petals is less vibrant than they actually were when I shot the photo.

Taking a look at **Figure 1.14**—a gamut graph of the photo in Figure 1.13—will help us understand what is going on. The green dots show the range of colors in my original capture (the original shot). You'll note that there is a large group of green dots outside the CMYK gamut (the orange box), which explains why I think that the colors look dull here. It is also interesting to note that there are many dots that fall outside the gamut of my monitor (the white box). So, while my camera was able to capture a wide range of color, I could not see many of the rich pinks on my monitor, nor are they reproduced in this book. This is why the photograph printed here is much less colorful than the flowers themselves—their gamut was beyond the range of colors that can be reproduced on a typical printing press.

FIGURE 1.14
This gamut graph shows the range of
colors in the photo as green dots. The
big cluster outside the orange box repre-
sents the colors outside the CMYK gamut.
The green dots outside the white box are
colors captured by my camera that cannot
be displayed on my monitor.

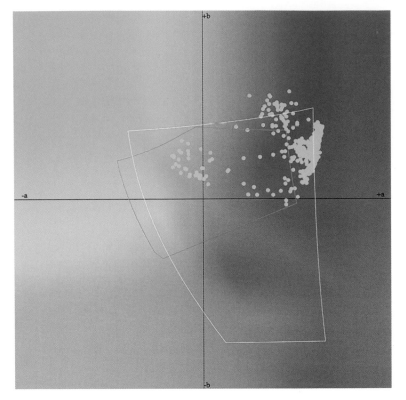

So, if you've ever shot a photo of a sunset or a flower that lacks the beauty that you actually experienced, it is likely that the scene contained colors that just could not be captured or printed. Don't despair. Obviously, beautiful photographs are created and printed every day. As photographers, though, we need to be aware of the limitations of our gear and the opportunities to use lighting as a way to overcome these limitations. Also, know that the technology of image-processing software gets better every year. I've no doubt that someday I will be able to print the full range of colors that I saw in those roses.

WHY I NO LONGER WORK IN BLACK AND WHITE

As far as I'm concerned, the greatest miracle of human vision is that we see in color. So, I'm going to jump up on my soapbox (again) and say that I have no interest in doing black-and-white photography. I think it's okay if you have no interest in black-and-white either.

As a guy who spent years in photo school, long before the digital era, I made too many black-and-white photographs—mostly because working in color was expensive and hard to control. I think that most of the 20th-century masters who influenced me at the time—guys like Edward Weston, Ansel Adams, and Minor White—worked in black-and-white for the same reason.

Today, with our digital cameras, computers, and printers, color photography is as affordable and controllable as black-and-white. Further, and I say this quite seriously, if black-and-white is such an important way to communicate, then why did master painters, from Michelangelo to Rembrandt to Cézanne work primarily in color? I think they painted in color because that's how they saw the world.

Again, I say that color vision is a miracle. Embrace that gift in your photography.

CONTRAST

Is the transition from the highlights to the shadows subtle or sudden?

Contrast describes how the highlights transition into the shadows. The brightest areas of the image are the *highlights*. The darkest areas are the *shadows*. In between, the image will have *lights*, *midtones*, and *darks*.

Check out the Poring Over the Picture spread on pages 2–3 (the one of Tony at the lake). You will see that I noted that I exposed the image such that the details of the hair highlights would not blow out to white. This meant that the details in the shadow are too dark (at least too dark for a perfectionist). So, you could say that this image has too much contrast.

DYNAMIC RANGE

The *dynamic range* of a scene describes how much brighter the brightest spot is than the darkest spot. The human eye can see a wider dynamic range than our cameras can record. Likewise, our cameras can record a wider dynamic range than our monitors can display and, typically, our monitors can display a wider range of light than printers can print. Every generation of gear narrows the gap between what we

see and what it can capture, display, or print. Eventually, I expect that this gap will become a non-issue. In the meantime, as this is a book on lighting, throughout the many pages ahead, we will discuss how to manage these differences by adding light to and, in some cases, subtracting light from our shots.

Here is a quick example of how lighting can adjust the dynamic range of a scene so that the camera can record it more faithfully (**Figures 1.15** and **1.16**). A car outdoors on a sunny day has a huge dynamic range. The glints of light coming off the chrome are the brightest highlights—in fact, they are so bright that we call them *spectral highlights*, meaning that they are direct reflections of the light source (in this case, the sun). At the other end of the dynamic range are the shadows—in this case, the treads of the tires just where they meet the asphalt.

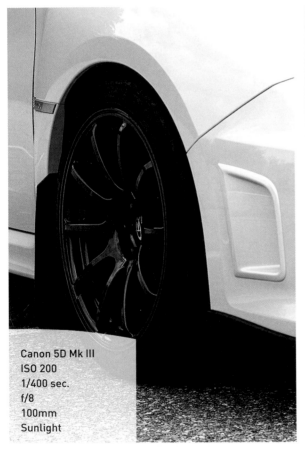

Canon 5D Mk III
ISO 200
1/400 sec.
f/8
100mm
Sunlight

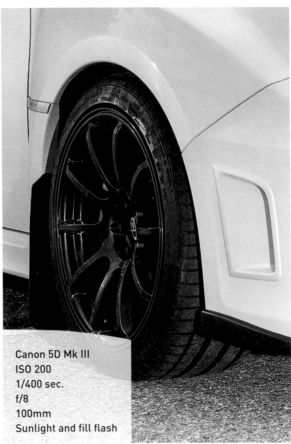

Canon 5D Mk III
ISO 200
1/400 sec.
f/8
100mm
Sunlight and fill flash

FIGURE 1.15
Even though I could distinctly see the difference between the tire and the asphalt, there was too much dynamic range in this scene. Exposing to see the tire details would have blown out important highlights.

FIGURE 1.16
Adding light into the shadows actually reduces the dynamic range of the scene. In this shot, I used a pair of Speedlites to add light underneath the fenders.

In direct sunlight, there is often too much contrast. Here the details in the shadows of the tire treads merge to black. We might be able to see most of the details between the two extremes. Yet, as shown in Figure 1.15, the camera cannot record this full range of light and shadow. So, as the photographer, I decided to expose for the detail in the hood and let the shadows fall where they may. As you can see, the tread of the tires cannot be distinguished from the wheel well or from the asphalt.

As we will explore in greater detail later in the book, one option is to add light into the shadow areas so that the dynamic range of the scene is reduced to the range that the camera can record. In Figure 1.16, you can see can see many more *shadow details* because I used two Speedlites to create fill flash (**Figure 1.17**).

FIGURE 1.17
By adding fill flash, the contrast is reduced into the dynamic range that the camera can record. So, shadow details are revealed.

EXPOSURE AND POST-PROCESSING

When the difference between the highlights and the shadows is beyond the dynamic range of the camera, then either some of the highlight details will be captured as pure white, some of the shadow details will be captured as black, or both will happen. We call this *blowing out the highlights* and *crushing the shadows*.

In the field, you will often have to decide what is most important and skew your exposure to protect that portion of the image. For a wedding portrait, the details of the bride's dress are likely more important than the details of the groom's tuxedo. So underexposing a bit to preserve the highlight detail in the dress would be a safe decision.

In Chapter 2, we will talk about the benefits of shooting RAW files instead of JPEG files as one way to maximize your options for challenging shots with a wide dynamic range. Then, by using a full-featured image-processing program—like my favorite, Adobe Lightroom—you can often save important highlight details with the Highlight slider and reveal details in the shadows with the Shadows slider (**Figure 1.18**).

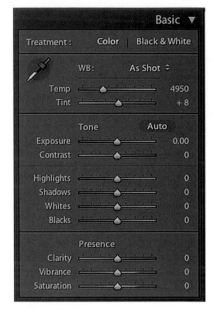

FIGURE 1.18
In the Develop module of Adobe Lightroom, the sliders for White Balance, Tone, and Presence can go a long way to restoring the look of a poorly exposed capture. Still, using software to fix problems is no substitute for learning to light.

HARDNESS

What do the edges of the shadows look like?

You will recall that, near the beginning of the chapter, I said, "Look at the light and *think* about the shadows." The shadows will reveal many details about the lighting. For instance, you can draw a line from a point on a shadow to the spot that created it and you'll see the direction of the light source. You can also examine the edges of the shadows and learn if the light source was small or large.

HARD AND SOFT SHADOWS

Think about the shadows! Are they defined sharply—like your shadow on a sunny day? Or are the edges fuzzy—like your shadow on a cloudy day? Photographers call a light that creates a sharply defined shadow a *hard light* and a light that creates shadows with fuzzy edges a *soft light*. In **Figures 1.19** and **1.20**, you can see the difference between hard and soft shadows.

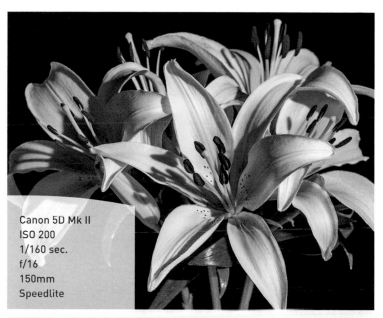

Canon 5D Mk II
ISO 200
1/160 sec.
f/16
150mm
Speedlite

FIGURE 1.19
I lit this shot with a single Speedlite at 45° right. Because the flash was smaller than the bunch of flowers, it created many hard-edged shadows within the shot.

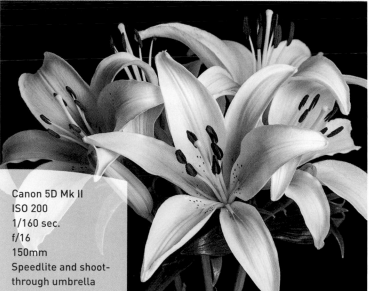

Canon 5D Mk II
ISO 200
1/160 sec.
f/16
150mm
Speedlite and shoot-through umbrella

FIGURE 1.20
Without moving the Speedlite, I added a shoot-through umbrella between the flash and the flowers. This increased the apparent size of the light source so that it could send light at the subject from multiple angles. As you can see, all of the hard shadow edges have disappeared.

Hard shadows are created when the size of the light source is small when compared to the size of the subject. Astronomers tell us that the size of the sun is huge. Yet, Earth's distance from the sun makes it appear relatively small in our sky. So, on a sunny day, your shadow has hard edges.

Conversely, soft shadows are created when the size of the light source is larger than the subject. Let's say that, while you are admiring your hard-edged shadow on the sidewalk, a bank of clouds drifts between you and the sun. You notice that the edges of your shadow become very soft. What causes this? Essentially, the clouds replaced the sun as the light source. Sure, the light originated at the sun. But, as it traveled through the mist of the clouds it bounced around. So instead of the light coming at you from one direction (the sun), the light came at you from many directions (the clouds).

As photographers, we have many tools to increase the *apparent size* of our light sources: reflector disks, diffusion panels, umbrellas, and softboxes—all of which will be covered in later chapters. For now, review Figures 1.4–1.6 to make sure that you understand the differences between direct, diffused, and reflected light. In your photos, the differences will be revealed by the shadows.

LIGHTING LESSONS ARE EVERYWHERE

After you've learned the five characteristics of light, begin to decode the light that you see around you and in the media. Ask yourself questions like, "Why is that shadow line soft?" or "What could have created that thin slice of light that outlines the left side of the face?" There are lighting lessons everywhere—waiting for you to think about them. Here are some sources to look at:

- **Magazine ads**: Publishers and advertisers spend huge sums of money styling the people and products that appear in magazines. Fashion magazines like *Vogue* and *Harper's Bazaar* are filled with expensive ads and stories that are beautifully styled and lit. Likewise, lifestyle magazines like *Martha Stewart Living* and *Real Simple* are a treasure trove of high-quality images. No matter what your interest, clip images that you like and collect them in an "inspiration binder."

- **Movies**: Much of what I know about lighting comes from studying the tools and concepts that Hollywood uses to light movie sets. Every time you watch a movie, you have lighting lesson after lighting lesson playing in front of you. Be sure to check the bonus features on DVDs and Blu-ray Discs for behind-the-scenes stories about how the movie was made.

- **City streets**: I love walking around Manhattan and looking at the light. The skyscrapers may create canyons for those on the street, but the glass and stone facades provide huge reflective surfaces that enable sunlit to cascade down in magical ways. The next time that you find yourself at a big city intersection, look around. Do the pedestrians have hard shadows because the sun is bouncing down between two tall buildings? Or perhaps each person has multiple shadows heading in different directions?

Chapter 1 Assignments

Direction—Exploring the Compass

Put your camera on a tripod and point it at a patient friend sitting on a stool. Then, using a hard light source (shop light, small flash, etc.), make a series of headshots with the light circling around the subject so that you can see how the position of the light changes the shadows.

Intensity—Creating Shape by Dimming the Light

Light a friend or an object with a pair of identical light sources. Position them 45° to the left and right of your subject so that the light is balanced. Take a shot. Now, turn down one light or move it farther back. Take another shot. How does the appearance of the subject change between the two shots?

Color—Setting White Balance on Your Camera

Set your camera's white balance to Daylight. Photograph a friend or an object under several different light sources. Does the color of the image change as the source changes? Repeat the series with your camera set to Auto White Balance.

Contrast—Filling Shadows to See Detail

Photograph a friend or an object under direct sunlight—with the sun coming from behind the subject. Now turn on your camera's flash or use a white card to bounce light into the shadows. Make another photograph. How does the detail in the shadows change?

Hardness—Making Soft Light from Hard Light

Photograph a friend or an object with a direct (hard) light source. Now diffuse the light by putting a semi-transparent material between the light and the subject. A white sheet or a white garbage bag should work. How do the edges of the shadows change as you modify the apparent size of the light source?

Share your results with the book's Flickr group!

Join the group here: flickr.com/groups/lightingfromsnapshotstogreatshots

PORING OVER THE PICTURE

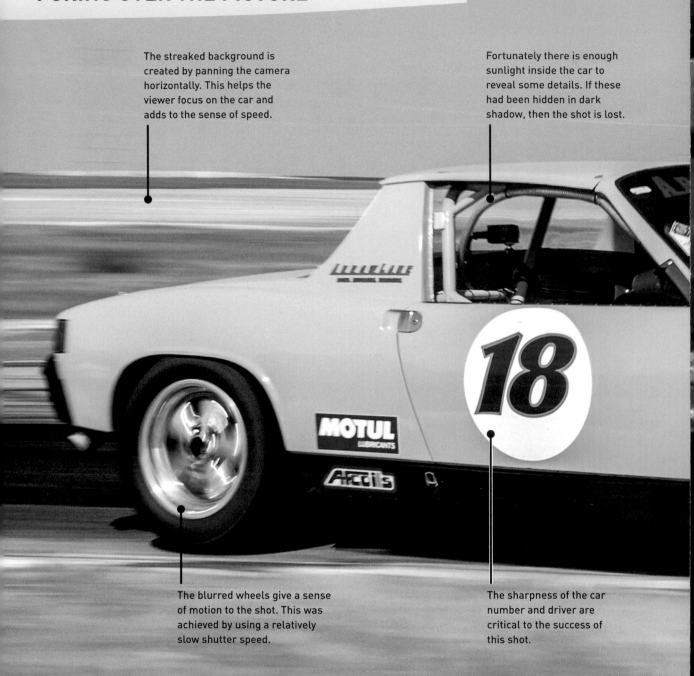

The streaked background is created by panning the camera horizontally. This helps the viewer focus on the car and adds to the sense of speed.

Fortunately there is enough sunlight inside the car to reveal some details. If these had been hidden in dark shadow, then the shot is lost.

The blurred wheels give a sense of motion to the shot. This was achieved by using a relatively slow shutter speed.

The sharpness of the car number and driver are critical to the success of this shot.

Use your camera settings for creative effect. For instance, you can use your shutter speed to either freeze or portray motion. Here, my 1/125" shutter speed is relatively slow because the racecar was speeding by so swiftly. The impact of this shot is created by the contrast between the blurred and streaked elements with the sharpness of the car number and the driver.

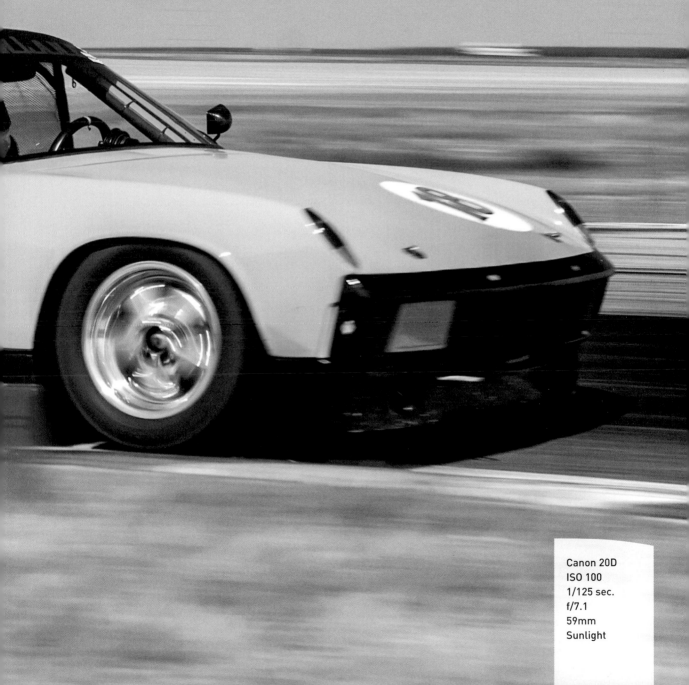

Canon 20D
ISO 100
1/125 sec.
f/7.1
59mm
Sunlight

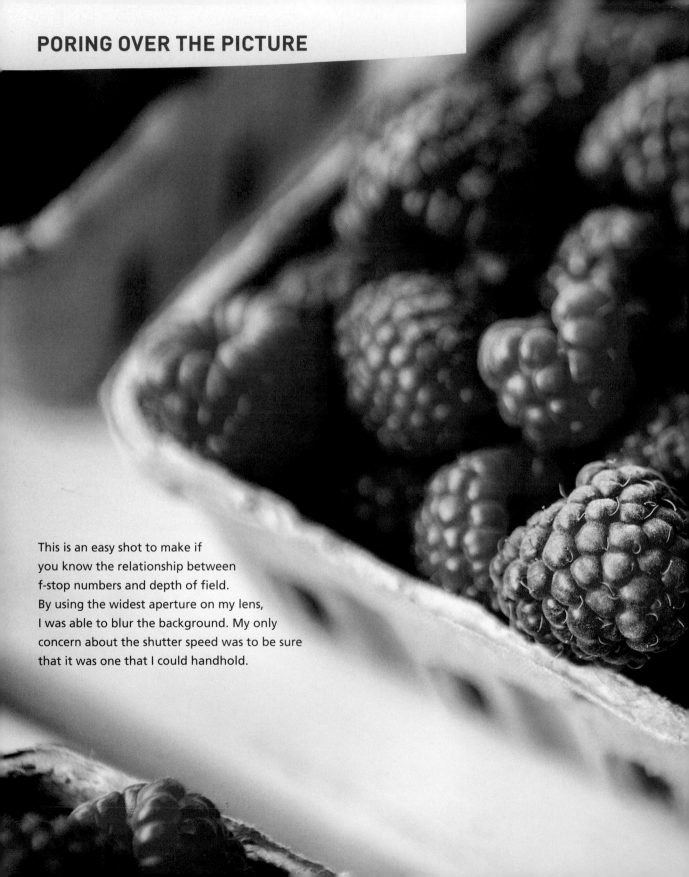

This is an easy shot to make if
you know the relationship between
f-stop numbers and depth of field.
By using the widest aperture on my lens,
I was able to blur the background. My only
concern about the shutter speed was to be sure
that it was one that I could handhold.

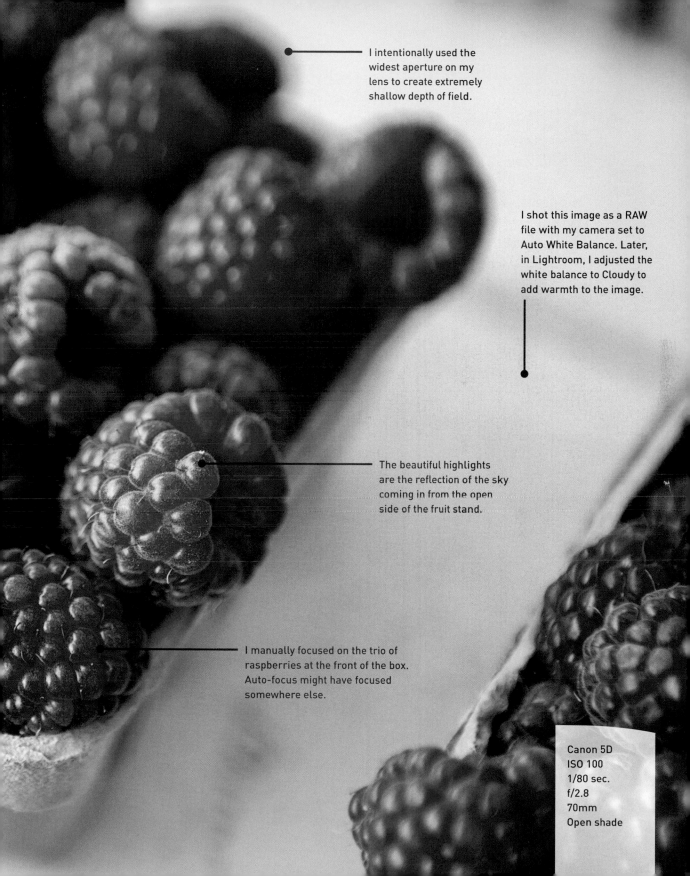

I intentionally used the widest aperture on my lens to create extremely shallow depth of field.

I shot this image as a RAW file with my camera set to Auto White Balance. Later, in Lightroom, I adjusted the white balance to Cloudy to add warmth to the image.

The beautiful highlights are the reflection of the sky coming in from the open side of the fruit stand.

I manually focused on the trio of raspberries at the front of the box. Auto-focus might have focused somewhere else.

Canon 5D
ISO 100
1/80 sec.
f/2.8
70mm
Open shade

WHOLE-STOP INCREMENTS

Throughout this chapter and beyond, you will often read the term *stop*. When you double or halve a camera setting—shutter speed, aperture, ISO, and even flash power—you have changed it by a whole stop (one stop). Stops are an easy way to calculate how a change in one camera setting can be offset by a change in another setting, such as using a faster shutter speed to offset the wider aperture that you selected to create shallower depth of field. We call these offsetting relationships "equivalent exposures."

So, again, doubling or halving a camera setting is a one-stop change. If you double the double or halve the half, then you've made a two-stop change. To count the stops, count how many "jumps" you've made either doubling or halving the setting. For instance, using the increments listed in **Figure 2.1**:

- 1/30" to 1/60" is a one-stop move (1/60" is half the time of 1/30")
- 1/30" to 1/125" is a two-stop move: 1/30" > 1/60" > 1/125"
- 1/30" to 1/250" is a three-stop move: 1/30" > 1/60" > 1/125" > 1/250"

FIGURE 2.1
Sometimes it is easier to understand the relationship of one shutter speed to another if you can see it visually. Here we have a range of shutter speeds in whole stop increments— meaning that the shutter speed is cut in half as each bar moves to the right.

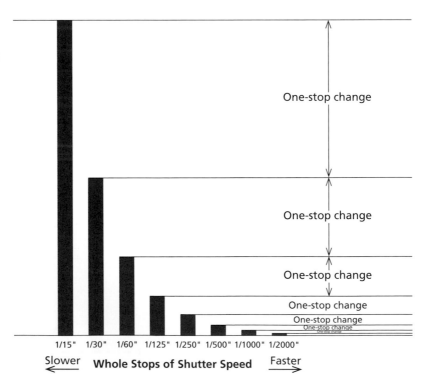

Don't worry if this seems confusing now. We will discuss all of the settings and their interrelationship throughout the rest of the chapter. Use the chart in Figure 2.15 to help keep them sorted out. Also, check to see if your camera is set to show half- or third-stop increments for shutter, aperture, and ISO. If so, you will see one or two additional numbers between the whole-stop numbers shown on the chart. Over time, as you get to know the whole-stop increments, all of these numbers will not seem so intimidating.

SHUTTER SPEED: SLICING TIME THICK OR THIN

Every camera has a shutter mechanism that controls the length of the exposure. Digital single-lens reflex (DSLR) cameras and old-school 35mm cameras have a mechanical shutter that is typically a pair of curtains that opens and closes in front of the sensor or film. Point-and-shoots and the new generation of mirrorless, interchangeable lens cameras typically have an electronic shutter—meaning that the sensor is turned on and off very quickly.

Shutter speeds are typically measured as a fraction of a second—1/1000" is faster than 1/30". For low-light photography, such as when outdoors at night, your exposure might be several seconds (or even minutes) long.

Here are whole-stop increments of shutter speed from slow to fast: 1" > 1/2" > 1/4" > 1/8" > 1/15" > 1/30" > 1/60" > 1/125" > 1/250" > 1/500" > 1/1000" > 1/2000" > 1/4000" > 1/8000". Your camera is likely set to show half- or third-stop increments of shutter speed (typically changed in custom functions). So, if you see numbers between the shutter speeds I've listed, remember that they are slightly more or less than a whole stop.

Your choice of shutter speed can be used to convey a sense of motion (with slower shutter speeds) or to freeze action (with faster speeds). As shown in **Figure 2.2**, a fast shutter speed slices time very thin and freezes motion. Conversely, as shown in **Figure 2.3**, a slow shutter speed can be used to accentuate motion. These are essentially the same shot—yet they have completely different feelings. The "right" image is determined by what the photographer wants to convey.

FIGURE 2.2
(left) This shot uses a fast shutter and a wide aperture to freeze the runner in mid-stride.

FIGURE 2.3
(right) This shot uses a slow shutter and a narrow aperture to create motion blur. The exposure change between the shots is six stops of shutter and aperture—which were changed in opposite directions.

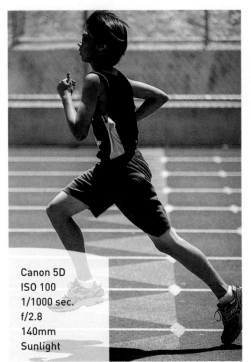

Canon 5D
ISO 100
1/1000 sec.
f/2.8
140mm
Sunlight

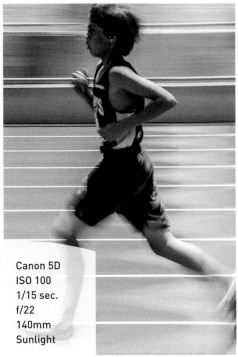

Canon 5D
ISO 100
1/15 sec.
f/22
140mm
Sunlight

IS = IMAGE STABILIZATION

Many lenses and some cameras have motion sensors and moving elements that work together to stabilize the shot during exposure (**Figure 2.4**). The great advantage of this technology is that you can now handhold the camera at slower shutter speeds. This is especially helpful in low-light areas where flash photography is frowned upon—such as museums. Typically you will gain two to four stops of shutter speed with image-stabilization technology. So, if you can handhold your camera down to 1/60" without an IS lens, then with an IS lens or camera, you will get steady shots down to 1/15" (two stops), 1/8" (three stops), or even 1/4" (four stops).

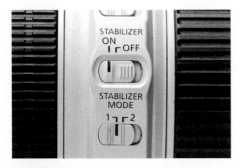

FIGURE 2.4
There are two image stabilization buttons on the Canon 70–200mm f/2.8 L IS. The top button activates the IS system. The lower switch enables the IS to work when the camera is being panned with a moving subject (Mode 2).

SHUTTER SPEEDS UNDER CONTINUOUS LIGHT AND FLASH

As you will read in greater detail in the next several chapters, light sources can be divided into two broad categories: continuous and flash. Continuous sources include the sun, the electric lights in your house, and photographic lights that use incandescent, fluorescent, or LED bulbs. Flash includes everything from the small tube built into your point-and-shoot camera to hotshoe flashes and studio strobes.

In terms of the range of shutter speeds that you can use under continuous sources, there is no limitation as long as your aperture and ISO settings are adequate for a good exposure. When shooting with flash, your camera has a limitation on the shutter speed—called the *sync speed*—which is typically 1/250" or so. We will talk at length about sync speed in Chapter 4.

APERTURE: CONTROLLING DEPTH OF FIELD

Your lens has a set of blades inside the barrel that open and close like the pupil in your eye. The hole between the blades is the *aperture*. Its size is referred to as an *f-stop*. When you see "f/5.6," think or say, "eff five point six."

Every time you change the aperture by a *whole* stop, you are either doubling or halving the amount of light that passes through the whole. **Figure 2.5** shows whole-stop increments of aperture from wide to narrow.

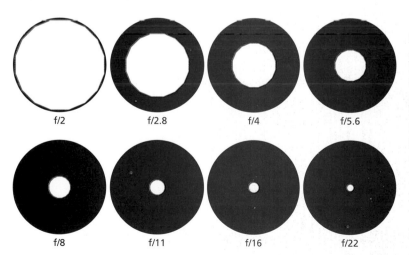

| f/2 | f/2.8 | f/4 | f/5.6 |

| f/8 | f/11 | f/16 | f/22 |

FIGURE 2.5
Whole stops of aperture from f/2 to f/22. Your camera will likely show these numbers with additional numbers between them. These additional increments are either half- or third-stops (depending upon the setup of your camera).

Sometimes a change in aperture is used to offset the change in shutter speed—as was the case in Figures 2.2 and 2.3 above. At other times, you can select the aperture and let the shutter speed change accordingly (which is how Aperture Priority mode on your camera works). Changing the aperture affects how much of the image appears to be in focus from front to back. Using a wide aperture creates shallow depth of field (DOF), as shown in **Figure 2.6**. Using a narrow aperture creates deep DOF, as shown in **Figure 2.7**. By using a wide aperture, you can force your viewer to concentrate on specific elements. Conversely, by using a narrow aperture, you can reveal many details about the environment in which the photograph was shot.

FIGURE 2.6
(left) The wide aperture (f/1.4) created shallow depth of field—which focuses the viewer's attention onto Ariana.

FIGURE 2.7
(right) Using a small aperture (f/16) created deep depth of field. Now the background foliage competes with Ariana for the viewer's attention.

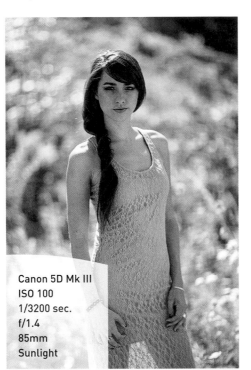

Canon 5D Mk III
ISO 100
1/3200 sec.
f/1.4
85mm
Sunlight

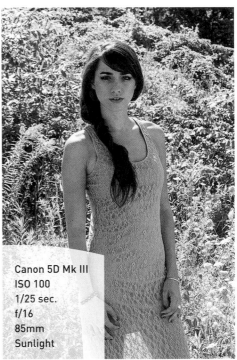

Canon 5D Mk III
ISO 100
1/25 sec.
f/16
85mm
Sunlight

BIG/WIDE VS. SMALL/NARROW

When we talk about a "big" or "wide" aperture, we're describing the size of the opening and not the f-stop number. As you can see in Figure 2.5, f/4 is a bigger/wider aperture than f/16. Likewise, f/22 is smaller/narrower than f/8.

MY SWIMMING POOL ANALOGY

I know it's hard to keep all of these numbers straight. So here's how you link an f-stop number to depth of field—think about them as numbers along the side of a swimming pool. Then it will be easy to remember that f/2.8 has shallow DOF and f/22 has deep DOF (**Figure 2.8**).

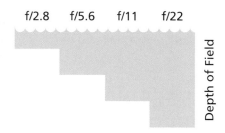

FIGURE 2.8
Think of f-stops as the numbers along the side of a swimming pool.

A DOF CALCULATOR IN YOUR POCKET

While the mathematics of how depth of field is calculated are beyond the scope of this book, there are times when it can be very helpful to know how much DOF a particular lens and aperture will yield. If you have a smartphone or tablet, you can quickly get this information with a DOF calculator app. For simple calculations, I use TrueDOF on my iPhone. For a more visual display, I use the pro-grade pCAM (**Figure 2.9**).

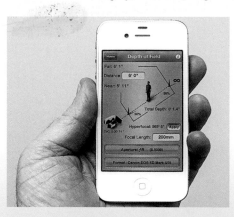

FIGURE 2.9
pCAM is an iOS app that allows me to calculate depth of field based on the camera, lens, aperture, and distance to the subject. This often keeps me out of trouble during shoots. For instance, here the combination of a 200mm lens on a Canon 5D Mark III yields a depth of field of only 1.4" when the subject is 6' away.

If depth of field is not a concern, then you can also use your aperture to help when shooting under dim light. Specifically, when the light is dim, you can use a wider aperture to allow more light through the lens and when the light is extremely bright, you can use a narrower aperture to reduce the amount of light coming through the lens. The following sections on ISO and equivalent exposures will help you understand this concept in greater detail.

ISO: KEEPING SHUTTER AND APERTURE IN A DESIRED RANGE

Back in the film days, ISO referred to the sensitivity of the film to light. Today it refers to the volume of the signal coming off the digital sensor. But the concept is the same: low ISOs are used in bright light and high ISOs are used in dim light. ISO 100 is "low/slow." Conversely, ISO 6400 is "high/fast" (**Figure 2.10**).

Here are the whole-stop increments of ISO from slow to fast: 100 > 200 > 400 > 800 > 1600 > 3200 > 6400 > 12800. As with shutter speeds and apertures, your camera probably displays ISO in either half- or third-stop increments. For simplicity, I change my ISO in whole-stop moves, which means that I count three clicks on the dial to make a one-stop ISO move on my cameras. (You can often select half- or third-stop increments in the custom function settings on your camera.)

FIGURE 2.10
ISO measures the volume of the digital signal coming from the camera's sensor—the higher the ISO, the higher the volume. Generally, as the light dims, the ISO is increased.

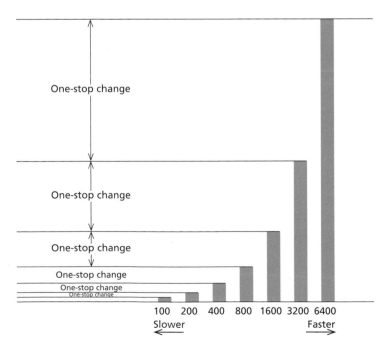

One-stop change

One-stop change

One-stop change

One-stop change

One-stop change

One-stop change

100 200 400 800 1600 3200 6400
Slower Faster

As an old-school film shooter, one of the most challenging concepts I encountered when I switched to digital a decade ago is the idea of using ISO as a creative tool. With a 36-exposure roll of film in the camera, I was basically stuck with the same ISO for the entire length of the roll. Now, in the digital world, it's perfectly normal to switch ISO between frames just as I switch shutter speed and aperture.

So, why would I use one ISO over another? As a general rule, I try to keep my ISO as low as possible. Then, as the light dims, I will raise my ISO to keep my shutter and/or aperture in the range that I want them to be.

For example, if I'm shooting an event without a tripod and the light gets dim, I will raise my ISO so that the shutter remains at a speed that I can handhold. Likewise, if I'm shooting a wide aperture outdoors because I want shallow DOF and the sunlight gets brighter because the clouds moved away, then I can lower the ISO to keep the aperture wide. (As we'll see in the next section, "Equivalent Exposures," using a faster shutter speed would also be an option…but we're talking about ISO here, aren't we?)

ISO AND DIGITAL NOISE

If you think of ISO as the volume of the digital signal coming off the sensor, then it's easy to visualize that the louder the volume, the greater the distortion in the signal. Photographers describe this distortion as "digital noise," which appears as random bits of color in the dark areas of an image.

The amount of noise depends upon the model of your camera and the ISO. Newer cameras generally have less noise than older cameras. In **Figure 2.11**, I've run a series of shots with my ancient Canon 5D (vintage 2005), my road-weary Canon 5D Mark II (vintage 2008), and with my brand-new Canon 5D Mark III (vintage 2012). You can see that each generation has significantly lower noise at ISO 1600.

FIGURE 2.11
Each new generation of the Canon 5D has improved noise performance at high ISOs. From left to right: Canon 5D, Canon 5D Mark II, Canon 5D Mark III—all at ISO 1600.

So, what can you do about noise when shooting at a high ISO is unavoidable? Take a look at **Figure 2.12**, which is a shot I made at ISO 3200 on my Canon Powershot S95 (a small camera that is often in my pocket). My friend Issa is lit by the flame of his cigarette lighter and a bit of dim tungsten light in the background. See the speckles of color? That is the digital noise. Most image-editing software, like Adobe Lightroom, have some degree of built-in noise-reduction capability. When a more robust solution is needed, as in the case of Figure 2.12, I move the image over to Photoshop and use the Noiseware Professional plug-in by Imagenomic. As you can see in **Figure 2.13**, the results can be amazing. Is the result a perfectly lit photograph? No, but for a souvenir snapshot it is a huge improvement.

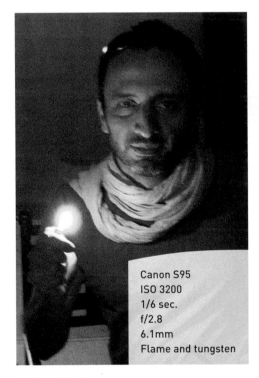

Canon S95
ISO 3200
1/6 sec.
f/2.8
6.1mm
Flame and tungsten

FIGURE 2.12
Lit mostly by the flame of a cigarette lighter with a bit of tungsten in the background, this shot of my friend Issa shows the color speckling that is typical of shots made at high ISOs.

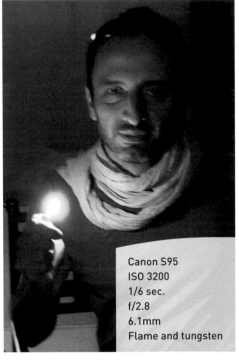

Canon S95
ISO 3200
1/6 sec.
f/2.8
6.1mm
Flame and tungsten

FIGURE 2.13
After processing the image with the Noiseware Pro plug-in for Photoshop, the digital noise has been reduced significantly.

EQUIVALENT EXPOSURES—TYING SHUTTER, APERTURE, AND ISO TOGETHER

For any given amount of light, there are many combinations of shutter speed, aperture, and ISO that will yield a well-exposed image. These various combinations are known as *equivalent exposures*.

So, to paint in broad strokes for a moment, if you use a fast shutter and a wide aperture to make a shot, then you could also use a slow shutter and a narrow aperture to make the same shot. Deciding which is the best of these equivalents depends upon what you want to achieve visually.

THE EXPOSURE PYRAMID AND INVERSE RELATIONSHIPS

Photographers use the term *exposure triangle* to describe how shutter, aperture, and ISO connect to create an exposure. I like to add in flash power (which we will discuss in Chapter 4) and call it the Exposure Pyramid (**Figure 2.14**). An important tip to remember is that the relationships between these settings are *inverse*. If you make one setting larger, then you have to make one or more of the other settings smaller to keep the exposure the same. You will typically do this when you make a change in the aperture to increase/decrease depth of field or a change in the shutter speed to freeze/emphasize motion.

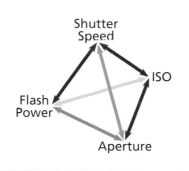

FIGURE 2.14

My Exposure Pyramid is a reminder that the relationships between shutter, aperture, ISO, and flash power are inverse. If you increase one setting for creative effect, then you will have to decrease one or more of the other settings to keep the overall exposure the same.

In **Figure 2.15**, I have listed whole stops of shutter, aperture, ISO, and flash power. As you learn photography, you can use the chart to count the number of whole stops of change between one setting and another. Then you can count the same number of stops in the opposite direction for another setting. That will give you an equivalent exposure.

FIGURE 2.15

Camera Settings			Flash Power
Shutter	Aperture	ISO	
slower / longer = motion blurred	wide = shallow depth of field	fast / high = more sensitive	high-power = brighter
1"	f/1.0		
1/2"	f/1.4		
1/4"	f/2.0		
1/8"	f/2.8	12800	1/1
1/15"	f/4.0	6400	1/2
1/30"	f/5.6	3200	1/4
1/60"	f/8	1600	1/8
1/125"	f/11	800	1/16
1/250"	f/16	400	1/32
1/500"	f/22	200	1/64
1/1000"	f/32	100	1/128
1/2000"	f/45		
1/4000"	f/64		
1/8000"	f/90		
faster / shorter = motion frozen	narrow = deep depth of field	slow / low = more sensitive	low-power = dimmer

(WHOLE STOPS)

Here is a practical example. In **Figure 2.16**, I photographed the rose at f/22. As you can see, the deep depth of field allows the foliage in the background to compete visually with the flower. So, to create a more pleasing shot with shallow depth of field, I opened the aperture all the way from f/22 to f/4. If you use the chart above, you can count that the move from f/22 to f/4 is a five-stop move: f/22 > f/16 > f/11 > f/8 > f/5.6 > f/4—as shown by the red arrow.

To offset the wider aperture—and the additional five stops of light that the wider aperture lets in—I had to make a move in the opposite direction in the shutter column, the ISO column, or both. Since I shot Figure 2.16 at ISO 400 and the minimum ISO on my camera is 100, I made a two-stop move in ISO, as follows: 400 > 200 > 100 (blue arrow). Now, what change must I make from the 1/125" shutter speed to get the additional three stops of change? Again, since I moved up on the chart in the aperture column, I have to move down the chart in the shutter column. So, a three-stop move from 1/125" is as follows: 1/125" > 1/250" > 1/500" > 1/1000" (green arrow).

So, f/22, 1/125", ISO 400 is an equivalent exposure to f/4, 1/1000", ISO 100. As you can see in **Figure 2.17**, the overall exposure looks the same as the previous shot (i.e., the same exact amount of light is hitting the sensor in both exposures). Yet the wider aperture creates shallow depth of field that makes the background less distracting.

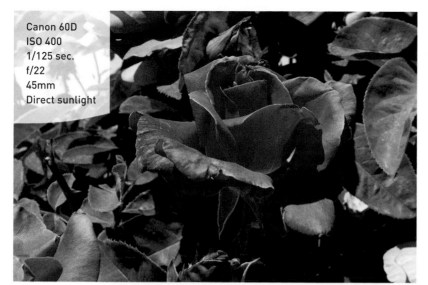

Canon 60D
ISO 400
1/125 sec.
f/22
45mm
Direct sunlight

FIGURE 2.16
With the aperture set at f/22, the background details compete with the main subject of this photograph.

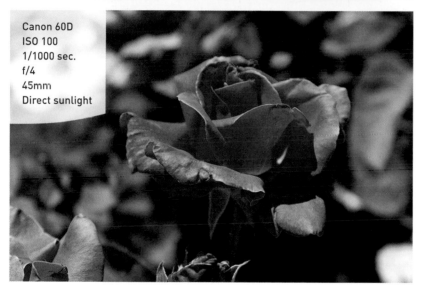

Canon 60D
ISO 100
1/1000 sec.
f/4
45mm
Direct sunlight

FIGURE 2.17
Opening up the lens to its maximum aperture, f/4, creates shallow depth of field, which allows the viewer to focus on the beauty of the rose. To offset the five-stop move in aperture, I lowered the ISO by two stops (400 > 100) and sped up the shutter by three stops (1/125" > 1/1000").

Again, to summarize this equivalent exposure move, I made the aperture five stops wider to create shallow depth of field. I offset this move by making my ISO two stops less sensitive and my shutter three stops faster. If you need to, count out the moves using Figure 2.15. The equivalent exposures in this pair of shots are:

- f/22 > f/4 = five stops wider
- ISO 400 > ISO 100 = two stops less sensitive
- 1/125" > 1/1000" = three stops faster

CAMERA MODES—WHO SETS WHAT

The reality of modern, digital cameras is that they have become far smarter than most people who use them. So, it's not surprising that camera engineers have come up with all types of automatic shooting modes—ways in which the exposure settings are calculated and set.

The choice of camera mode depends upon your experience and what you want to do. I will take you through a quick survey that will start with the most automatic and end with fully manual. Along the way, we'll consider specific reasons to use each.

FULLY AUTOMATIC

In "green box" mode, your camera controls everything—shutter, aperture, ISO, and even flash. When you have no idea how to work your camera, this can very helpful. However, since you're reading *Lighting for Digital Photography,* it is obvious that you want to learn. So, let's quickly move beyond full auto.

SCENE-BASED CAMERA MODES

Scene-based automatic modes try to select the best exposure, focus, and drive settings for a specific situation. For example, if you are shooting a kids' soccer game, then switching your camera into Sports mode will set the shutter to high-speed continuous shooting (so the camera will keep firing while the shutter button is pressed), the focus to Servo (which keeps the lens adjusting the focus on the fly), and will disable the flash (because the camera assumes that the action is beyond the range of the flash).

Conversely, if you set the camera to Close-up mode, the shutter is set to single shot, and the flash is activated automatically. While scene-based camera modes are fine when you are starting out, my recommendation is that you work your way into using the creative camera modes described below.

CREATIVE CAMERA MODES

 Program mode (P) is similar to green box mode, except that you set the ISO. The camera then sets the shutter and aperture. If necessary, the camera will prioritize the shutter speed and set it at a minimum speed that most people can hold (typically 1/60"). Honestly, I don't find much use for Program mode.

 Aperture priority mode (Av or A) sets the shutter speed automatically based on the aperture and ISO that you set. My photography is typically more concerned with depth of field than it is with freezing or emphasizing motion. So, Av is a natural place for me to start. If I want shallow DOF, I dial in f/2.8 or f/4. If I want maximum DOF, I dial in f/22. If I want something in between, I dial in f/8 or f/11. Even when I expect that I will end up controlling my camera settings in Manual mode (as described below), I will start with my camera in Av so that I can quickly establish a starting point for my exposures.

 Shutter priority mode (Tv or S) is great when freezing or emphasizing motion with the shutter speed is more important than controlling depth of field with the aperture. In Tv, you set the ISO and the shutter speed. The camera sets the aperture. Shutter priority mode is also helpful when you want to shoot at a specific maximum or minimum shutter speed—such as shooting at, but not above, the camera's flash sync speed, or shooting at the slowest shutter speed that you can handhold.

 Manual mode (M) gives you full control. You set the shutter, aperture, and ISO. The biggest advantage of Manual mode is that the exposure remains consistent from frame to frame. You don't have to worry that a change in the framing of the shot will cause the camera to set a different exposure. Also, in low-light situations with flash, Manual mode is a big help because it allows you to lock in your ambient exposure and then light your subject with flash. I'm a big fan of running your camera in Manual mode.

WHITE BALANCE

White balance is a camera setting that tells the camera how to record the light that it sees. You will recall from Chapter 1 that the first C in DICCH refers to *color* and that we touched upon the idea that various light sources have different *color temperatures*— meaning that some light sources appear more yellow and others appear more blue. The idea behind the white balance setting on your camera is that it applies a bit of the opposite color so that whites appear white.

Take a look at **Figures 2.18** and **2.19**. Both were shot under a tungsten (incandescent) light source. In Figure 2.18, the white balance setting on the camera was Daylight. In Figure 2.19, the white balance setting was Tungsten. When you set your camera to Tungsten white balance, then the computer inside adds a blue tint to the file to offset the yellowish cast of the tungsten (incandescent) light bulb.

FIGURE 2.18
This shot has an orange color cast because I had my camera's white balance set to Daylight while shooting under tungsten light.

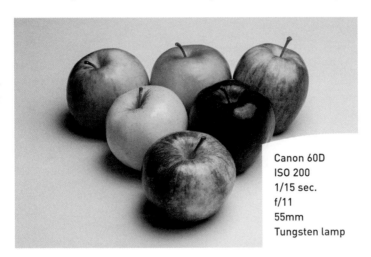

Canon 60D
ISO 200
1/15 sec.
f/11
55mm
Tungsten lamp

FIGURE 2.19
Switching the camera's white balance to Tungsten produced a shot with more neutral colors.

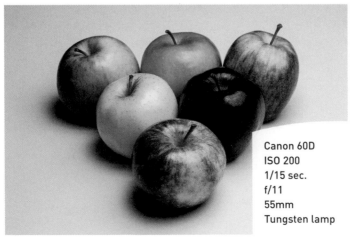

Canon 60D
ISO 200
1/15 sec.
f/11
55mm
Tungsten lamp

Likewise, if you switch to Cloudy white balance, then the camera adds a yellow tint to the file to offset the cool cast of skylight. Again, the goal is to make the whites look white rather than slightly blue or slightly yellow. Later in the book, we will also talk about the creative use of color temperature and white balance settings.

AWB–AUTOMATIC WHITE BALANCE

If most of your shooting is casual, a-few-shots-of-this and a-few-shots-of-that photography, then feel free to leave your camera set to *AWB–Auto White Balance*. Modern, digital cameras do a good job of estimating the color temperature of the light source. When the light source is frequently changing, the convenience of shooting in AWB is huge.

SOURCE-SPECIFIC WHITE BALANCE SETTINGS

The time to switch into a specific white balance is when you will be shooting a large number of frames under a specific light source—such as a wedding photographer who shoots inside the church, then outside on the lawn, and finally back inside at the reception. By locking the camera into a specific white balance setting for each of these sessions, the photographer can then make global color correction moves to the entire set rather than have to work each image individually.

RAW VS. JPEG

When I started in digital photography a decade ago, the costs of data storage and processing speed were far more expensive than they are today. Back in the day, I shot in JPEG because I thought the compressed files were more economical to store and faster to work. Then, after Adobe introduced Adobe Camera Raw, I embraced the flexibility and future-proofing that the RAW format provides. Today, with affordable memory cards being measured in gigabytes and affordable hard drives being measured in terabytes, I now shoot in RAW almost exclusively.

Shooting in RAW gives you tremendous latitude in processing the file after capture. If your file is severely over- or underexposed, with a RAW file it is likely that you can still make a usable image. For instance, as shown in **Figure 2.20**, I grossly underexposed this shot of a falconer in Dubai. Thanks to the great latitude of RAW files, I was able to process out this file into the image you see in **Figure 2.21**. Had I been shooting in JPEG, I am certain that the image would have been a total loss. As it was, the severe

underexposure resulted in an image full of digital noise. So, the final step was to process out the noise with Imagenomic's Noiseware Professional. To see details of the before and after noise, refer back to Figures 2.12 and 2.13.

While some recovery is possible with a JPEG, I do not think that the savings in file size is worth the limited range of post-processing.

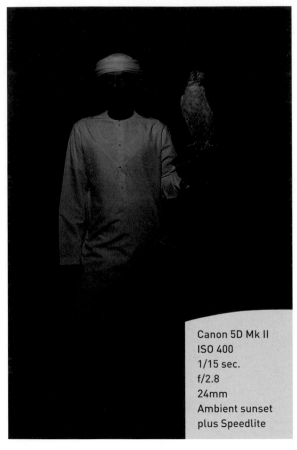

Canon 5D Mk II
ISO 400
1/15 sec.
f/2.8
24mm
Ambient sunset
plus Speedlite

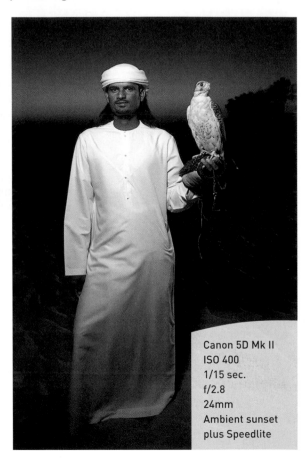

Canon 5D Mk II
ISO 400
1/15 sec.
f/2.8
24mm
Ambient sunset
plus Speedlite

FIGURE 2.20
In this quick sunset shoot of a falconer in Dubai, I was so focused on the image on my camera LCD that I neglected to check the histogram. If I had, I would have discovered that my shots were severely underexposed. The brightness of the LCD was set to Auto and appeared very bright in the dim light.

FIGURE 2.21
Here is where shooting RAW saves the day. I was able to salvage a portfolio shot in Lightroom by adding three stops of exposure in the Develop module. The adjusted shot was so noisy that I also had to use Noiseware Pro in Photoshop.

A SITUATION WHEN JPEG MAKES SENSE

The exception to my no-JPEG rule is when I am shooting a time-lapse series of stills for conversion into video. Given that the pixel dimensions of high-definition TV is 1920 x 1080, the Small JPEG file produced by most cameras provides more than enough data. The key must-do, in this case, is to make certain that my white balance and exposure settings are dialed in correctly.

Why not shoot a series of RAW files to keep my options open? Well, since video streams at 30 frames per second, one minute of time-lapse equates to 1,800 frames (30 x 60 = 1,800). That is a load of frames to process out into a format that can be imported as a video stream. Processing 1,800 RAW captures, at 20 MB or so per frame, requires more horsepower than I have on my computer.

Fortunately, the relatively new Small RAW file may give me reason to abandon JPEG once again. In Small RAW, each frame is about four megabytes. So, a stack of 1,800 frames in Small RAW is about eight gigabytes of data to process. My newest computer, with its solid-state hard drive and 16 GB of RAM, is just up to the task…just.

POST-PROCESSING

Having spent an entire chapter discussing camera settings, I cannot close without sharing a few insights about how I manage all the digital files that I create.

LIGHTROOM—THE BACKBONE OF MY WORKFLOW

If you ever attend one of my workshops or seminars, you will hear me chant, "I choose to be a photographer and not a retoucher." What I mean by this is that I take all the time I can before the shutter button is pushed to assure that I am making the best digital capture possible. If this means that I work harder at my lighting, then I'll light as needed. If it means that I move my camera to create a better composition, then I'll move my camera. By contrast, many photographers say, "Don't worry about it. I can fix it in Photoshop." I encourage you not to think this way.

As for my typical post-capture workflow: the vast majority of my computer work is done in Adobe Lightroom. If you are not yet using a program designed specifically to import, catalog, process, print, and then archive your digital files, I encourage you to check out Lightroom. As of this writing, you can download a free 30-day trial from Adobe.com.

My reliance on Lightroom is based on the fact that it is a non-destructive workflow. What actually happens in Lightroom is that all my moves in the Develop module are written out as instructions that will be applied to the RAW file when it is exported. This gives me the opportunity to change my mind about an adjustment in the future and to take advantage of improved processing algorithms that come out with future generations of the program.

In terms of the moves I make most often, look at the Develop panel in **Figure 2.22**. My moves are typically limited to global moves (meaning they apply to the entire image). In many ways, this is like choosing a specific film stock in the "old" days—Ektachrome to emphasize blues and greens, Kodachrome to emphasize reds, Velvia for a super-saturated look. Here is a quick list of my most-used moves:

FIGURE 2.22
Here is the Basic portion of the Develop panel in Lightroom. To save the shot in Figure 2.20, I added three stops of Exposure (shown here) to arrive at the shot in Figure 2.21.

- Temp—to adjust the warmth/coolness of the image

- Exposure—to fine-tune the capture (and occasionally to save my backside)

- Highlights—to restore highlight details that are overexposed

- Shadows—to reveal details in shadow areas that are underexposed

- Clarity—to add snap to the midtones

- Vibrance—to add punch to colors (sparingly!)

WHAT ABOUT PHOTOSHOP?

Photoshop is now eight generations beyond the version I started with in the mid-90s. So, I'm sure that I've spent a couple thousand hours driving Photoshop over the years.

Do I still use it? Yes, when I have to. For instance, all of the photographs in this book had to be converted for CMYK printing. This is something that Lightroom does not do. So every image you see was exported from Lightroom into Photoshop for this final step.

My friend, Zeke Kamm (nicephotomag.com) once shared another healthy attitude about Photoshop. He said, "I use Photoshop to create images that are either too expensive or too dangerous to shoot in real life."

Using the Light Around You

GETTING STARTED WITH NATURAL LIGHT

When learning to light, my recommendation is that you first become a student of the light that is already around you. Everyone knows that the largest source of natural light in our world is the sun. Yet, sunlight comes in many forms. The color and contrast of midday sun is different than the golden light before sunset. Direct sunlight is significantly different than the diffused sunlight that happens on cloudy days. Both sunlight that bounces in through a window and open shade provide usable, soft light. Knowing how to maximize the opportunities provided by many types of natural light will go a long way to making you a successful photographer. To begin, we will explore how sunlight changes throughout each day. Then, we'll learn to shoot in many types of sunlight—both direct and indirect.

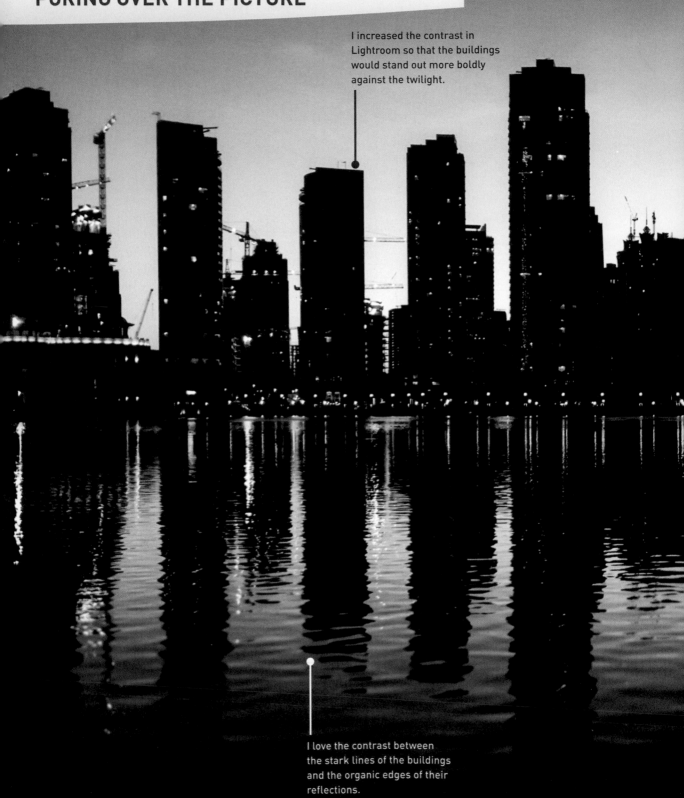

PORING OVER THE PICTURE

I increased the contrast in Lightroom so that the buildings would stand out more boldly against the twilight.

I love the contrast between the stark lines of the buildings and the organic edges of their reflections.

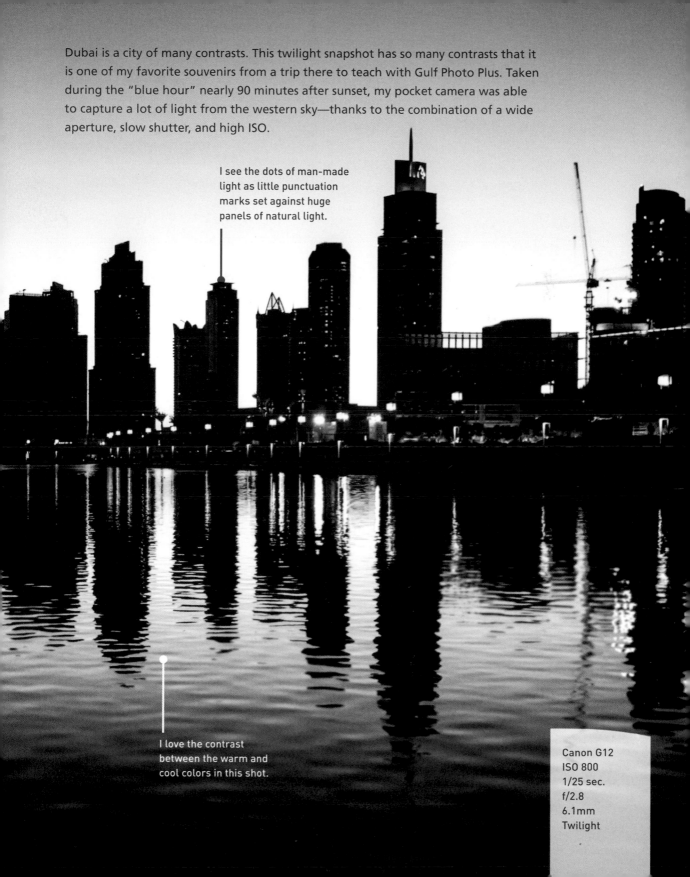

Dubai is a city of many contrasts. This twilight snapshot has so many contrasts that it is one of my favorite souvenirs from a trip there to teach with Gulf Photo Plus. Taken during the "blue hour" nearly 90 minutes after sunset, my pocket camera was able to capture a lot of light from the western sky—thanks to the combination of a wide aperture, slow shutter, and high ISO.

I see the dots of man-made light as little punctuation marks set against huge panels of natural light.

I love the contrast between the warm and cool colors in this shot.

Canon G12
ISO 800
1/25 sec.
f/2.8
6.1mm
Twilight

PORING OVER THE PICTURE

This is another Dubai snapshot—taken in the souk (an open air market) shown in the opening photograph of this chapter. Available light shots like this are easy to make in foreign countries—provided that you are willing to communicate with gestures. The beautiful light is typical of the magic that happens in open shade. A nearby building allowed a bit of sunlight to bounce in.

Using a wide aperture kept the depth of field shallow, which allows the viewer to focus on the face rather than background elements.

The highlights from the sunlight bouncing in from a nearby building add depth to the face and texture to the skin.

My camera's Auto White Balance setting did a great job off-setting the blue tint of open shade so that the white shirt appears white.

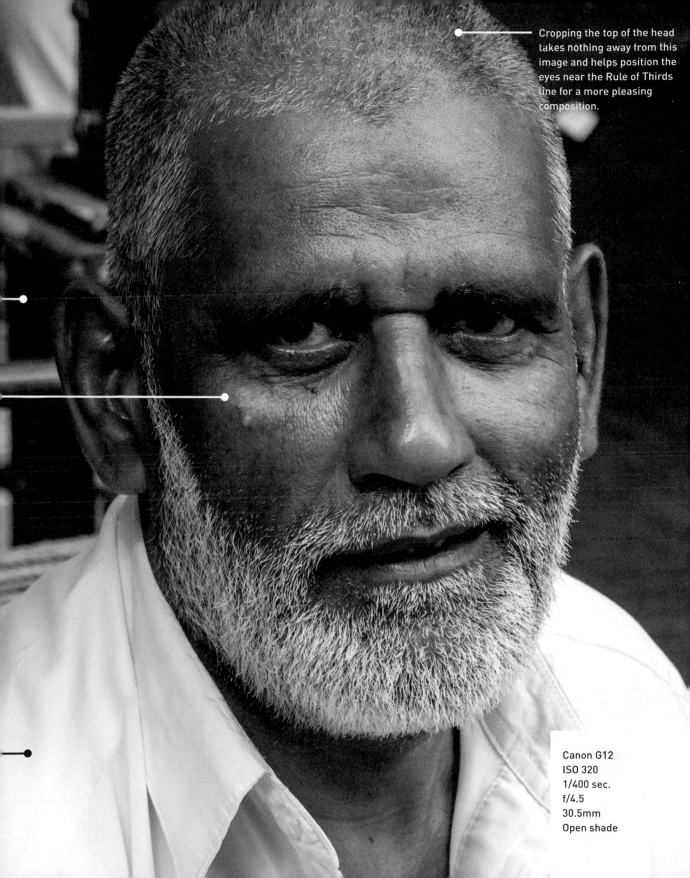

Cropping the top of the head takes nothing away from this image and helps position the eyes near the Rule of Thirds line for a more pleasing composition.

Canon G12
ISO 320
1/400 sec.
f/4.5
30.5mm
Open shade

LIGHT: NATURAL, ARTIFICIAL, AVAILABLE, AND AMBIENT

Natural light, for the most part, comes directly or indirectly from the sun. Sure, there are other sources of natural light, such as firelight, but the main source of natural light in our world is the sun. (Moonlight, in case you're wondering, is recycled sunlight—at least in my view.)

Artificial light describes the many forms of electric light that we create with light bulbs—both continuous and flash. We'll discuss these in Chapter 4.

Available light and *ambient light* describe the same thing—the light that is already there in your shot. Many photographers mistakenly assume that available light means only *natural light*. Regardless of the source—sunlight, lamplight, or firelight—if it's already in the scene, then call it available light or ambient light. For the record, as you will see throughout this book, I prefer the term ambient light.

DEAL WITH THE AMBIENT LIGHT FIRST

When I start into a shoot, I always consider what I want to do with the ambient light first. Even when I know that I am going to add light from another source, such as flash, I settle on the exposure for the ambient light first. My shutter speed is the tool I use most often to control how my camera records the ambient light. If I want to brighten the ambient light, as is often the case on cloudy days, then I can use a longer shutter speed. If I want the ambient light to appear dimmer, to saturate the colors in the sky for instance, I can underexpose the ambient light with a faster shutter speed.

Regardless of whether you are shooting indoors or outside, and regardless of whether your ambient light is natural or man-made, you will want to consider the DICCH of the light that is already there—Direction, Intensity, Color, Contrast, and Hardness. Sometimes you can directly modify the available light, by flipping a switch or placing a modifier (such as a diffusion disk) between the light source and your subject. At other times, you might have to add available light back into itself, such as when using a reflector disk to bounce sunlight back into the shadows.

THE DAILY CYCLE OF SUNLIGHT

As a photographer, have you ever considered how sunlight changes through the day? I'm sure you know that the direction and intensity of sunlight change. Can you also describe how the color, contrast, and hardness of sunlight change? For instance, how is early morning sunlight different than sunlight at high noon? Or what is sunlight like a half hour after the sun drops below the horizon?

As shown in **Figure 3.1**, the nature of sunlight changes rhythmically throughout each day—from the cool pre-dawn twilight, through the golden glow just after sunrise, to the neutral white light at noon. Then the cycle reverses itself in the afternoon as the sun continues across the sky to the western horizon and beyond. Day after day, sunlight follows this rhythmic pattern—which gives you the opportunity to schedule shoots for a particular quality of light.

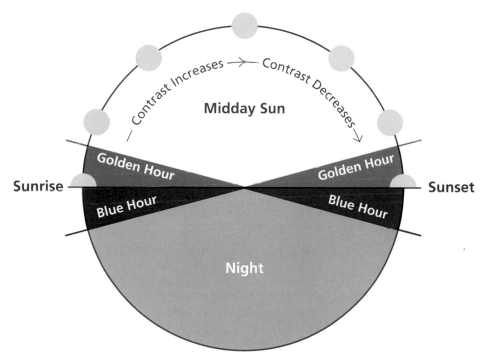

FIGURE 3.1
The daily cycle of sunlight begins before sunrise and continues until after sunset. Between the morning and evening Blue Hour (twilight), there are two Golden Hours separated by a long stretch of Midday Sun. The DICCH of sunlight changes in this rhythmic pattern day after day.

MIDDAY SUN

Thirty to sixty minutes after sunrise, as the sun continues to climb, its rays pass through a thinner and thinner layer of atmosphere (**Figure 3.2**). The color of sunlight shifts from warm to neutral as the intensity of the sun peaks at noon. As the intensity of the sunlight increases, so does the contrast of its shadows.

For many photographers, the extreme contrast of midday sun can be problematic. Actually, I don't think it is the light that is problematic; I think it is the skills of the photographers that create the midday challenges. As you will see in the next section of this chapter, there are many ways to modify direct sunlight so that you can create great shots throughout the middle of the day—the key is to reduce the contrast of the sunlight, either by diffusing the sun directly or by bouncing light into the shadows.

GOLDEN HOUR

When the sun is above, but still near the horizon, its rays pass through a thick slice of the atmosphere (**Figure 3.3**). As the rays bounce off of dust, water vapor, and other particulates, the light scatters—taking on a very warm cast. The beautiful colors and relatively low contrast of sunlight during the *golden hour* makes this a great time to photograph. Like the rush hour on an urban freeway, the golden hour is seldom exactly 60 minutes long.

BLUE HOUR / TWILIGHT

You may have never thought of making photographs when the sun is below the horizon, but with a sturdy tripod and long exposures, you can create captivating images during *twilight*. In case you are wondering, the difference between *night* and *twilight* is that at night you cannot distinguish the horizon from a dark sky and during twilight you can.

During twilight, even though we cannot see the sun directly, the sun's rays bounce off the upper atmosphere and cascade down (**Figure 3.4**)—taking on a very blue color. So photographers often call twilight the *blue hour*, although twilight is seldom exactly 60 minutes long.

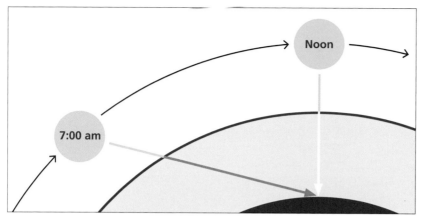

FIGURE 3.2

Midday Sun: When the sun is close to the horizon, its rays pass through a thicker slice of the atmosphere, which warms the color of sunlight (orange arrow). During the middle portion of the day, the sun's rays pass through a thinner slice of the atmosphere (white arrow). We define noon sunlight as being neutral white—neither warm nor cool.

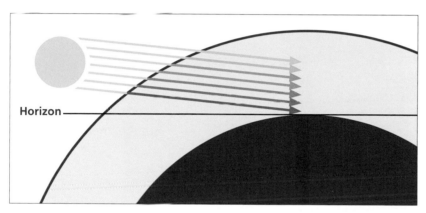

FIGURE 3.3

Golden Hour: For a period after sunrise and before sunset, the sun's rays angle through a thick slice of the atmosphere. The blue rays are defracted by water vapor and particulates. During this *Golden Hour*, the sunlight takes on a distinctively warm color—the longer the path through the atmosphere, the warmer the color.

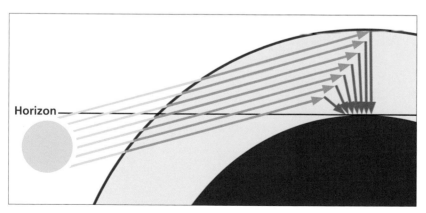

FIGURE 3.4

Blue Hour: During twilight, the period before sunrise and after sunset when the sun's rays still reach us even though the sun itself is below the horizon, the sunlight bounces off the atmosphere. During this period, called the *Blue Hour* by photographers, the light is very soft and has a distinct blue tint.

WHITE BALANCE AND VARIOUS TYPES OF SUNLIGHT

Compare the four images in **Figures 3.5–3.8**. They were shot at the following times of day: late afternoon sun (Figure 3.5), during the golden hour shortly before sunset (Figure 3.6), during the blue hour about 55 minutes after sunset (Figure 3.7), and in near dark 80 minutes after sunset (Figure 3.8). To keep the shot consistent from frame to frame, I locked my camera down on a sturdy tripod. If you look at the exposure details, you will see how I changed the shutter speed and ISO to accommodate the dimming light.

FIGURE 3.5
This late afternoon shot, made 40 minutes before sunset, is typical of midday sunlight. The whites are neutral and the shadows are contrasty.

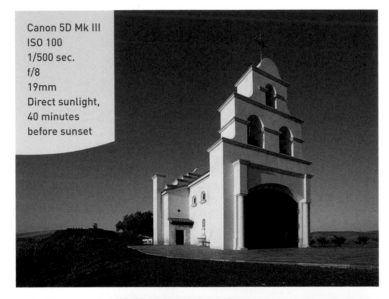

Canon 5D Mk III
ISO 100
1/500 sec.
f/8
19mm
Direct sunlight,
40 minutes
before sunset

FIGURE 3.6
This golden hour shot, made 10 minutes before sunset, shows the warm glow that happens when the sun is near the horizon. To make this shot, I slowed my shutter by two stops, from 1/500" to 1/125", to capture this beautiful light.

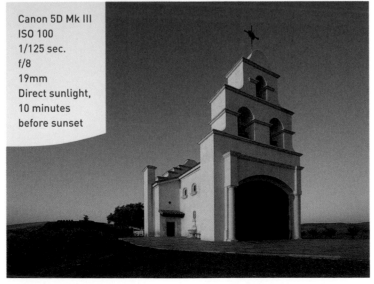

Canon 5D Mk III
ISO 100
1/125 sec.
f/8
19mm
Direct sunlight,
10 minutes
before sunset

The biggest tip I can share about shooting during the "special hours" is to not use Auto White Balance because AWB will try to neutralize the warm or cool colorcast. Instead, set your camera's white balance to match the light source you are using—Daylight. Then your golden hour shots and blue hour shots will be captured with the tint that you expect.

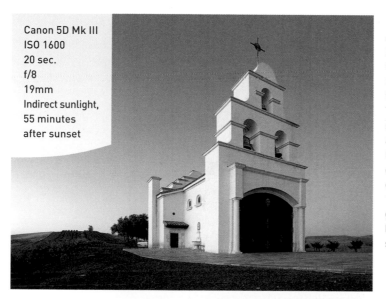

Canon 5D Mk III
ISO 1600
20 sec.
f/8
19mm
Indirect sunlight,
55 minutes
after sunset

FIGURE 3.7

After the sun drops below the horizon, there is still a significant amount of light that can be captured. To make this blue hour shot nearly an hour after sunset, I used a long shutter speed and dialed the ISO up. The combined change was 15.33 stops from the golden hour shot. Note how the light takes on a soft, blue quality.

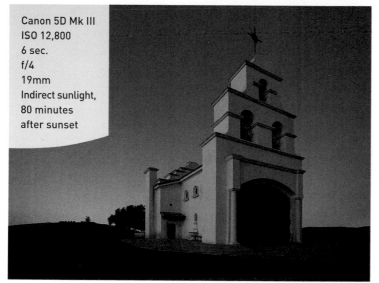

Canon 5D Mk III
ISO 12,800
6 sec.
f/4
19mm
Indirect sunlight,
80 minutes
after sunset

FIGURE 3.8

With the latest generation of digital cameras, it is possible to get great shots in near darkness. Even though I could hardly see the chapel 80 minutes after sunset, an extremely high ISO enabled me to capture enough light to make this beautiful shot. To make sure that the stars were pinpoints rather than streaks, I switched to a faster shutter speed and opened up the aperture.

SHOOTING IN DIRECT SUNLIGHT

Depending upon where you live, sunny days will either be the norm or a rarity. Except for a few wet months in winter, the climate where I live on the central coast of California is very sunny. Over the years, I have become very good at making photographs under direct sunlight—largely out of necessity rather than choice.

Direct sunlight has the twin challenges of creating intense contrast and hard shadows. Here is my big tip for making great images in broad daylight: you have to adjust the dynamic range of light hitting your subject to fit within the capabilities of your camera. This is a fancy way of saying that you have to make direct sunlight appear less bright so that your camera can record details in the shadows without having important highlight details blow out to pure white.

In this section and in the next chapter, we'll explore several strategies for shooting in direct sunlight. You can use them individually or in combination. They are:

- Diffusing the sunlight
- Bouncing sunlight into the shadows
- Moving the subject into shade
- Filling shadows with flash (covered in Chapter 4)

DIFFUSING SUNLIGHT

Relative to the size of our sky, the sun appears as a small object, measuring 0.5° across—meaning that it would take 360 suns, edge to edge, to span the sky from horizon to horizon. Of course, the sun is not small. Rather, earth's distance from it makes it appear small. The same is true for any light source—the farther it is from the subject, the smaller it appears. As we discussed in the section on Hardness in Chapter 1, the smaller the light source is relative to the size of the subject, the harder the light will be. So, direct sunlight creates hard-edged shadows because the sun appears to be a relatively small light source in our sky.

To soften sunlight, photographers use translucent diffusers to make the *apparent size* of the sun bigger than the subject. Depending upon the size of the subject, these diffusers can range from 12" across to many feet. Like a cloudbank, this means that the rays of light now come at the subject from a wide set of angles. When light comes at a subject from a wide set of angles, the shadows thrown to one side are filled by light coming from that side and vice versa. (Look back at Figures 1.4 and 1.5 if the "set of angles" concept seems confusing.) So, using a diffuser between the subject and the sun reduces the contrast of the light and softens the shadow edges.

In terms of seeing the difference between direct and diffused sunlight, take a look at **Figures 3.9** and **3.10**. In the first image, Christina stood in direct sunlight. You can see that harsh shadows rake across her face and that the background is lost into black. For the second image, the diffuser panel overhead greatly softened the shadow edge and reduced the contrast.

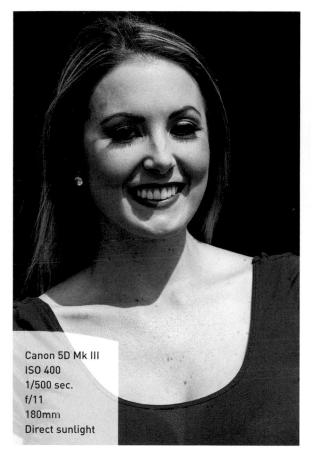

Canon 5D Mk III
ISO 400
1/500 sec.
f/11
180mm
Direct sunlight

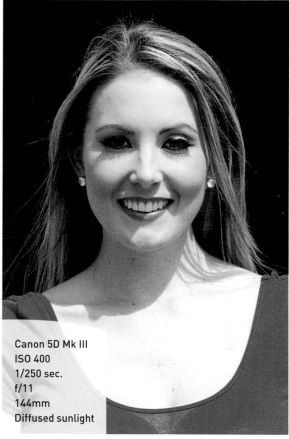

Canon 5D Mk III
ISO 400
1/250 sec.
f/11
144mm
Diffused sunlight

FIGURE 3.9
With the sun high overhead, the direct sunlight in this shot creates distracting shadows across the face and neck. Notice also how the background details are lost to black—evidence that my camera cannot record the full range of highlight and shadow details that I could see.

FIGURE 3.10
The translucent fabric of the overhead diffuser panel lowers the intensity and contrast of the sunlight. Note how the shadows are softer. Also, I was able to slow my shutter by one stop, which captured a bit of detail in the background foliage.

As shown in the set shot, **Figure 3.11**, I used a 42" Scrim Jim panel with a full-stop silk. It is held aloft on a sturdy C-stand. For professional work, I am very fond of the Scrim Jim system because it is lightweight, versatile, and easy to transport. When you are just starting out, I recommend the 5-in-1 reflector kit that I describe in the "Essential Gear" sidebar later in this chapter as an economical alternative.

FIGURE 3.11
To diffuse the sunlight, I placed a 42" Scrim Jim panel with diffusion fabric held above Christina on a C-stand. The Scrim Jim is a modular system that comes in a variety of sizes and fabrics—for both diffusion and reflection.

FILLING SHADOWS WITH BOUNCED SUNLIGHT

When it is not feasible to get a diffuser disk over the top of your subject, another option is to bounce light into the shadows. While the subject will still be in direct sunlight, the contrast of the shadows will be reduced by the bounced fill light (**Figures 3.12** and **3.13**).

Photographers often use foam core (a rigid white panel sold in many office supply stores) or fabric disks and panels to bounce light into shadows. Generally, the reflector should be larger than your subject. So, if you are photographing flowers, a 12" disk reflector or a sturdy sheet of paper might suffice. If you are shooting portraits, then a 30" or 42" disk reflector or a large sheet of foam core is a better choice.

Canon 5D Mk III
ISO 400
1/800 sec.
f/11
200mm
Direct sunlight,
white bounce

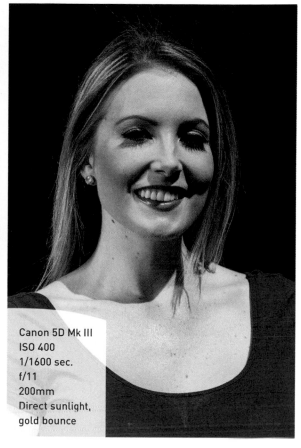

Canon 5D Mk III
ISO 400
1/1600 sec.
f/11
200mm
Direct sunlight,
gold bounce

FIGURE 3.12
Using a white reflector to bounce sunlight into the shadows helps soften the light in this shot. However, the direct sunlight creates strong contrast in the eyelash and chin shadows.

FIGURE 3.13
A gold reflector can be helpful for fill light when shooting during golden hour. Here the warmth of the fill light from the gold reflector does not blend naturally with the cooler light of midday sun.

The basic technique is to place the reflector just outside the frame of the shot on the shaded side of the subject. As shown in **Figure 3.14**, angle the reflector so that it catches light flying past the subject and pushes it back into the shadows. If the reflected light is too bright, then pull the reflector away from the subject; the more distance you create between the reflector and the subject, the less powerful the fill light will be.

FIGURE 3.14
Here I have
changed out the
fabric in the 42"
Scrim Jim panel to
a white reflective
panel and angled it
towards Christina
to bounce sunlight
into the shadows.
If you don't have a
sturdy stand to hold
the reflector, ask
a friend to be your
assistant.

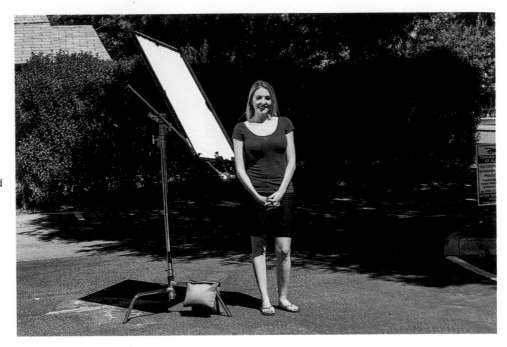

There are many options for reflector fabrics. White provides a very soft fill because it reflects a small amount of the light. Silver reflects more of the light and, thereby, creates highlights with more snap. Gold significantly warms up the fill light. This can be quite helpful when shooting when the sun is close to the horizon because the warm light from the gold reflector will match the overall quality of light. At other times of the day, if used too heavily, the bounce from a gold reflector can resemble a bad, spray-on tan.

BE MINDFUL OF SQUINTING WITH METALLIC REFLECTORS

When you are using a silver or gold reflector in bright sun, be mindful to not focus the light on your subject for so long that she squints. When this happens, ask your assistant (the person holding the reflector) to aim the reflector on the subject and then pull it away so that she can relax her eyes. Then, when you are ready to shoot, have the assistant swing the reflector back into position so that you can quickly fire off a frame or two. Repeat this until you are done with the shoot.

I consider a 40" 5-in-1 reflector set to be a must-have bit of gear. It is inexpensive, portable, and versatile. So what is it? A 5-in-1 consists of a diffuser disk made of translucent fabric and a zip-off cover. The cover is made of four fabrics—white, black, gold, and silver—and can be zipped over the diffuser with either side out (**Figure 3.15**). You can use the diffuser disk overhead on a sunny day to take the hard edge off of sunlight. You can zip the cover over the disk and use the white, gold, or silver side to bounce light into the shadows: the color and amount of the fill light depends upon the color you choose. And finally, if you want to kill the bounced light coming off of a surface, you can use the black side of the cover to absorb light that is flying past your subject so that it does not hit a nearby reflective surface and bounce back into the shot.

FIGURE 3.15

A five-in-one reflector set is made of two parts: a round diffuser disk (far left) and a removable cover that slips over the disk. The cover is made of four fabrics: white, silver, gold (for fill), and black (to block bounce from a nearby surface).

COMBINING AN OVERHEAD AND A BOUNCE

Once you get the hang of filling the shadows with a reflector and/or flash (which we'll talk about in Chapter 4), you can combine this technique with an overhead diffuser or *solid*. A solid is like a diffuser, except that it is an opaque fabric that is used when you want to take a big bite out of the sun's intensity.

Using an overhead to reduce the sun and then creating softer, more controllable light underneath is a technique often used by pro shooters in bright daylight conditions. The next time you see a catalog photo of a swimsuit model on a beach, look at the light on her—is it hard or soft? I'll bet that it is soft light. Now ask yourself how the photographer pulled this off—by using an overhead to knock the sun's power way down and then lighting from underneath with a reflector or flash. Even if you're not a swimsuit photographer, you can put this technique to good use (**Figures 3.16** and **3.17**).

FIGURE 3.16
This shot was created with a favorite combination for outdoor portraits: a solid overhead to put the subject into shade and a white reflector to bounce sunlight in from the side. Notice how soft the shadows have become with this combination.

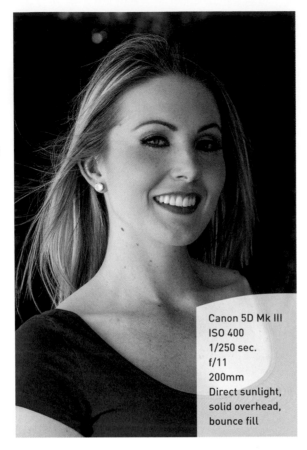

Canon 5D Mk III
ISO 400
1/250 sec.
f/11
200mm
Direct sunlight,
solid overhead,
bounce fill

FIGURE 3.17
This set shot shows the two panels I used to create Figure 3.16. The solid panel is held above the model by a C-stand. My assistant holds a white reflective panel to bounce sunlight in from the side.

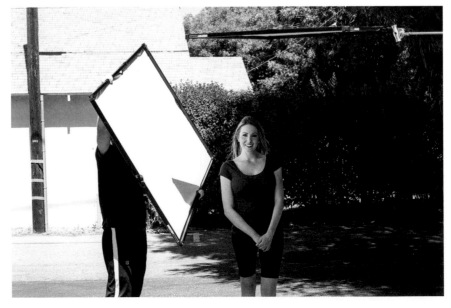

Another option for filling shadows is to use a flash instead of a reflector. One benefit is that fill flash will not make your subject squint from the bright reflection. We will talk about the details of using fill flash in Chapter 4, "Creating Your Own Light."

SKYLIGHT—SHOOTING IN OPEN SHADE

When the sun is blazing above and you don't have any modifiers or lights, an easy way to make a portrait in soft light is to place your subject in a spot where she will be shaded from the direct sun and exposed to a wide swath of open sky. The shady side of a tall building can be a good place to start. Photographers and artists refer to this light as *skylight*.

By heading into open shade, you are now lighting your subject with light rays that come in from all across the dome of the sky. Because the light is coming in from a wide set of angles, skylight is very soft light.

Compare Figures **3.18** and **3.19**. These are a couple of quick headshots that I made in an alley near my studio. In Figure 3.18, Christina is backlit directly by the sun and indirectly by light bouncing off the wall of a nearby building. In many ways, this is a lovely shot. I especially like the highlights in her hair.

Now take a close look at Figure 3.19. For this shot, we moved a few steps from sun into the shade (as shown in **Figure 3.20**). I think this is the better of the two headshots. While it lacks the glinting highlights in her hair, her eyes and skin appear more luminous—thanks to the soft light found in open shade. If I have to choose between bright eyes and hair highlights, I will select bright eyes every time.

FIGURE 3.18
(left) Shot in full sun with fill light bouncing off a nearby building—this photo has lovely highlights in the hair, but the eyes are a bit too dark.

FIGURE 3.19
(right) Shot in open shade—this photo benefits from the softness of skylight, which makes the model's eyes and skin appear more luminous.

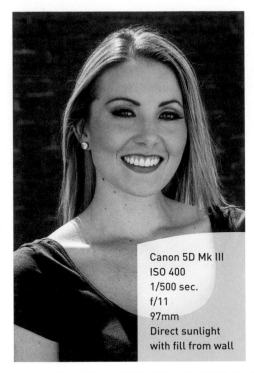

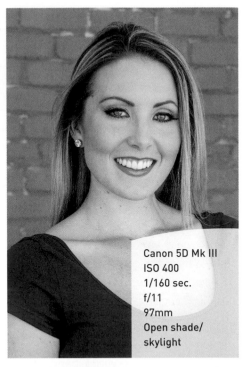

Canon 5D Mk III
ISO 400
1/500 sec.
f/11
97mm
Direct sunlight
with fill from wall

Canon 5D Mk III
ISO 400
1/160 sec.
f/11
97mm
Open shade/
skylight

FIGURE 3.20
Open shade/sky-light refers to light that is coming indirectly from a wide swatch of sky. Here is our set for Figure 3.19—the shady side of a building in an alley near my studio. (Photo by Tony Arena)

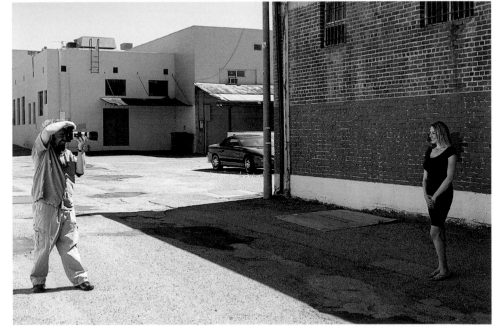

DEEP SHADE—SHOOTING UNDER TREES

The main difference between open shade and deep shade is that the latter typically has coverage overhead, such as the foliage of a tree, and open shade is clear above. The light of deep shade has two main characteristics: it is relatively soft and very cool. The softness is usually the reason you headed into shade in the first place. So this is not a problem.

The coolness of deep shade should be managed so that colors appear more natural. If you shoot JPEG, switch your camera's white balance to the Shade setting. (Look for an icon that resembles a house with shade on one side.) This white balance setting adds a bit of yellow to the file to offset the blue cast. If you shoot RAW, you can also warm up the image later in post-processing—which is the difference between **Figures** 3.21 (Daylight setting) and **3.22** (Shade setting). **Figure 3.23** shows the set for this image.

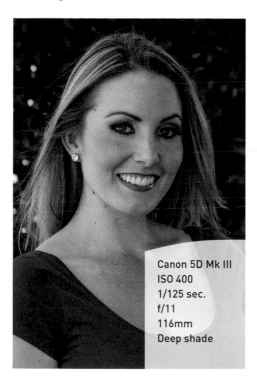

Canon 5D Mk III
ISO 400
1/125 sec.
f/11
116mm
Deep shade

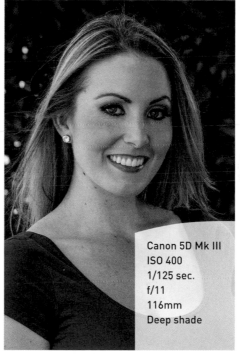

Canon 5D Mk III
ISO 400
1/125 sec.
f/11
116mm
Deep shade

FIGURE 3.21
Made in the deep shade under a large tree, the light in this shot is soft and pleasing. The coolness of the skin tones is the result of using the Daylight white balance setting in Lightroom (5500K).

FIGURE 3.22
This is the same shot as Figure 3.21. The difference is that I changed the white balance in Lightroom's Develop panel to Shade (7500K), which warms the shot significantly.

FIGURE 3.23
Deep shade is
easily found under
large trees. Here
is the set for the
shot in Figures 3.21
and 3.22. (Photo by
Tony Arena)

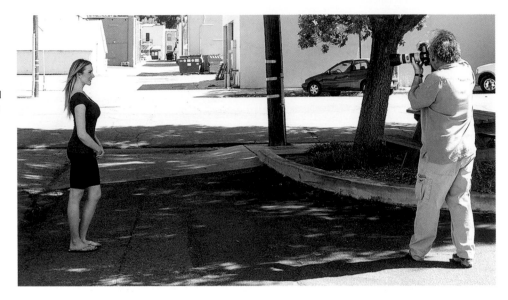

CLOUDS—NATURE'S DIFFUSION PANELS

Landscape and nature photographers love cloudy days because the dynamic range of the light easily falls within the limits of modern cameras. Portrait and sports photographers often enjoy an overcast day too. Clouds act like giant softboxes that reduce the impact of the shadows. Essentially, the clouds replace the sun as the light source and send the light at the subject from many angles. So the light coming from one side fills the shadows created by the light coming from the other side and vice versa. Take a look again at Figure 1.5 back in Chapter 1. Think of the sun as the flash and the clouds as the diffuser.

The thickness of the clouds and their span across the sky determine how soft the sunlight becomes. If the clouds are thin, then the diffusion will be modest, and you'll still see contrast between the highlights and shadows. If the clouds are thick, then the diffusion will be heavy, and the light will be very flat.

You can think of thin clouds as having the effect of open shade (Figure 3.19) and thick clouds as having the effect of deep shade (Figure 3.21). As we will explore i n Chapter 6, *Lighting Fundamentals for Portraits,* if your ambient light is extremely flat, then you can use off-camera flash to add rim light so that your subject has more depth.

In terms of white balance, as you likely know, cloudy days are bluer than sunny days. Changing your camera's white balance setting to Cloudy will offset this blue cast by adding a bit of yellow to the entire frame. This is very similar to the difference shown

in Figures 3.21 and 3.22 above. If you shoot in Auto White Balance and want more warmth in your cloudy day images, then use the temperature slider in your image-processing software to remove the blue cast later.

WINDOWLIGHT

Many portrait photographers, myself included, have a fascination with windowlight—both the windowlight we see and the windowlight painted by master painters like Rembrandt and Vermeer. (If you don't know their work, look it up. You will learn a tremendous amount about how to light a face by studying their portraits.)

In many ways, sunlight coming in through windows is just like sunlight outdoors; it can be direct or indirect, hard or soft, neutral or tinted. In Chapter 6, Figure 6.7 is an example of an indoor portrait shot in direct sunlight. For the most part, however, we think of windowlight as being large and soft, like that shown in **Figure 3.24**.

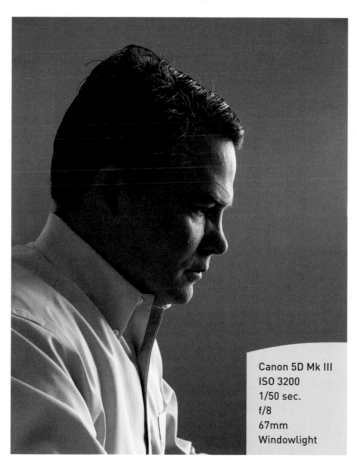

Canon 5D Mk III
ISO 3200
1/50 sec.
f/8
67mm
Windowlight

FIGURE 3.24
The delicate highlights that define the profile in this shot were created by indirect daylight coming in through a nearby window.

To maximize the beauty of windowlight, try to frame your shot so that your subject appears against a dark or plain background (**Figure 3.25**). The effect is that the viewer will concentrate on the beauty of the light falling on your subject and not be distracted by the background.

To create this look when the sun is shining in harshly, you will need to cover the window with a translucent fabric. If you are lucky, perhaps the window has a sheer curtain. Another option is to tape or hang a very thin white sheet across the window—the thinner the better. If you have the space, experiment with how close you position your subject to the window. As you move the subject farther from the window, you will see that the contrast increases on the shadow side of your subject.

FIGURE 3.25
Here's the set shot of the portrait above. Note how I framed the shot so that the subject's profile was caught against the blank wall behind him.

Chapter 3 Assignments

Follow the Sun One Day

Watch how sunlight changes through an entire day. Get up before the sun and check out the morning blue hour. Then watch how twilight melds into the sunrise. Enjoy the morning golden hour and try to sort out visually when it is over. Throughout midday, observe the changes in the contrast and hardness of direct sunlight. In the afternoon, watch the cycle reverse into golden hour, sunset, and twilight.

Modify Sunlight

In this chapter, we talked about many ways to shoot in sunlight. So, put those ideas into action. Make a series of headshots—first with the subject in full sun. Then diffuse the sun overhead. Use a reflector and fill flash. At first do each one solo. Then try to combine the techniques into one shot. For kicks, try the series of shots first with the sun behind your subject and then with the sun in front of your subject.

Explore Shade

Shoot a half-length portrait in full sun. Then shoot it again in open shade and deep shade. Watch how the light appears flatter as you go into deeper shade. If possible, in each type of shade, position your subject so that there is a sunlit background and then so that there is a shaded background. Does the background compete with or complement the subject?

Shoot by Windowlight

Shoot a portrait or still life lit by windowlight. Experiment with the distance between your subject and the window. Does moving the subject away from the window change the quality of the light? Keep an eye on the background in your shots. If necessary, change the camera angle so that your subject is framed against a simple background. If this is not possible, then use a dark-colored sheet or towel as a backdrop. If there is too much light bouncing back from nearby walls, then use a dark card or fabric just out of the camera's frame on the side opposite the window.

Share your results with the book's Flickr group!

Join the group here: flickr.com/groups/lightingfromsnapshotstogreatshots

4

Canon 5D Mk III
ISO 250
1/200 sec.
f/11
70mm
Fluorescent

Creating Your Own Light

GETTING STARTED WITH ARTIFICIAL LIGHT

In addition to the many types of sunlight in our world, photographers also shoot under a wide range of artificial lights—the lights found in our homes and workplaces, as well as continuous lights, flashes, and strobes made specifically for photography. Just as sunlight comes in many colors and can be shaped by clouds and other natural modifiers, each type of artificial light has a unique set of characteristics that provide opportunities and challenges. Once we survey the world of continuous lights—both commonplace and photographic—we'll jump right into the basics of flash photography.

PORING OVER THE PICTURE

You seldom think about a broken trash bag as being the inspiration for a still life shot. Yet, I was drawn to the contrast between the beauty of the rose and the mess of everything else that fell onto the floor. Fortunately, our kitchen lights are warm fluorescent. So they blended nicely with the breath of the morning sunlight bouncing in through a nearby window. The softness of the light and the delicacy of the shadows give this image tremendous depth.

The tiniest bits of trash contribute to the authenticity of this scene.

Although the light was warm and beautiful, there was not much of it. Given my settings of ISO 100 and f/11, I had to set my tripod right over the trash and shoot straight down to accommodate the long shutter speed.

If this bloom had been soiled, there would have not been a shot. It was the contrast between the rose and the "true" garbage that caught my eye.

Given that light was bouncing in from all directions, due to the bank of fluorescent tubes in our kitchen ceiling and a nearby window, the light has a beautiful, soft quality that also contrasts with the garbage.

Canon 20D
ISO 100
3.2 sec.
f/11
57mm
Fluorescent
and daylight

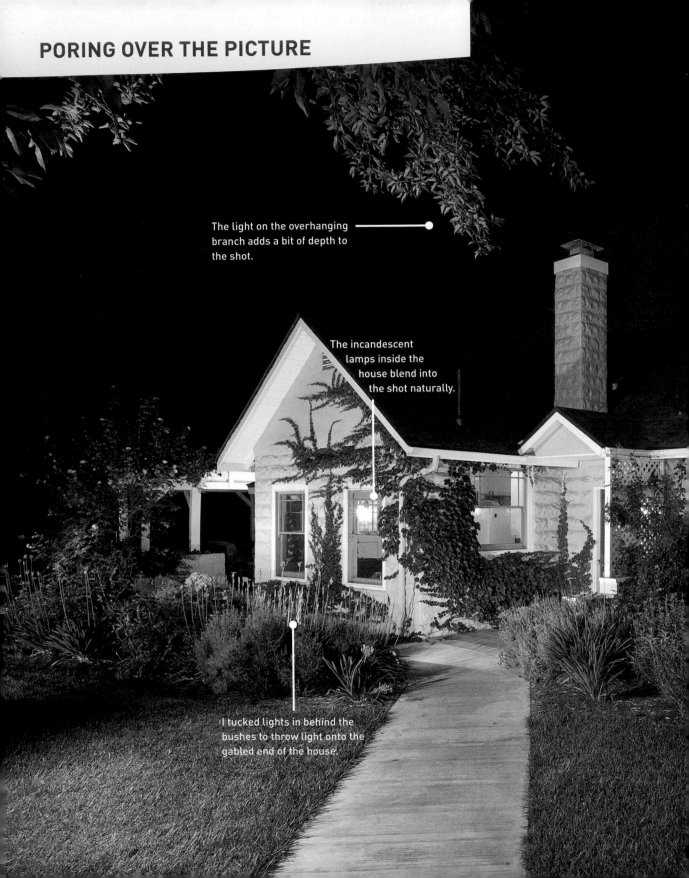

PORING OVER THE PICTURE

The light on the overhanging branch adds a bit of depth to the shot.

The incandescent lamps inside the house blend into the shot naturally.

I tucked lights in behind the bushes to throw light onto the gabled end of the house.

It is not necessary to spend a load of money to light homes at night. For this shot, I went to a home improvement center and purchased a dozen halogen flood lights—the rugged ones designed to illuminate work areas and job sites. They are cheap; the whole lot cost me less than $100. I then borrowed every extension cord and ladder I could get my hands on (the ladders were my light stands). After the sun dipped below the horizon, I set my camera's white balance to Tungsten to neutralize the warm cast of the incandescent bulbs. A nice windfall of this setting was that it intensified the blue of the twilight sky.

A bit of the sun's glow lingers in the western sky 30 minutes after sunset.

If you look carefully at the shadows, you will see clues about the intensity and position of my lights.

Canon 5D
ISO 100
4 sec.
f/11
19mm
Tungsten
shop lights

SHOOTING UNDER HOME AND OFFICE LIGHT

Around home and at the office, most of us take electric light for granted. We flick a switch and the lights come on. We seldom pause to think about whether the light is incandescent or fluorescent, warm or cold, hard or soft. Yet, as photographers, we need to understand the differences between these many types of light so that we can recognize the opportunities and challenges provided by each.

So, when looking around your home and office, there are several characteristics to which we should give our consideration, including:

- **Hard or soft**—Bulb design and the shape of the fixture will determine whether the shadow edge is hard or soft. While you can diffuse a hard source to make it softer, it is difficult to focus a soft source to create hard edges.

- **Color temperature**—It used to be that tungsten bulbs were decidedly yellow, and fluorescent tubes were definitely green. Thanks to great advances in lighting technology, bulbs come in a wide range of color temperatures. Some packages will display a color temperature rating. Others will use adjectives like *warm* or *soft.*

- **Single source or mixed lighting**—When shooting a room that has multiple sources of lights with different color temperatures, such as a room lit by both windowlight and incandescent bulbs, you (or your camera) will have to decide on the proper white balance setting. As a general rule, if sunlight is streaming in through the windows, set the camera's white balance to Daylight, which will give the interior lights a warm appearance.

INCANDESCENT/TUNGSTEN

Despite a long run as the dominant light source in homes, today the incandescent bulb is going the way of the dinosaur. Compared to other types of light, incandescent is not very energy efficient. A tremendous amount of energy is given off as heat rather than as light. So, the incandescent bulb is being legislated out of the marketplace in favor of more energy-efficient designs—like fluorescent and LED. Still, there are literally billions of household incandescent bulbs in use today and will be for many years.

FIGURE 4.1
Despite the labeling
on their pack-
ages, household
tungsten bulbs
all have a similar
color temperature.
From left to right:
Full Spectrum,
Soft White, Crystal
Clear. (These were
shot in Daylight
white balance for
comparison.)

Color correction for incandescent/tungsten—Compared to the neutral white of mid-day sunlight, tungsten bulbs produce amber light (**Figure 4.1**). To eliminate this color tint, switch your camera's white balance to Tungsten (typically identified by a light bulb icon). Revisit Figures 2.18 and 2.19 for examples of using the Tungsten white balance setting correctly.

Shadow quality of tungsten light—When it comes to the hard/soft look of shadows, there is no typical look to tungsten light. Incandescent bulbs are small and often used with reflectors or shades. So it's actually the light modifier used with the bulb that defines its look. If the reflector is small, then the light will be hard. If the bulb bounces its light off a large reflector or through a lampshade, then the light will be softer.

FLUORESCENT

Although fluorescent bulbs have been used widely in classrooms, kitchens, and factories for over a half-century, it has only been in the last decade that significant advances in fluorescent technology have made it a mainstream light source through-out the home. In contrast to incandescent bulbs, fluorescent light is extremely energy efficient. The CFL (Compact Fluorescent Lamp) has recently become the heir apparent to the incandescent household bulb.

FIGURE 4.2
Fluorescent bulbs come in a wide range of color temperatures. As described on the package, from left to right: Daylight, Soft White, and Daylight. (These were shot in Daylight white balance for comparison.)

Color correction for fluorescent—In the early decades of fluorescent light, the tubes emitted a green-tinted light. Thanks to the widespread acceptance of CFLs, fluorescent technology has taken huge strides forward and the green tint is largely gone (**Figure 4.2**). When shooting under "cool white" fluorescent, set your camera's white balance to the Daylight or Auto setting. When shooting under "warm white" fluorescent, set your camera's white balance to Tungsten.

Shadow quality of fluorescent light—In contrast to incandescent light, which can be hard or soft, depending upon its reflector/lampshade, fluorescent light is almost always soft. The long fluorescent tubes used as ceiling lights in offices and stores give off soft light. Further, the placement of multiple fixtures in the ceiling grid softens the light even more. So, if you are shooting in a fluorescent-lit environment, consider adding contrast to your shot by adding a bit of rim flash (covered in Chapter 6) or by placing your subject in front of a dark background.

LIGHT EMITTING DIODES/LED

In contrast to incandescent and CFL bulbs, LED bulbs have high price tags. This, of course, was true for CFLs just a handful of years ago. Certainly the price will come down as LEDs are used on a more widespread basis. Given that spent CFLs need to be treated as hazardous waste (due to the mercury vapor in the tube), the U.S.

Department of Energy is focusing on LEDs and other forms of solid-state lighting as the future of lighting (**Figure 4.3**).

Color correction for LED—Unless you are using an LED panel designed specifically for photography, you may find that it is difficult to faithfully capture a neutral spectrum of colors when using LED as the main light source. As with fluorescent, if the LED bulb is described as "Cool White," start with Daylight or Auto as the white balance setting on your camera. If the LED bulb is described as "Warm White," start with the white balance set to Tungsten.

Shadow quality of LED light—The LED bulbs currently coming to market are intended as replacements for incandescent bulbs. So they have the same general shape as a traditional light bulb. As with tungsten bulbs, the shadow quality of LED lights depends upon the size and shape of the reflector or lampshade.

FIGURE 4.3
This bulb by Phillips won the L Prize from the U.S. Department of Energy as being the first commercially viable LED light bulb. It's rated life of 30,000 hours is 30 times longer than that of a 60-watt incandescent bulb. When energized, its lights matches the look of a household tungsten bulb. (Shot in Daylight white balance for comparison.)

INDUSTRIAL VAPOR

Industrial vapor lights are the giant bulbs used outdoors as streetlights and indoors for lighting in huge spaces like warehouses and school gymnasiums. Industrial vapor lamps have extremely long lifetimes—which makes them very handy for high, hard-to-reach locations. They also use less energy than incandescent and most fluorescent lights.

Their downside is that they are not color-balanced. Nor is their color spectrum continuous—meaning than their light comes from narrow bands of just a few colors. Mercury-vapor lamps emit a blue-green light. Sodium-vapor lamps emit an orange-colored light (**Figure 4.4**).

Color correction for industrial vapor—There is no white balance setting on your camera that will neutralize the color cast of mercury- or sodium-vapor lamps. When you have to shoot in gymnasiums and similarly lit spaces, the best option is to shoot in RAW and correct the color during post-processing (**Figure 4.5**).

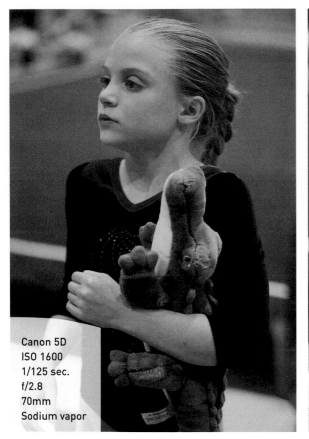

Canon 5D
ISO 1600
1/125 sec.
f/2.8
70mm
Sodium vapor

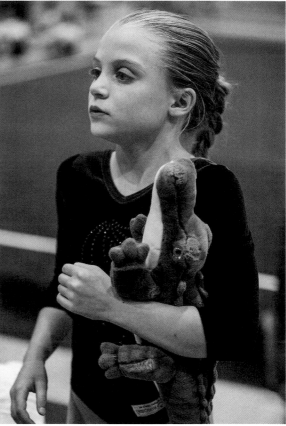

FIGURE 4.4
School gymnasiums are often lit with sodium vapor lamps, which create an intense amber glow that often confuses Auto white balance settings on cameras. This is the uncorrected shot.

FIGURE 4.5
Here I've color corrected the shot shown in Figure 4.4. To neutralize the amber colorcast, I lowered the white balance in Lightroom's Develop module to 2300K and increased the tint to +13 (which adds magenta).

Shadow quality of industrial vapor lights—Industrial vapor bulbs are giant when compared to the similarly shaped incandescent bulbs used in households. They are typically housed individually in a large reflector that mounts to a high ceiling (indoors) or tall post (outdoors). The shadow quality is a function of the number of lamps in use. When used as lights in parking lots, their spacing will likely create hard shadows. When used indoors, such as in gymnasiums and warehouses, their spacing and the surface reflections will generally create soft shadows.

PHOTOGRAPHIC LIGHTS: CONTINUOUS

Photographers often work with continuous light sources—the largest of which is the sun. The many types of residential and office light that we discussed above are also continuous light sources. In contrast to flash, which is on for only an instant, *continuous light sources* provide what-you-see-is-what-you-get lighting. For this reason, many novice photographers prefer to learn lighting with continuous sources before moving on to the basics of flash. As we will discuss later in this chapter, the big advantages of flash units are that they produce much more light and that many operate on batteries.

TUNGSTEN

Photographers and moviemakers still use specially made tungsten bulbs designed to fit in light modifiers, such as metal reflectors and softboxes. Not surprisingly, these are known as "hot lights," and one misplaced finger will reconfirm the suitability of the name (**Figures 4.6** and **4.7**). Just as the residential incandescent light bulb is being replaced by more energy-efficient designs, tungsten lights are giving way to cooler fluorescent and LED systems. That said, tungsten lights are still among the most affordable of photographic lights—especially if you need a lot of light.

FIGURE 4.6
The traditional photo flood uses a large, delicate bulb inside a silver reflector. The unit puts out a lot of light, but the heat makes it less convenient to use than other types of light.

FIGURE 4.7
This compact light by Lowel uses a small, halogen bulb—which provides more durability than the photo flood. The unit can be adjusted from flood to spot via the knob on the side. The attached "barndoors" also provide a means to control the light.

FLUORESCENT

Just as CFLs have made great strides in office and residential lighting, the CFL is now a popular light source for photographers. The main difference between residential CFLs and photographic CFLs is color temperature. Residential CFLs use broad terms like "warm white" and "cool white"—which you can loosely think of as Tungsten and Daylight. Photographic CFLs typically include a color temperature rating. So, a true daylight-balanced bulb would have a color temperature of 5000K.

Regarding the brightness of the light, when it comes to comparing CFLs with incandescent bulbs, you should not rely upon the *wattage*—which is a measurement of energy consumed. Rather, take a look at *lumens*—which is a measure of brightness. Here is a quick table for comparing incandescent bulbs to CFLs. The exact output of each bulb model varies, so check the details on the packaging.

Incandescent	Lumens	Fluorescent
60 watts	800 lumens	15 watts
150 watts	2,600 lumens	45 watts
350 watts	5,300 lumens	85 watts

Many lighting kits are designed to work with either tungsten or CFL bulbs (**Figure 4.8**). If given the choice, choose the CFL version. Again, tungsten bulbs are called "hot lights" for a reason. Also consider whether you want a single bulb fixture or a multi-bulb fixture—which gives you the ability to adjust the amount of light by turning individual bulbs on or off (**Figure 4.9**).

FIGURE 4.8
The Westcott uLite is a continuous light system for novices that can be used to create soft light portraits at home. It uses a single bulb—either tungsten or CFL—inside a simple softbox.

FIGURE 4.9

The Westcott Spiderlite system uses multiple bulbs inside a large, robust softbox. Shown here: six CFL bulbs inside the Spiderlite TD6. Spiderlites are popular among professional portrait and still life photographers, as well as videographers.

LED

Of all the lights we have discussed in this chapter, the difference between the residential and photographic applications of LED is the greatest. As shown above in Figure 4.3, the new residential LED lights are designed to fit into existing sockets. As shown in **Figure 4.10**, LED lights created specifically for photography use a matrix of individual LED bulbs in a flat panel.

LED panels were first embraced by the motion picture industry because they are portable, energy efficient, and modular (meaning that many panels can be ganged up to create a larger light source). Their growing use among still photographers started a few years ago with hybrid DLSR shooters who wanted lights that would work for motion (video) as well as stills. Now, even photographers who do not shoot motion appreciate the speed and ease of LED panels. They are especially popular with wedding photographers.

FIGURE 4.10

This camera-mounted LED panel by Litepanels runs on AA batteries. It can provide a few hours of continuous light on a set of AA batteries. LED lights are often used by photographers who also shoot motion.

In terms of size, small panels with 100 or so LEDs can attach directly to the camera's hotshoe and draw power from a handful of AA batteries. Larger panels use a larger matrix of LEDs—upwards of 1,200 in a panel that measures 12" x 16"—and can be powered either by batteries or AC power. As a general rule of thumb, you can estimate that one LED equates to one-half watt of incandescent light. So, a 100-LED panel has about the same illumination as a 50-watt incandescent bulb.

PHOTOGRAPHIC LIGHTS: FLASH AND STROBES

In terms of jargon, *flash* and *strobe* are basically the same device—a glass tube filled with xenon gas that is connected to a capacitor. When fired, the capacitor sends a high voltage charge through the xenon, which glows brightly for a very brief period of time, typically 1/500" to 1/5000".

So what is the difference between a flash and a strobe? In broad strokes, it is the size. A flash is built in to or can be attached directly to your camera. Strobes are larger and designed to be supported independently of your camera. Flash uses a cylindrical tube between a reflector and a plastic lens so that the light flies forward. Strobes use a donut-shaped tube that sends light in all directions. Flash is often used without a modifier (although advanced shooters often use modifiers with hotshoe flash). Strobes are almost always modified—with a reflector, softbox, etc.

When compared to continuous light sources, flash/strobes have the advantage of producing more light with less gear. The disadvantage of flash/strobes is that you cannot see the effect of the light until after the exposure is made. With continuous light sources, what you see is what you get.

BUILT-IN AND POP-UP FLASH

Point-and-shoot cameras typically have a small flash built into the camera body (**Figure 4.11**). Consumer DSLRs have a flash that pops up above the viewfinder (**Figure 4.12**). The advantage of the built-in/pop-up flash is that it is always with your camera. The disadvantages are that its power is relatively low and its position cannot be changed.

FIGURE 4.11
The small flash built in to the corner of the Canon Powershot G12 (just above the Canon logo) provides excellent fill flash for daytime shots. The camera also features a hotshoe that communicates with the larger Canon Speedlites.

FIGURE 4.12
The pop-up flash on the Canon 60D can be used to light subjects and to control slaved flashes.

USE YOUR FLASH DURING THE DAY

I think that built-in and pop-up flash should be turned on when you are shooting in the sun and off when the ambient light is very dim. If you expected me to say the opposite, remember that under bright sun the camera has a hard time recording shadow detail. So the on-camera flash provides valuable fill flash—which we'll talk about later in the section "Automatic Fill Flash." In dim light, when the camera wants the flash to be the main source of light, the position of the flash near the lens means that both sides of your subject are lit equally—which flattens the sense of depth and texture. We will talk more about off-camera flash in our chapters on shooting portraits.

Some pop-up flashes can also be used as a "master" to control off-camera "slave" flashes. This is a great way to begin learning how to use off-camera flash. All you need to buy to get started is one hotshoe flash that is compatible with your camera system (Canon, Nikon, Sony, etc.). However, the relatively low power of the pop-up means that the off-camera slave must be within a 10–15' range, and it must be in front of the camera. As your off-camera flash skills develop, you will likely want use a hotshoe flash as the master so that you can position your slave flashes farther away and more widely to the side. Still, the pop-up is a great way to start with off-camera flash.

SPEEDLITE, SPEEDLIGHT

Throughout the book, "Speedlite" refers specifically to Canon gear and "Speedlight" refers to Nikon gear. For references to hotshoe flash in general, I use the word "speedlight."

HOTSHOE FLASH/SPEEDLITES/SPEEDLIGHTS

Hotshoe flashes sit in the middle ground between the limited power/functionality of built-in flashes and the sometimes-cumbersome weight and size of strobes **(Figures 4.13** and **4.14)**. The hotshoe flash is a portable and versatile partner when paired with a DSLR. In fact, many hotshoe flash systems provide functions that are not available with other types of flash.

To access this expanded functionality, you must use a unit designed to work with your camera brand. If you shoot Canon, then your dedicated hotshoe flash is called a *Speedlite.* If you shoot Nikon, then your dedicated flash is a *Speedlight.* When the camera senses that a dedicated flash is attached, it can perform many functions that I'll explain in the next several chapters. These functions include:

- Adjusting the flash power automatically (Canon = ETTL, Nikon = ITTL)

- Timing the firing of the flash for creative effects (2nd-Curtain Sync)

- Controlling other dedicated, off-camera flash units as slaves

- Changing the way the flash fires so that any shutter speed may be used (High-Speed Sync)

- Firing a repeating series of flashes in a single frame (Multi mode)

- Zooming the flashhead to match the coverage of the lens (20mm to 200mm)

- Displaying all flash functions on the larger, easy-to-read camera LCD

FIGURE 4.13
The Canon Speedlite 600EX-RT is the flagship of Canon flash. It provides several modes of automatic and manual flash that can be controlled from the camera's LCD monitor. Thanks to the built-in radio system, it can also work wirelessly with other 600EX-RTs as master or slave over great distances.

FIGURE 4.14
The LumoPro LP160 is a budget-priced speedlight that operates in Manual mode only. To change any setting—power, zoom, etc.—the photographer must push a button on the flash. It does offer a seven-stop power range (1/1–1/64), several ports to connect radio triggers, and an optical slave eye that fires the flash when it sees the light fire from another flash.

STROBES

As stated previously, the main difference between a strobe and a flash is the strobe's larger size and power, as well as the intent for it to mount independently of the camera. Due to their greater flash power, most strobes are designed to run on AC power, although a few have battery packs that enable use in the field. Strobes that have the controls, capacitors, and flashtube in one assembly are called *monolights*, while strobes that separate the flashtube from the controls and capacitors are called *power pack strobes* (**Figures 4.15** and **4.16**).

Strobes offer several advantages over hotshoe and pop-up flash:

- Greater power (typically between three and twelve times more powerful than hotshoe flash)

- Faster recycling (recharging)

- Ability to fill large modifiers (softboxes, umbrellas, etc.) more easily

FIGURE 4.15
(above) The Einstein E640 is a moderately priced monolight that offers a 10-stop power range and a wide range of reflectors, softboxes, and other modifiers. The power is adjusted directly on the back of the head. Although designed to work with AC power, the manufacturer also sells a lightweight lithium-ion battery/power convertor that can be used on location.

FIGURE 4.16
(right) A power pack strobe separates the power pack and controls into one unit (sitting on the floor) that connects to the flash head via a heavy cable. The power is adjusted from controls on the pack, which means that the head can be placed out of reach on a tall stand without compromising ease of use. This is a set shot of a shoot featured in the opening of Chapter 6.

CONNECTING A FLASH TO A LIGHTSTAND

When connecting a speedlight to a lightstand, you will need a *swivel adapter* between the stand and the light. This allows you to easily adjust the angle of the light and to connect modifiers like umbrellas and softboxes. I prefer metal swivel adapters, like the Manfrotto 026 (**Figure 4.17**), as they are more durable than the plastic swivel adapters.

Swivel adapters are sometimes called "umbrella adapters" because they can also hold the shaft of an umbrella. Note the adapter should be mounted so that the umbrella hole is above the handle—otherwise the umbrella will not tilt. The umbrella hole angles through the adapter. Be sure that you start the shaft through the high side and push it through to the low side. This positions the flash so that it fires into the center of the umbrella.

If you are using a strobe, then you can mount it directly to a 5/8" brass stud inserted into the top end of the swivel adapter. If you are shooting a speedlight, you will also need either a hotshoe or coldshoe threaded onto the stud.

Hotshoes and coldshoes are both designed so that the foot of a speedlight can be locked into it. The difference is that the hotshoe has one or more electrical connections that send instructions to the flash. Off-camera cords, like the OCF cord shown in Figure 4.43, have a hotshoe that mimics the connection built into the top of your camera (**Figure 4.18**). The coldshoe lacks these connections. If you are firing your off-camera flash by some means other than a cord connected to your camera, a coldshoe will suffice.

FIGURE 4.17
The swivel adapter is the link between your lightstand and flash. I prefer the all-metal Manfrotto 026 Swivel Adapter because it is more durable than the plastic versions.

FIGURE 4.18
The hotshoe at the end of an off-camera cord (shown on right) mimics the configuration of the hotshoe on top of your camera. Note that the Canon hotshoes in this photo have five round connection points. Nikon cords have four connection points. Be sure that you buy a cord that works with your camera brand.

Coldshoes are used to connect speedlights to lightstands. They can be made of metal, plastic, or a combination of the two (**Figures 4.19–22**). When you are attaching a flash to a lightstand, you will typically have to thread a coldshoe onto the swivel adapter and then connect the adapter to the stand (as shown previously in Figure 4.17).

FIGURE 4.19
The clamp-style coldshoe is a tiny vice that can tighten onto the foot of a flash for an extra-secure connection.

FIGURE 4.20
The block-style coldshoe is robust and simple. I added the bit of tape to ensure that the pins on the foot of the speedlight do not touch the metal.

FIGURE 4.21
The Frio is a plastic cold shoe. The tab on the back prevents the flash from sliding out if the foot is not secured tightly.

FIGURE 4.22
All cold shoes have a socket on the bottom that threads onto the stud in the swivel adapter.

FLASH BASICS

For many photographers, the first steps with flash photography result in frustration and confusion. Here are the basic concepts that will give you a handle on how to use flash successfully. Then, as you read through the rest of the book, you will see that I return to these basic concepts again and again to put them into action.

AUTOMATIC VERSUS MANUAL FLASH

The difference between automatic flash and manual flash is who sets the power—the camera or you. If the camera sets the flash power, then it's automatic flash. If you dial the power setting in directly, then it's manual flash. There are good reasons to use both—as I'll explain in a bit.

In terms of how much power is needed from a flash, there are several factors, including:

- the amount of ambient light
- whether the flash is providing fill light or is the main (key) light
- the distance between the subject and the flash
- the ISO and aperture settings on the camera
- the use of modifiers, like umbrellas, softboxes, grids, or gels

The good news is that if you use a hotshoe flash that is dedicated to your camera system, then your camera and flash can work together to automatically calculate the proper power. Again, Canon calls their automatic flash ETTL (for Evaluative Through-The-Lens metering). Nikon calls their automatic system ITTL (for Intelligent Through-The-Lens metering).

The goal of both systems is the same: to automatically calculate and set the flash power in a split-second. I shoot automatic flash (ETTL) any time the subject-to-flash distance is variable (such as when shooting at an event). I use ETTL in this situation because subjects that are closer to the flash need less light than subjects that are farther away. So, if I'm photographing someone at a party who is three feet from my flash and then turn to photograph someone who is six feet from my flash, the flash power needs to be increased—which ETTL/ITTL figures out automatically.

All of my Canon Speedlites can be operated in ETTL or Manual mode (**Figure 4.23**). Budget-oriented hotshoe flash units and virtually all strobes are manual-only—meaning that you, the photographer, must adjust the power by hand. This is not as cumbersome as it sounds when you are shooting at a slow pace in a controlled environment—such as when doing a few headshots for a friend in your home studio. Manual flash is also very helpful when you are shooting a large number of similar shots—such as at a high school prom where every couple steps onto the spot you've pre-marked on the floor. Again, where manual flash becomes a nuisance is when you are shooting at a fast pace in a situation where the distance between the subject and flash changes frequently.

FIGURE 4.23
One advantage of using a dedicated hotshoe flash, like the Canon 600EX-RT Speedlite, is that it can be controlled on the camera's LCD. Here, I am switching the flash mode from Manual to ETTL (automatic) flash mode on the back of my camera.

AUTOMATIC FILL FLASH

If you have an automatic flash system, you should turn it on when shooting outdoors under bright sunlight. As we discussed previously, the dynamic range of your camera is more limited than the dynamic range of human vision. So your camera will have a hard time recording shadow details when the ambient light is extremely bright. ETTL/ITTL will do a good job getting you started with fill flash (**Figures 4.24** and **4.25**).

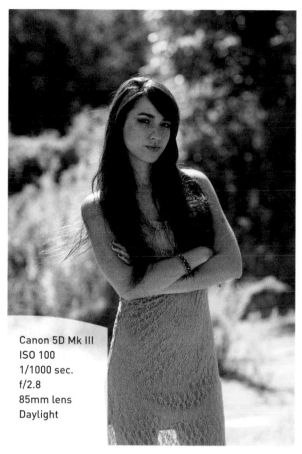

Canon 5D Mk III
ISO 100
1/1000 sec.
f/2.8
85mm lens
Daylight

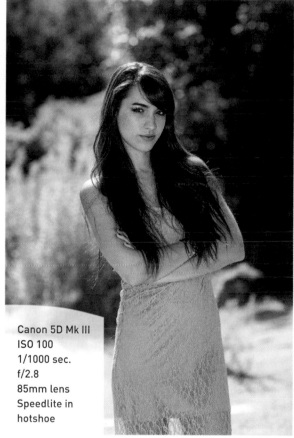

Canon 5D Mk III
ISO 100
1/1000 sec.
f/2.8
85mm lens
Speedlite in
hotshoe

FIGURE 4.24
I placed Ariana so that the sun would come from behind and create rimlight on her hair and shoulders. The result is that her face and arms are in shadow and appear too gray.

FIGURE 4.25
The addition of fill flash to this shot adds catchlights in Ariana's eyes and enhances her skin tone.

FINE-TUNING AUTOMATIC FLASH

As smart as modern cameras are, they cannot interpret your vision as a photographer. So, there will be times when you are shooting in an automatic flash mode (ETTL/ITTL) and you want more or less flash.

Flash Exposure Compensation (FEC) enables you to fine-tune the flash power calculation made by your camera. If you are shooting in ETTL/ITTL and want more or less flash, then you dial the FEC up or down. Typically FEC provides two or three stops of adjustment in 1/3-stop increments (**Figure 4.26**). So, when you are starting out with FEC, avoid the urge to change the setting by one or two tick marks. Rather, make a big move and then see if you have gone too far. I think that going too far in the first

FIGURE 4.26
Flash Exposure Compensation (FEC) can be adjusted on the Speedlite or on the camera. Here, I am dialing down the power of the automatic flash by one stop.

move and then jumping back halfway is more informative than marching forward in baby steps.

There is no FEC for manual flash. In Manual mode, when you want more or less flash power, you simply dial it up or down directly. FEC is available only when you are shooting in ETTL/ITTL (**Figures 4.27** and **4.28**).

ALTERNATIVES TO USING FLASH

You should use flash when there is not enough light to otherwise make an exposure (which I know sounds obvious). The key to this concept is "otherwise." So, what are some alternatives to using flash? You can:

- Raise the ISO on your camera (keeping in mind that going too high will create digital noise in your files)

- Use a wider aperture

- Use a slower shutter speed (and maybe a tripod for very slow shutter speeds)

- Move your subject closer to an existing source of light.

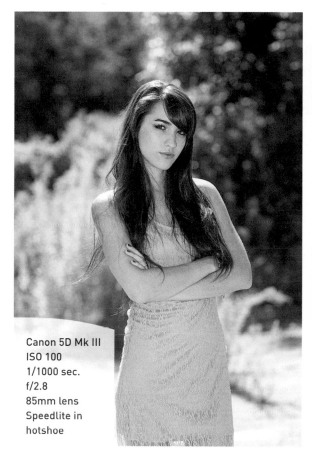

Canon 5D Mk III
ISO 100
1/1000 sec.
f/2.8
85mm lens
Speedlite in
hotshoe

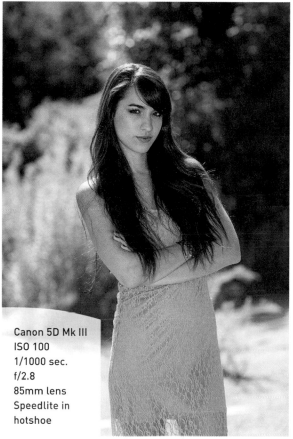

Canon 5D Mk III
ISO 100
1/1000 sec.
f/2.8
85mm lens
Speedlite in
hotshoe

FIGURE 4.27
Here is the shot the camera made with the Speedlite in ETTL and the Flash Exposure Compensation (FEC) dialed to 0. To my eye, the fill flash is too bright on Ariana's face.

FIGURE 4.28
For this shot, I reduced the power of the automatic flash by one stop (–1 FEC). Now the fill flash appears more natural.

SETTING FLASH POWER MANUALLY

There are two main situations when Manual flash is better than ETTL/ITTL flash. The first is when the distance between the subject and the flash does not change from shot to shot. The second is when you are learning the basics of flash photography and need to see the effect of changing the flash power by a specific amount. We'll discuss both of these situations in greater detail in the next chapter.

As for where to control the flash power manually, there are usually two options (but it depends upon your specific gear). The first place to dial the power manually is on the flash unit itself (**Figure 4.29**). The second place in on the camera's LCD panel (**Figure 4.30**). As a Canon shooter, I can access every menu option found on my Speedlite via the LCD on the back of my cameras. This means that I can put my Speedlites inside of softboxes or other hard-to-reach places and still control the manual flash power directly.

FIGURE 4.29
Here I am dialing the flash power manually to 1/4 directly on the Speedlite.

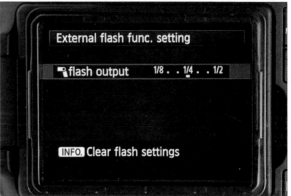

FIGURE 4.30
Here I am dialing the flash power manually to 1/4 via the LCD panel on my camera. This allows me to move my flash off-camera on a dedicated cord and still control the power during the shoot.

Increments of flash power are expressed in fractions of full power (1/1). So, in whole-stop increments, flash power settings (from strong to weak) are 1/1, 1/2, 1/4, 1/8, 1/16, 1/32, 1/64, and 1/128. Depending upon the model of your flash, your minimum power might be something other than 1/128. If you recall the information in Chapter 2, a "whole stop" change means that a setting has been doubled or halved. So, if your flash is set to 1/8, and you want to double the amount of light, you would change the power to 1/4. If you wanted to cut the power in half, you would switch from 1/8 to 1/16. Review the table in Figure 2.15 if you need a refresher.

As I said in the section "Automatic Versus Manual Flash," there are several criteria that affect what is the correct amount of flash power. When I have no idea where to start in terms of power, I set the power at 1/8 (because it is halfway down the scale) and then take a test shot. If the light is too dim, I will move the power all the way up to 1/1 and take another test shot. Then, if the light is too bright, but only slightly so, I will dial the power down to 1/2. If the light is much too bright, then I will dial the power from 1/1 down to 1/4. I hope you've noted that I'm making big jumps and

sticking to whole-stop increments of power. Your flash likely also has half- or third-stop increments (often expressed something like "1/2 +.3" or "1/16 –.7"). The only time that I use the smaller power increments is when I'm very close to the light I want and need to make a final adjustment. Otherwise, I stick to the whole-stop settings that I listed above.

THINK OF APPLE PIE WHEN SETTING FLASH POWER

If you have a hard time remembering how fractions relate to flash power, think of how you cut up a pie (**Figure** 4.31). You know how to cut a pie in half. If you cut the remaining half in half, then you have two quarters (1/4). When you cut one of those quarters in half, you have two one-eighth slices (1/8). It's the same all the way down the power scale.

FIGURE 4.31

SHUTTER SPEEDS FOR FLASH PHOTOGRAPHY

When shooting with a flash, it is important to know your camera's *sync speed*. This is the fastest shutter speed that will work when shooting with flash. For crop-sensor DSLRs, the sync speed is typically 1/250". For full-frame DSLRs , the sync speed is typically 1/200".

Sync speeds are created by the mechanics of the shutter. If your camera has two curtains (common in DSLRs), then the shutter speed is the difference between the opening of the first curtain and the closing of the second curtain. As shown in **Figure 4.32**, at relatively slow shutter speeds (your camera's sync speed and slower), the first curtain opens fully and then the second curtain begins to close. This provides an interval when the flash can fire and the entire sensor will have an opportunity to see the light (frame 3 in Figure 4.32).

At shutter speeds faster than your camera's sync speed, the second curtain begins to close before the first curtain has opened completely (**Figure 4.33**). As the shutter speed gets faster, the gaps between the curtains narrows. Above the camera's sync speed, there is no instant when the entire sensor can see the flash. If the flash does fire, part of the sensor will not see the light (frame 3 in Figure 4.33).

FIGURE 4.32

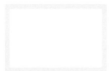

1. Camera ready to fire—first shutter curtain closed.

2. First curtain opening.

3. First curtain fully open—flash fires—whole sensor exposed.

4. Second curtain closing.

5. Second curtain closed.

FIGURE 4.33

1. Camera ready to fire—first shutter curtain closed.

2. First curtain opening.

3. Second curtain begins to close—flash fires—portion of sensor blocked.

4. Second curtain continues to close.

5. Second curtain closed.

FAST/SHORT VS. SLOW/LONG

There are several ways to casually describe shutter speeds. A *fast shutter* produces a *short shutter speed*—something like 1/500". A *slow shutter* produces a *long shutter speed*—something like 1/30".

This shutter mechanics business will make more sense if we take a look at a few demo shots. So here's the situation—I'm outdoors in full sun shooting a quick headshot. As expected, with the sun high and slightly behind my subject, his face is too dark—it needs a breath of fill flash (**Figure 4.34**).

So, I slip my Speedlite into my camera's hotshoe and turn it on. Since I'm looking for just a bit of fill flash, I'm happy to let the camera figure out the power. I confirm that my flash is in ETTL mode. Then I take the shot again. And whammo! The frame

is completely blown out. There is way too much light (**Figure 4.35**). And this is where many photographers return their speedlight to the closet and start to say, "I only shoot available light."

What you need to understand is that the gear is working perfectly. What happened was not that the flash put out too much fill flash. Rather, the camera forced the shutter speed (previously 1/3200") back to the camera's sync speed of 1/200"—a four-stop change in the exposure.

With a dedicated speedlight connected to the hotshoe and turned on, the camera will force the shutter back to the sync speed regardless of the camera mode. Even if you are shooting the camera in Manual mode and have set the shutter speed yourself, the camera will take control if it senses that a speedlight is connected. Again, the overexposure results not because the flash power was too strong, but rather because the shutter speed was too slow and allowed too much ambient light to come in.

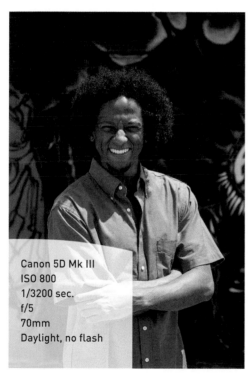

Canon 5D Mk III
ISO 800
1/3200 sec.
f/5
70mm
Daylight, no flash

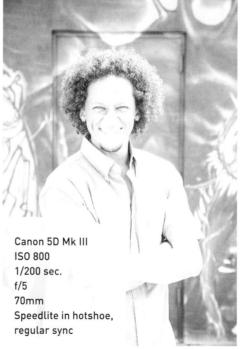

Canon 5D Mk III
ISO 800
1/200 sec.
f/5
70mm
Speedlite in hotshoe,
regular sync

FIGURE 4.34
To blur the background in this sunlit shot, I used a fairly wide aperture—which required a very fast shutter to balance the exposure. As you can see, the sun was slightly behind my subject. The shot needs a bit of fill flash to add some sparkle to the eyes.

FIGURE 4.35
When I activated my Speedlite for a bit of fill flash, the camera forced the shutter speed from 1/3200" down to its sync speed of 1/200"—a four-stop change. The resulting overexposure was caused by the shutter allowing in too much sunlight, not by too much flash.

So what do you do for fill flash when shooting outdoors in bright sun? If you have a dedicated flash, check to see if it offers a *High-Speed Sync* (HSS) function (sometimes called *Auto FP Sync*). If so, familiarize yourself with how to activate HSS on your gear. Then, when you want to exceed your camera's sync speed with a faster shutter speed, you can change the flash sync into HSS.

This special flash sync alters the way the flash fires (**Figure 4.36**). Rather than sending out one big pulse of light, in HSS the flash sends out a rapid-fire series of lower-powered pulses for a period of time (frames 2–4 in Figure 4.36).

FIGURE 4.36

1. Camera ready to fire—first shutter curtain closed.

2. Flash fires—first curtain opening.

3. Flash continues to fire—second curtain begins to close.

4. Flash continues to fire—second curtain continues to close.

5. Second curtain closed.

The effect is that, for a brief moment, your flash appears to be a continuous light source, which enables you to use virtually any shutter speed. The downside to HSS is that it significantly reduces the power of your flash to about a fifth of its regular-sync power. When starting out with flash photography, the best use for HSS is when you need fill flash under bright sun (**Figure 4.37**).

Now what happens if you are using a non-dedicated speedlight (like the LumoPro, that is generically designed to work with any brand of camera)? Or, what happens if you have a simple radio trigger between your camera and strobe? Well, the camera cannot sense that the flash is attached. So, it will allow you to shoot at any shutter speed you want. If you turn the power down real low, you might even find that it creates a nice bit of fill flash.

However, the problem of sync speed remains, as you can see in **Figure 4.38**. Look at the bottom edge of the image. See how the lower torso and arms appear to be covered in a black bar? This is the instance shown in frame 3 of Figure 4.33 above. The second curtain covered a portion of the sensor when the flash fired. The background on either side of the subject is not affected because the flash did not reach that far, and it was lit with ambient light only. So, an important tip to remember about buying inexpensive, non-dedicated flashes is that you will not have high-speed sync available when you want a bit of fill flash in the middle of the day. If you must use a non-dedicated flash in this situation, the solution is to dial the shutter back to the camera's sync speed, lower the ISO as far as possible, and then select the appropriate aperture to complete the exposure. You might not be able to shoot at a wide, background-blurring aperture.

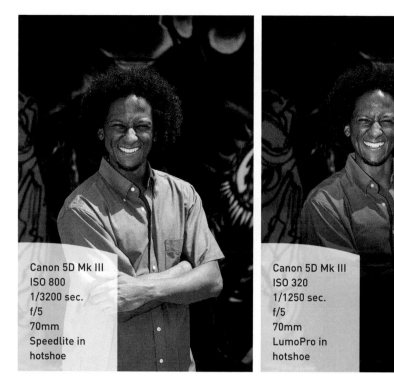

Canon 5D Mk III
ISO 800
1/3200 sec.
f/5
70mm
Speedlite in
hotshoe

Canon 5D Mk III
ISO 320
1/1250 sec.
f/5
70mm
LumoPro in
hotshoe

FIGURE 4.37
Once High-Speed Sync was activated on the Speedlite, the camera reverted back to the proper shutter speed of 1/3200". As you can see, the fill flash opens up the shadows in Deollo's face and adds catchlights to the eyes.

FIGURE 4.38
The black bar at the bottom of this shot was caused by shooting faster than the camera's sync speed. When you are using a non-dedicated speedlight or strobe, your camera will not limit the shutter speed to the sync speed.

HOW TO BOUNCE FLASH

Another advantage of using a hotshoe flash instead of a pop-up flash is that you can pan the head of the flash right and left, and you can tilt it up. This flexibility gives you the ability to bounce the flash off of a nearby surface rather than fire it directly at your subject. As we discussed in Chapter 1, increasing the apparent size of your light source softens the edges of the shadows. The idea behind bouncing flash is that you greatly increase the apparent size and, thereby, create more flattering light.

Which is the best way to bounce a flash—to the side or off the ceiling? Let's take a look at the options. In **Figure 4.39**, the Speedlite faced directly ahead (its normal position). As you can see, the light appears hard. Then, in **Figure 4.40**, I panned the head 45° to the left and bounced it off a nearby wall. As you can see, the light is much softer and there is a nice edge of rim light along the edge of my subject's face. The other option was to tilt my flash up to bounce it off the ceiling, as I did for **Figure 4.41**. The problem with ceiling bounce is that the subject's eyes often appear too dark. So, drumroll please...when I bounce flash, I prefer to bounce the light sideways off of a wall rather than down from the ceiling.

FIGURE 4.39
Left: The Speedlite was fired forward, aimed directly at the subject. Right: the on-camera light illuminates both sides of Deollo's face equally and flattens the shadows.

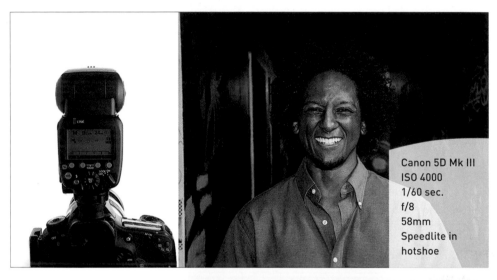

Canon 5D Mk III
ISO 4000
1/60 sec.
f/8
58mm
Speedlite in hotshoe

FIGURE 4.40
Left: The Speedlite was panned left 45° and bounced off the wall. Right: The light coming from the wall creates a nice rim light on the side of Deollo's face.

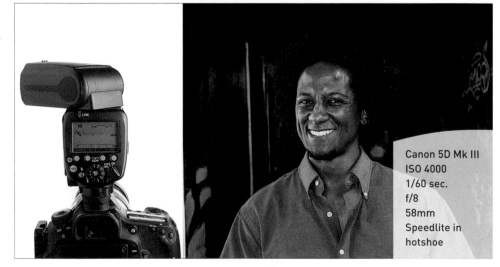

Canon 5D Mk III
ISO 4000
1/60 sec.
f/8
58mm
Speedlite in hotshoe

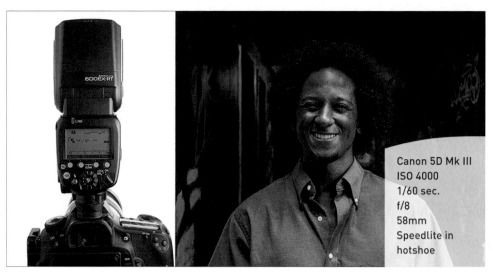

FIGURE 4.41
Left: The Speedlite was tilted up 45° and bounced off the ceiling. Right: The light coming down from the ceiling adds unflattering highlights to the forehead, cheeks, and nose while the eyes remain too dark.

Canon 5D Mk III
ISO 4000
1/60 sec.
f/8
58mm
Speedlite in hotshoe

Here are a few tips for bouncing flash:

- Shoot in an automatic flash mode (ETTL/ITTL) so that the camera will increase the power as needed to compensate for the longer path taken by the flash.

- Bouncing flash off a wall is generally better than bouncing off a ceiling. When the light comes steeply from above, eye sockets may become too dark.

- Turn the flash head in the same direction that your subject is looking. This way you will light your subject's face rather than the back of his head.

- Consider a crowd of people to be a good substitute for a wall. This is especially helpful when shooting wedding receptions in large rooms. Just pan the head to the side and fire away.

- If there is nothing to bounce the light off of, then improvise. Use your hand, a sheet of paper, or a reflector as a bounce surface.

- Colored surfaces will tint the color of your flash. When you have the option, bounce off of white walls.

- There is little to bounce off of outdoors. Firing your flash at that building across the park will not return any usable light. Again, improvise something to bounce off of when you lack a suitable surface.

- A Rogue FlashBender is a handy modifier for bouncing flash. It is pictured in Figure 6.20.

MOVING YOUR FLASH OFF-CAMERA

You will recall from Chapter 1 that the D in DICCH stands for "Direction" and that the position of the light relative to the camera is what controls the appearance of depth in the image. Specifically, way back in Figures 1.2 and 1.3, we compared the difference between the look of on-camera and off-camera flash. So, if off-camera flash creates shadows that give a sense of depth in a photo, how does one control and trigger a flash that is not sitting in the camera's hotshoe? Fortunately, there are several options to fire one or more off-camera flashes.

CORDS

I carry two ETTL cords in my Speedlite kit. One is a 3' coiled cord that I use to control a Speedlite held at the end of my arm—a handy method when I'm shooting in a crowded area (**Figure 4.42**). Wedding photographers use these short cords to connect their flash to the hotshoe when using a flash bracket.

The other cord is a 33' straight cord from OCF Gear that allows me to put the Speedlite inside of a softbox and control the whole system from the back of my camera (**Figure 4.43**). Note that I said 33' straight cord. There are also long coiled cords, but the danger is that you might topple a lightstand when trying to get a bit of extra length from the cord. The advantage of the 33' length is that the cord drops straight down to the floor and then minimizes the tripping hazard while still giving me a large working area.

FIGURE 4.42
A short, coiled ETTL cord allows me to move my Speedlite slightly off-camera—to the end of my arm or onto a camera-mounted flash bracket. Even a small separation between the camera and flash will provide depth-enhancing shadows when shooting crowded events and wedding receptions.

FIGURE 4.43
The 33' straight ETTL cord from OCF Gear allows me to place my Speedlite in an off-camera position and still control it from the LCD of my camera. If you have only one speedlight, this is a convenient and affordable way to get started with off-camera flash.

Another advantage of the long cord is that when you decide to purchase your second flash, you can set one up as the master on the end of the cord and have it control the other as a slave. This is much better than having the master sitting in the hotshoe on your camera—both in terms of money and in terms of the light created.

Note also that both of my cords are ETTL (because I shoot Canon). If you shoot Nikon, then buy ITTL cords. These cords maintain the full communication between the camera and the speedlight. There are very simple sync cords that only say "Fire Now!" and drop the rest of the ETTL/ITTL communication. These cords (often called "PC sync cords") should be avoided.

BUILT-IN WIRELESS

Virtually all dedicated flash systems provide a way to control off-camera speedlights via a built-in optical wireless system. The advantages of using the built-in system over external triggers are that you already have it in your gear and that it minimizes the potential for bad connections between gear. Virtually all of my photography with small flash is built upon using the wireless systems built into my Canon Speedlites— optical and now also radio.

For this system to work, you have to have a master flash connected to the camera's hotshoe (directly or indirectly via an ETTL/ITTL cord) and one or more off-camera slave flashes. The pop-up flash on many consumer DSLRs now has the ability to serve as a master. Even though its range is limited and the slave(s) must be in front of the camera, using a pop-up is a great way to get started with wireless flash.

The key to reliable results when using the built-in wireless system is to twist the body of the slaves so that their wireless sensors are pointed at the flash head on the master—which is where the instruction signals originate as a coded series of flash pulses. Figure 4.40 shows this twist—except that the head of the slave would point towards your subject rather than towards a wall. Be sure to learn where the wireless sensor is on your gear. For Canon Speedlites, the wireless sensor is the black panel on the front of the flash just above the large red panel (**Figure 4.44**). For Nikon Speedlights, the wireless sensor is a small round dot (about the size of a pencil eraser) on the right side of the flash. If your slave cannot see the instructions firing from the master, then it will not fire.

FIGURE 4.44
On Canon Speed-lites, the wireless sensor is the black panel (outlined in red) on the front of the flash above the large red auto-focus assist panel. On other brands, such as Nikon, the slave wireless sensor is on the side of the flash.

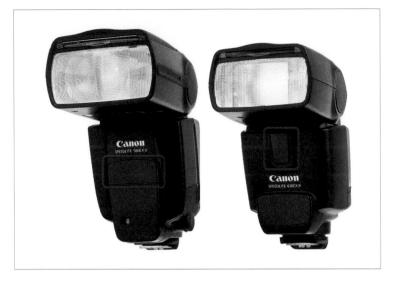

Canon recently introduced the first-ever flash system that has built-in radio communication. You still need a master unit (either the 600EX-RT Speedlite or the ST-E3-RT Transmitter) and one or more off-camera slaves (600EX-RT Speedlites). The benefit of this new technology is that you do not have to maintain the line-of-sight connection required by previous generations of wireless flash. This makes it easy to put the flash inside of modifiers (like the Westcott Apollo softbox) or somewhere other than the room in which you are shooting (such as creating the look of a setting sun by firing a gelled flash in through a window). While there are other radio triggers that can be added to existing gear, which we will discuss next, the benefit of the built-in system is that it integrates seamlessly with the Canon system.

RADIO TRIGGERS

The convenience of a radio trigger is that you do not have to maintain a line-of-sight connection between your camera and flash or strobe. This can be helpful when you want to put your flash inside of a modifier (like the Westcott Apollo softbox) or when you want to put your light outside and fire it through a window. (As mentioned above, long ETTL/ITTL cords also provide this functionality—but we're talking about radio triggers here.)

There are two broad categories of radio triggers: the manual triggers that only say "Fire Now!" (**Figures 4.45** and **4.46**) and those that carry the full ETTL/ITTL communication between the camera and flash (**Figure 4.47**). If you shoot manual speedlights or strobes only, then a manual radio trigger will suffice. If you want to shoot wireless ETTL/ITTL, then your choices become more limited and expensive. Keep in mind that for radio triggers you need a transmitter attached to your camera's hotshoe and a receiver connected to each flash.

My advice is to learn the system that is built into your gear first and then branch out with radio triggers. The challenge of jumping straight to triggers is that when something goes wrong (and it will), you won't know whether it's the flash system or the trigger that's causing the problem.

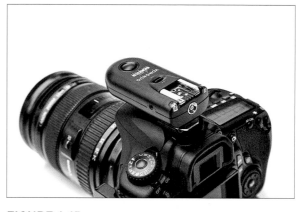

FIGURE 4.45
The Yongnuo RF-603 is a simple radio trigger that will fire your flashes in manual mode up to 30'. Typical cost: $25 per pair.

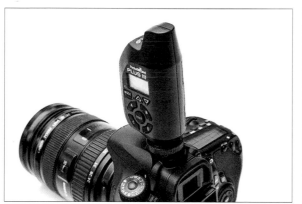

FIGURE 4.46
The PocketWizard Plus III is a manual radio trigger that has the ability activate up to four groups of lights individually. It will also relay the signal from unit to unit and thereby increase the working range of the system over great distances. Typical cost: $140 per unit.

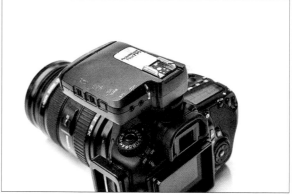

FIGURE 4.47
The PocketWizard Mini TT1 Transmitter and Flex TT5 Transceiver (shown) provide both ETTL/ITTL communication between the camera and flashes. This enables you to run speedlights in either ETTL/ITTL or Manual mode. Be sure to buy the models that are specific to your brand (Canon/Nikon). Typical cost: $225 per unit.

Chapter 4 Assignments

Tally the Light Sources in Your Home

How many different light sources do you have in your home? Walk through, room by room, and categorize the lights—incandescent, fluorescent, LED, etc. Within each group, sort out which are warm and which are cool/daylight. Can you see the difference in color temperature by looking at them?

Try Various White Balance Settings Indoors

Make a series of photographs of a white object under the various types of light you have found in your home. (A white coffee mug makes a good subject.) Under each light source, shoot the range of white balance settings on your camera—Auto, Daylight, Cloudy, Tungsten, Fluorescent, etc. You will find it helpful to leave yourself a note in the frame as to the light source and the white balance setting. When the series is complete, scroll through the photos on a computer monitor to see which white balance settings yielded the most neutral whites.

Shoot and Adjust Automatic Flash

Sort out whether your flash offers automatic (ETTL/ITTL) and/or manual flash. Go outdoors with a friend and position her so that the sun is behind her shoulders. Take a headshot without the flash. Do the shadows appear too dark? Now turn your flash on in ETTL/ITTL and take the shot again. If you want more or less flash, use Flash Exposure Compensation to adjust the flash power to suit your vision.

Push Through Your Camera's Sync Speed

With your friend outdoors on a sunny day, take a headshot (without flash) that uses a wide aperture with the camera in Aperture Priority mode (Av/A). For best effect, put the sun behind your subject and angle the camera so that the background is uncluttered and darker than your subject. Now, without changing the camera settings, turn your flash on and take the shot again. It will likely be overexposed due to the camera forcing the shutter back to the sync speed. Now, activate High Speed Sync (Auto FP Sync) and take the shot again. You should have a good shot with adequate fill light in the shadows.

Bounce, Bounce, Bounce Your Flash

Take a series of headshots indoors. First, use no flash. Then aim the hotshoe-mounted flash directly at your subject. Now pan the flash so that the head angles towards a nearby wall. Have the subject look at that wall. Take this shot. Now swing the flash head back to center and angle it towards the ceiling. Your subject can continue looking at the wall or directly at the camera. Take the shot. Check the image to see if the eyes are too dark. If so, angle the flash head straight up and place your left palm behind the flash. Most of the light will fly to the ceiling, but some will bounce forward. Do the eyes look brighter?

Share your results with the book's Flickr group!

Join the group here: flickr.com/groups/lightingfromsnapshotstogreatshots

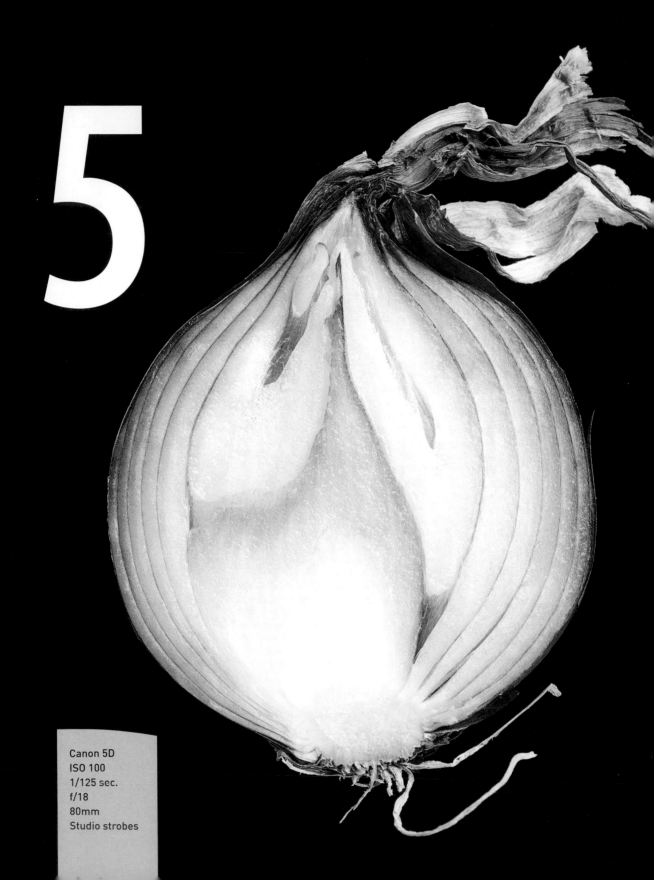

5

Canon 5D
ISO 100
1/125 sec.
f/18
80mm
Studio strobes

Lighting for Tabletop and Macro Photography

LEARN TO LIGHT BY STARTING WITH OBJECTS

Like any new set of skills, there are many ideas to remember when you first learn to light. If it seems overwhelming when you're just starting out, I suggest that you point your camera at objects for a while. Objects won't lose their patience and walk away. Even if what you want to know most is how to light portraits (the subject of the next two chapters), hone your basic lighting skills on objects first. You will find that all of the major lighting concepts apply equally well to items as they do to people. So, in this chapter, we'll apply six basic lighting techniques to items that will sit still for as long as you require.

This shadow reveals that the lights were on the right and left rather than near the lens.

I used a piece of black velvet to cover the table and then pulled it up behind the bottles as a backdrop.

Bête Noire

MAS DE MAH

VILLA CREEK CELLA

VC

PINK

ONDA

VILLA C

Photographing one wine bottle is tough enough. Photographing 19 wine bottles together as a family portrait required a keen eye for detail and a lot of patience. After the bottles were arranged in a loose fashion, each then had to be nudged to optimize the reflections in its glass.

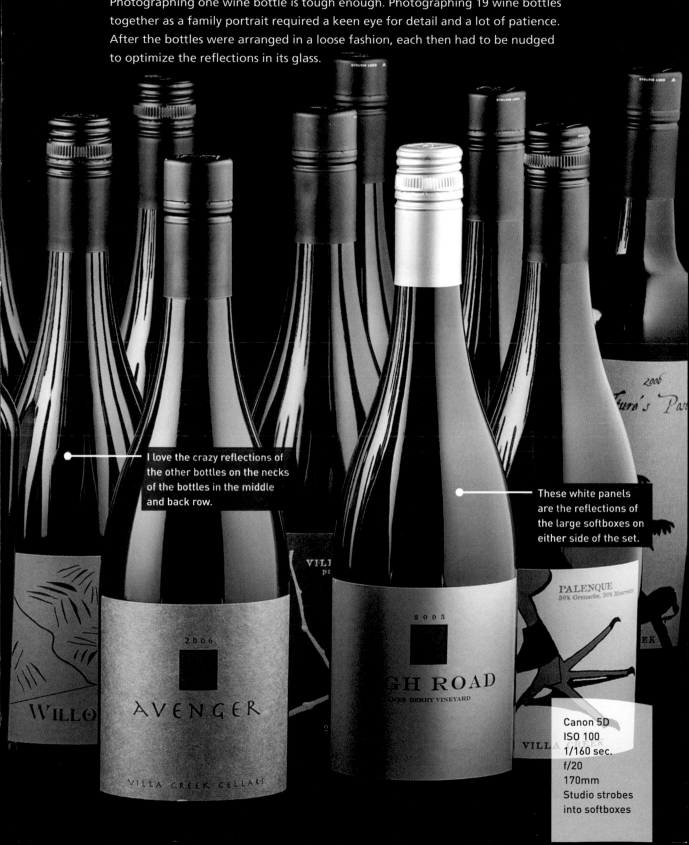

I love the crazy reflections of the other bottles on the necks of the bottles in the middle and back row.

These white panels are the reflections of the large softboxes on either side of the set.

Canon 5D
ISO 100
1/160 sec.
f/20
170mm
Studio strobes into softboxes

PORING OVER THE PICTURE

I spent an afternoon in my living room creating this shot as part of a personal project. The lighting was created by firing studio strobes through two 24" x 30" Chimera softboxes. The shadow running down the center of the stem (look just below the bloom) is the clue that the softboxes faced each other from the sides of the bloom. The strength of the shot is built upon the lighting and also calls upon the shallow depth of field to force your eyes up to the petals.

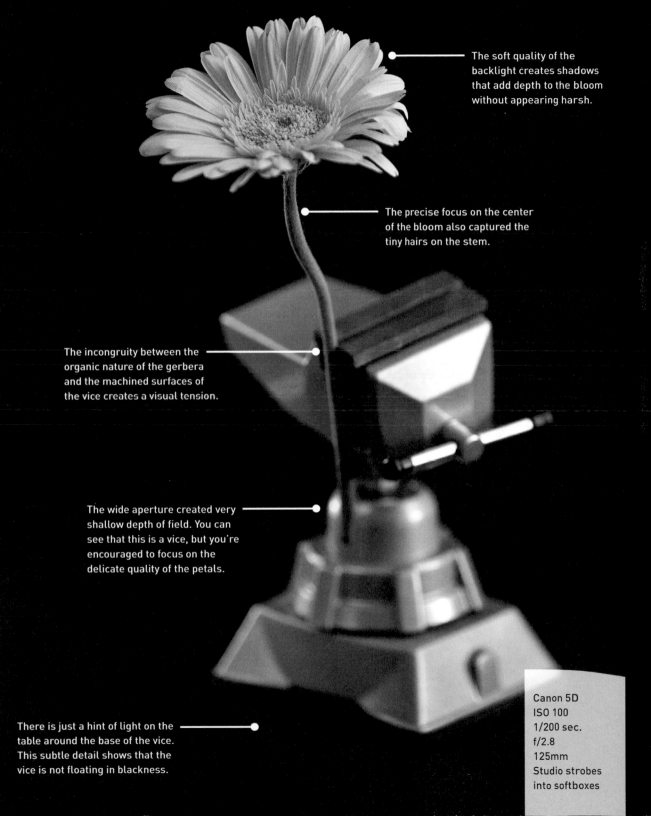

The soft quality of the backlight creates shadows that add depth to the bloom without appearing harsh.

The precise focus on the center of the bloom also captured the tiny hairs on the stem.

The incongruity between the organic nature of the gerbera and the machined surfaces of the vice creates a visual tension.

The wide aperture created very shallow depth of field. You can see that this is a vice, but you're encouraged to focus on the delicate quality of the petals.

There is just a hint of light on the table around the base of the vice. This subtle detail shows that the vice is not floating in blackness.

Canon 5D
ISO 100
1/200 sec.
f/2.8
125mm
Studio strobes
into softboxes

QUICK LOOK—SHOOTS AND CONCEPTS

Up to this point in the book, we have surveyed a wide range of concepts about light and how to apply those concepts to your photography. From this point forward, we'll take a more applied approach—specifically, this chapter and the two that follow will present as a series of shoots that illustrate how to use the concepts and your gear for specific purposes.

In this chapter, we'll work through six shoots that demonstrate some of the most important concepts in lighting. The subjects will be objects rather than people—which is helpful when you're starting out as you can take all the time you need to get the shot without losing the patience of your subject. So, here is a peek at where we're heading:

- **Shoot 1—Make It Look Like Cloudy Weather.** Soft light fits into the dynamic range of our cameras better than hard light (especially when shooting in full sun). Diffusion is a powerful tool for creating soft light when you need it.

- **Shoot 2—You Don't Have to Light Everything.** By lighting selectively, you can guide the viewer's eye through your photograph. Snoots and grids are great tools for limiting the spread of light.

- **Shoot 3—Define Shape with Rim Light.** If your subject blends into the background, place a light behind your subject to create a zone of brightness that defines the edge of your subject. If you don't have an extra light, you can also use a reflector to throw a bit of light onto your subject.

- **Shoot 4—Embrace the Power of Backlight.** Placing a large, soft light behind your subject is a quick way to create beautiful light—especially when shooting food and other moist subjects. A softbox or a diffusion panel is all that's needed to get started.

- **Shoot 5—Throw Light Everywhere.** High key photography is great for products and people because it eliminates most of the shadows. For objects, it is easy to surround them with light by shooting on a seamless background and by creating a house of foam core sheets.

- **Shoot 6—If It's Shiny, Light What It Sees.** Reflective materials, like glass and metal, require a different approach to lighting. Rather than lighting the object directly, you light surfaces near the object and photograph the reflections of those surfaces on the object.

GETTING STARTED WITH LIGHTING
ON A SMALL SCALE

Tabletop photography is exactly what it sounds like—putting something on a table and making a photograph of it. Of course, it's not that simple. The physics that make DICCH work for landscape and portrait photography also apply to small sets. If anything, Direction and Intensity need to be managed more closely for tabletop and macro work because the lights are inherently closer to the subject.

As you work through this chapter, I think you'll find that you have virtually all of the subjects I shot around your house. Well…okay, maybe you don't have a mouse laying around, but you should have most everything else—flowers, fruit, a piece of junk, and a bottle. The objects that you photograph are not as important as the techniques you learn by making the photographs.

If you have a tripod, use it to keep your camera in the same position from shot to shot. Then, you'll be able to see the effects of changes you make to your lighting setups.

For the most part, the desire for good depth of field in most tabletop shots requires the use of medium and small apertures. So, your tripod will also come in handy when your aperture selection requires the use of a long shutter speed.

Also, keep a set of index cards or sticky notes close by. As you make a change to the lighting, write a note to yourself and then photograph it. Then you'll be able to read your notes down the road when you pull up all of your pictures in an image browser. I used to write my notes down in a separate notebook. Trust me—photographing your notes as you make changes to the lighting is the way to go.

MAKE IT LOOK LIKE CLOUDY WEATHER

To create soft light outdoors in full sun, you need a way to make it look like cloudy weather. This is as important for small subjects, like flowers, as it is for larger subjects like people. Compare the differences between **Figures 5.1** and **5.2**. In Figure 5.1, the rose was lit directly by the sun. Although it is easy to get caught up in the beauty of the petals, if you look critically at the relationship between the bloom and the foliage, you will see that (no surprise) the contrast is too strong. Now cast your critical eye to the relationship between the bloom and the foliage in Figure 5.2. The darks are just as dark, and the whites are just as white—but the transition between the two is much gentler.

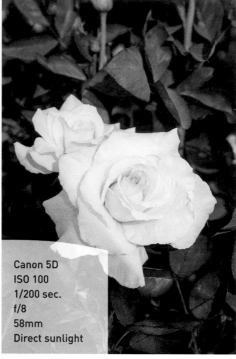

Canon 5D
ISO 100
1/200 sec.
f/8
58mm
Direct sunlight

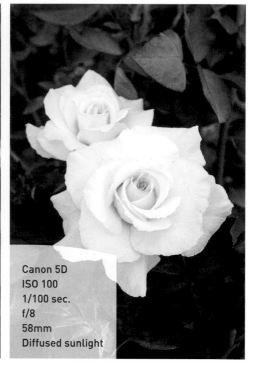

Canon 5D
ISO 100
1/100 sec.
f/8
58mm
Diffused sunlight

FIGURE 5.1
Although the bloom in this shot is beautiful, the direct sunlight creates too much contrast in the shadows.

FIGURE 5.2
Using a one-stop Scrim Jim diffuser panel, I softened the sunlight. Now the transition from the highlights to the shadows is much gentler.

To create the look of cloudy weather—meaning to create soft light in direct sun—use a translucent diffuser panel (like the 40" 5-in-1 reflector set I recommended back in Chapter 3 [see Figure 3.15]). Then, as you become more obsessed with lighting, add a larger diffuser system to your kit. As you can see in **Figure 5.3**, I used the Scrim Jim to diffuse the sunlight.

FIGURE 5.3
I used a C-stand to hold the Scrim Jim panel above the rose. Although I did not use flash for the shot, I set up a Speedlite in case I wanted to add a bit of directional light.

SCRIM JIM—MODULAR DIFFUSER/REFLECTOR SYSTEM

When you are ready to step beyond the economy of a 5-in-1 reflector set, take a look at the Scrim Jim system by F.J. Westcott Co. (**Figure** 5.4). It's a modular system built around lightweight aluminum tubing. The frame can be assembled in three panel sizes: 42" x 42", 42" x 72", and 72" x 72". Westcott offers an extensive range of fabrics for diffusion, reflection, and light blocking that attach quickly. The whole kit disassembles down to a package about the size of a light stand, which means that they are easy to transport.

FIGURE 5.4

YOU DON'T HAVE TO LIGHT EVERYTHING

Mystery is good—in novels, in movies, and in photography. If everything is revealed, then there is nothing to discover. In photography, concealing part of the frame in darkness forces the viewer to concentrate on the elements that are lit. So, you can literally guide your viewer's eye with your lighting.

Compare the lighting in **Figures 5.5** and **5.6**. I know you'll agree that there is a dramatic difference between the two shots—which are identical in all ways other than the lighting. In Figure 5.5, the blackness of the background and the shadows in the foreground force you to concentrate on the irony of the shot—namely that a tiny mouse is taking a nap on a giant mousetrap. The lighting fits the nature of the mouse as a creature that does not like to be seen out in the open.

Now take a look at Figure 5.6—which is easy to do since everything is lit. There is no mystery. Nor is there a connection between the lighting and the subject of the photograph. So remember, you don't have to light everything in the frame.

FIGURE 5.5
The lighting in this shot forces your eye to the important details—the mouse sleeping on the trap. There is enough light on the trap to reveal what it is, yet not so much light that you know where it is.

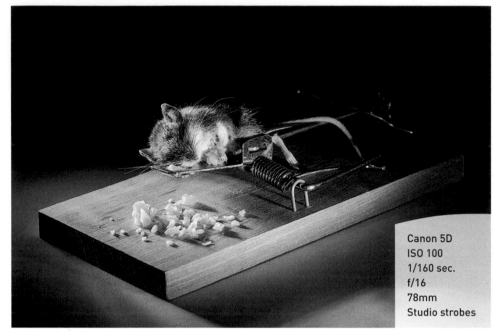

Canon 5D
ISO 100
1/160 sec.
f/16
78mm
Studio strobes

FIGURE 5.6
I showered the tabletop set with light by firing a strobe directly at the ceiling of the studio. There is little power to this image because the entire frame is lit equally.

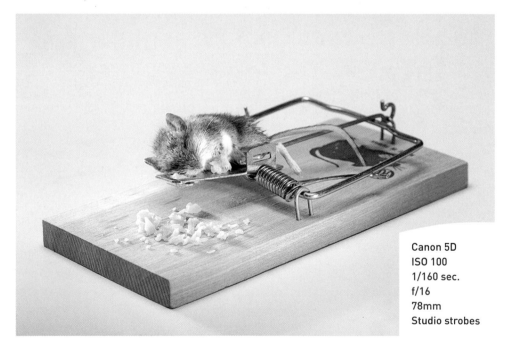

Canon 5D
ISO 100
1/160 sec.
f/16
78mm
Studio strobes

LIMITING THE SPREAD OF LIGHT

So how do you light a portion of the frame and not everything at once? The first step is to push your lights in close. If your lights are too far away, they will light the entire set. Now remember that the closer a light is to the subject, the brighter it appears. So, you will need to dial the power on your light way down—which makes the adjustability of flash easier to use in this instance than continuous lights. For small-scale tabletop work, speedlights are very handy, as their minimum power is a fraction of the minimum power of most studio strobes. Lastly, you'll need to modify the light—meaning that you'll likely need to further restrict the path of the light. So, if you're using a speedlight, use the Zoom button to manually adjust the spread of light. You might also need to use a snoot and/or a grid (see sidebar) to minimize the path of light even further (**Figure 5.7**). To block the light from specific areas of the shot and to eliminate unwanted fill light from bouncing off nearby surfaces, prop up small pieces of black foam core as needed.

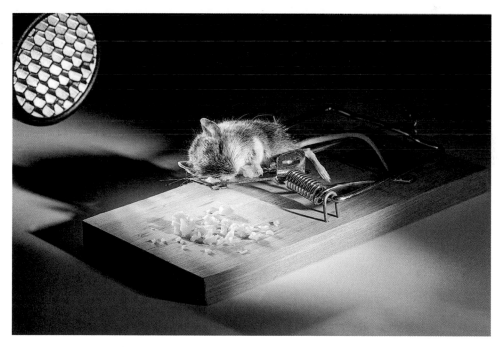

FIGURE 5.7
To limit the spread of the flash on the left, I attached a metal snoot to my strobe and then snapped a grid on the end. For the actual shot, the light was pulled back so that it was just out of the frame.

SNOOTS AND GRIDS

Snoots and grids are modifiers that restrict where the light flies (**Figure 5.8**). Snoots are either rigid cones made of aluminum and plastic or flexible tubes made of heavy cloth. The metal snoot that I used for Figures 5.5 and 5.7 is the Strobros snoot (shown on the left here). I'm also very fond of the Rogue Large FlashBender as it folds flat and travels well (pictured center). Note that I choose to roll the FlashBender inside out to minimize the reflection of light as it travels down the tube. When it comes to grids, my favorite setup is the Strobros Mini-Beauty Dish with grid insert (pictured right). There are other grids that strap right onto the face of a flash. I think that the larger size of the Strobros system (measuring 5" across) is a great size for portraits—as you will see in the following two chapters.

FIGURE 5.8

DEFINE SHAPE WITH RIM LIGHT

I've said it before—*light allows you to see the subject* and *shadows enable you to see its depth and texture.* So, in my view, shadowing is as important as lighting. Yet, there are times when the shadows merge into a dark background and the impact is lost. When this happens, you'll want to define the shape of your subject by placing a light or reflector slightly behind your subject and angle it forward to create *rim light.* Think back to the Lighting Compass in Figure 1.1—135° is a good position for a rim light.

Take a look at **Figures 5.9** and **5.10**. They are the same "portrait" of a grapefruit with the exception of the rim light. In Figure 5.9, notice how the rim light on the left edge enhances your perception of the grapefruit's shape. In Figure 5.10, the continuous tone of the shadow flattens the appearance of the fruit as the left side merges into the black background.

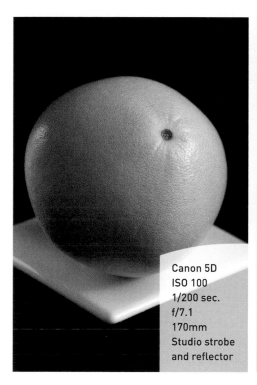

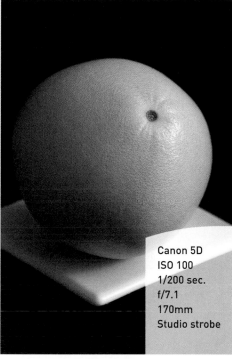

FIGURE 5.9
(left) I used a
studio strobe and a
small reflector for
this shot. The key
light was 45° on
the right. The
reflector was 135°
on the left.

FIGURE 5.10
(right) The lack
of rim light in
this shot makes it
appear flatter.

Canon 5D
ISO 100
1/200 sec.
f/7.1
170mm
Studio strobe
and reflector

Canon 5D
ISO 100
1/200 sec.
f/7.1
170mm
Studio strobe

Rim light is as important to tabletop photography as it is to portraiture. So, it's a valuable technique to have in your repertoire. An easy way to position your rim light is to draw a line from your key (main) light through your subject and to place your rim light on that line so that it faces your key light. If you do not have two lights, you can use a metallic reflector to catch some of the light flying past the subject and send it back. As you can see in **Figure 5.11**, I used a small metallic reflector to create the rim light on the grapefruit.

Light coming from behind the subject essentially skims off the subject on its way to the lens. In contrast, light coming from in front of your subject must literally bounce off the subject for the

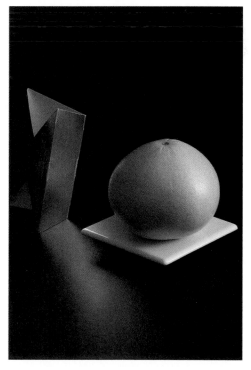

FIGURE 5.11
To create the rim
light, I placed a
Light Right reflec-
tor just outside
the frame. The
foil surface was
very effective at
bouncing the flash
back towards the
grapefruit.

return trip to the lens. So, when it comes to rim light, you don't need much power. You'll first see the rim light as a white patch on the edge of the subject. Keep turning the power down on the rim light (or moving the reflector away from the subject) until you can barely see it in a test shot. Then turn the power up (or move the reflector forward) until you have just enough rim light. Chances are, if you don't get to the point where there is too little, you'll likely have too much.

EMBRACE THE POWER OF BACKLIGHT

Here is the secret for quick and easy food photography—embrace the power of backlight. It does not matter if it is natural backlight from a conveniently located window or backlight that you create in the middle of the night with a softbox. Backlight is beautiful because it makes moist foods glisten.

As we discussed in the previous section, you create rim light by placing a light or reflector behind your subject. Backlight is essentially a giant form of rim light. Rather than provide a thin edge of separation from the background, the role of backlight (especially in food photography) is to provide a sheen of light across the entire frame.

To see what I mean, take a look at **Figure 5.12**. By looking at the shadows, you can see two important clues about my lighting. First, since the shadows move into the foreground, the light must have been behind the melon slices. Second, since the edge of the shadows is soft, the size of the light must have been much larger than the plate. The proof is in the set shot (**Figure 5.13**).

FIGURE 5.12
The beauty of this
shot is due to the
backlighting. Moist
foods glisten when
light comes from
behind and skips
into the lens.

Canon 60D
ISO 400
1/160 sec.
f/16
50mm
Speedlite into
Impact Quikbox

FIGURE 5.13
By placing a 24"
Impact Quikbox
behind the plate,
I was able to create
lovely backlight
with a single flash.
As you can see,
my tabletop was
a sheet of white
foam core.

To create the backlight, I used a 24" Impact Quikbox and a single Speedlite. The Quikbox is an affordable softbox that folds up flat for easy transport and storage. The Speedlite mounts on the back and fires forward through two layers of white nylon. As you can see in Figure 5.13, the front edge of the Quikbox was literally right above the melon, and the back edge rested on the foam core.

To understand the beauty and simplicity of backlight, you have to explore other lighting angles. If you mount your camera on a tripod, then it will be easy to see the difference in lighting from frame to frame. In **Figure 5.14**, I moved the Quikbox so that it was on the left side of the camera and slightly in front of the plate. Take a close look at how the melon lost its glisten in this light. Unless the light comes from behind, it can't skip off the moisture.

FIGURE 5.14
By moving the Quikbox around to the left and slightly in front of the plate, I took away the sheen that the backlight provided. When photographing moist subjects, it is critical to have some backlight.

Canon 60D
ISO 400
1/160 sec.
f/16
50mm
Speedlite into
Impact Quikbox

To close out the rotation of light, as shown in **Figure 5.15**, I shut off the flash and shot in the ambient light coming indirectly through the large garage door behind me. If you look closely at the tops of the melon slices, you will see small glints of backlight from a small door on the opposite side of the garage. Even though it's not much, every bit of backlight helps. So, if you're traveling and all you have to work with is ambient light, try to swing the camera around so that there is a window or door behind the plate.

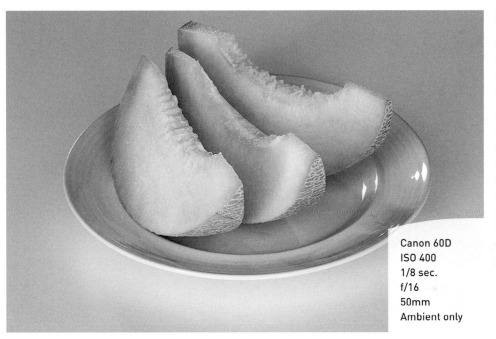

FIGURE 5.15
The soft lighting in this ambient-only shot happened because I rolled up the large garage door behind me. The small glints on the top edges of the slices are from the light coming though a small door on the opposite wall. Every bit of backlight helps.

Canon 60D
ISO 400
1/8 sec.
f/16
50mm
Ambient only

HIGH KEY VS. LOW KEY

High key and *low key* refer to shots where either the brights or darks dominate the image. When the majority of the frame is white or very bright (like the one we're doing in this section), the image is high key. When the majority of the frame is black or very dark shadows, the image is low key. Keep in mind that high key images will have dark shadows and black (just not much of them). Likewise, low key images will have whites and highlights.

THROW LIGHT EVERYWHERE

So how do you take a 50-cent yard sale item and turn it into a good profit on eBay? Specifically, how do you photograph the kerosene lamp in **Figure 5.16** in a way that inspires others to start a bidding war? You take away the distractions and surround it with beautiful light—light that enables the viewer to focus on the object rather than the background (**Figure 5.17**). The lighting should show details on all surfaces—meaning that strong shadows should be avoided. There are two keys to easy shooting for online auctions: shoot on a seamless and surround the object with light. Fortunately, both require only inexpensive items that you can find at an office supply store.

Canon 60D
ISO 800
1/5 sec.
f/8
50mm
Ambient only

Canon 5D Mk III
ISO 100
1/200 sec.
f/11
105mm
Speedlites

FIGURE 5.16
Here's the lamp as I found it—covered in rust and dust, forgotten on a shelf in the corner of a garage. Even though the ambient light isn't bad (meaning there are no harsh shadows), the plywood shelf and block wall do not enhance the desirability of the lamp.

FIGURE 5.17
This shot was lit with the pair of Speedlites firing into vee-flats of foam core. Note that the light is even across the object, and the subtle highlights and shadows work together to reveal depth.

A *seamless* is a background that curves into the surface on which your subject is placed. Seamless backgrounds are used in tabletop photography and, as you will see in Chapter 7, in portrait photography. When lit properly, a seamless will save you lots of time by eliminating the need to head into Photoshop and clip away shadows in the background. So, knowing how to create a seamless is a very handy photographic skill.

For this shoot, I used two white poster boards for the seamless. Essentially these are sheets of heavy paper. A pack of ten 20" x 24" sheets costs less than $5. *Seamless tip 1*: If one side is shinier than the other, place the shiny side up. *Seamless tip 2*: If you have to use two or more sheets, overlap the sheets so that the one closer to the camera is on top (**Figure 5.18**). Facing the overlap towards the curve in the seamless hides the edge from the lens.

FIGURE 5.18
I used two sheets of poster board (heavy paper) to create a tabletop seamless. Note how the sheet closest to the camera (on the right side of the frame) sits on top of the other sheet. Facing the overlap to the back hides the seam from the lens.

To surround the lamp with light, I created a "house" of foam core sheets. Foam core is an indispensible (and widely available) tool for photographers. Sheets up to 30" x 40" are usually available at large office supply stores. Bigger sheets, up to 5' x 10', are available at professional photo and theater supply houses. If you have the option, buy foam core that is black on one side and white on the other. Otherwise, buy sheets of both black and white. You will use white foam core to bounce light and black foam core to keep extra light from hitting your subject.

A convenient trait of foam core is that if you cut through the paper on one side, you can then snap the foam and use the paper on the other side as a hinge. Photographers call hinged foam core *vee-flats*. As you can see in **Figure 5.19**, I created two vee-flats for the sides of my house and then placed a flat sheet on top.

FIGURE 5.19
My "studio" was
literally assembled
on an old card table
in a corner of a
garage. I used three
sheets of white
foam core to sur-
round my subject
with light. If you
look on the left side,
you can see the
foot of a Speedlite
that I fired into the
vee-flat. There was
another Speedlite
firing into the vee-
flat on the right side.

So what does all this foam core origami produce? First, as you can see in Figure 5.17, there is no distinction between the tabletop and the background. The horizontal and vertical surfaces blend seamlessly. Further, there are no background shadows—which, as I said above, eliminates the step of fixing the photo in Photoshop. The pair of Speedlites bounced their flash all around the foam core and literally surrounded the old lamp with light. Compare this shot to the ambient shot (Figure 5.16). I think you'll agree that my lighting makes the lamp look more desirable—which is your goal when shooting for online auctions.

What other options do you have if you don't own a pair of Speedlites? Think in terms of using any two identical light sources. A pair of halogen desk lamps would work, for instance, if aimed into the vee-flats. The key is to make sure that the light sources do not light the item directly. If necessary, use a bit of aluminum foil or a small piece of foam core to as a flag to block the light.

A final comment about this type of lighting—most of your time will be spent setting up the lighting. So, make as many different photos as possible. Be sure to photograph each item from several sides (easily done by spinning the item slightly). Also, collect a number of items to photograph in one session—even if you are not going to auction them right away. Then, you'll have great images on hand when you need them.

A HEAVY-DUTY TABLETOP SEAMLESS

From time to time, I have the need to shoot an extended run of tabletop work. Rather than use poster board as a seamless, I head to the home improvement center and buy a 4' x 8' sheet of "tile board" for about $12. The tile board is actually a 1/8" sheet of Masonite that is painted white on one side. To set it up as a seamless, I use a pair of sawhorses or a 6' folding table, two light stands, and two Superclamps to support the tile board as shown (**Figure 5.20**). Conveniently, the tile board also works for full-length portraits—as discussed in Chapter 7.

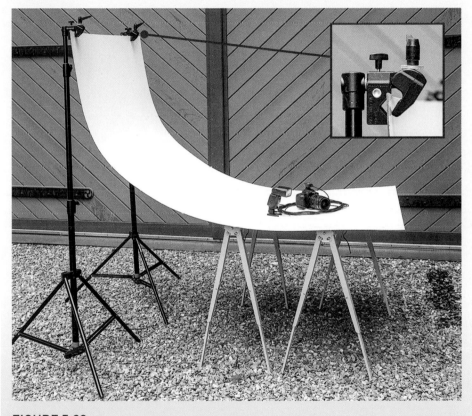

FIGURE 5.20

IF IT'S SHINY, LIGHT WHAT IT SEES

When it comes to lighting glass and metal objects, the key thing to remember is that you light what the object sees and not the object itself. That's a really important concept. So read that sentence a couple more times. I'll wait.

My hometown of Paso Robles is the hub of California's central coast wine district. So, I have honed my shiny object lighting skills by photographing legions of wine bottles—which I like to think of as cylindrical mirrors. If you can create a strong wine bottle shot that does not need to be "optimized" in Photoshop, then you're on your way to knowing how to light shiny objects (**Figure 5.21**).

Shiny objects are shiny because light bounces off of them. So, if you throw light directly at glass or metal, what you get in the shot are specular (direct) reflections of the light source itself. You'll also see a hard shadow running off one side (**Figure 5.22**).

Typically, though, what you are looking to create are panels of light and dark reflecting off the surface. It's actually these panels of light and dark that allow us to see the shape and depth of the reflective surface.

In Figure 5.22, I fired a Speedlite directly at a bottle of one of my favorite Paso Robles wines. The two white splotches are the reflection of this single flash. The strong shadow running off to the left is also a clue about how the light was created. The white reflection on the left was created by placing a tall sheet of white foam core just out of the camera's view on the left side of the frame. The panel was lit by light flying from the flash in front of the bottle. If you stare at the shot for a moment, you'll see that the reflections on the left side give the bottle a sense of shape and that the lack of reflections on the right makes the glass appear very flat.

Canon 5D Mk III
ISO 200
1/125 sec.
f/11
88mm
Speedlite into
diffuser, foam
core reflector

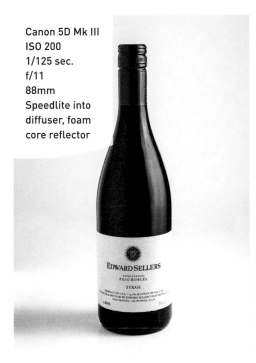

Canon 5D Mk III
ISO 200
1/125 sec.
f/11
88mm
Direct flash,
foam core
reflector

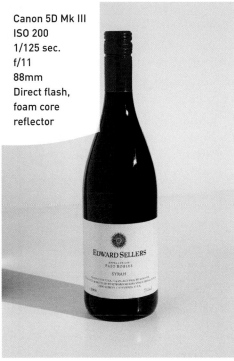

FIGURE 5.21
(left) Here is my
hero shot—lit with
a single Speedlite
and a sheet of
foam core.

FIGURE 5.22
(right) The two
tell-tale signs that
this was lit with
direct flash are the
two white specular
highlights on the
right side and the
distinct shadow
running off the left
side. The white
reflection on the
left side of the
bottle was created
by a tall panel of
white foam core
just outside the
camera's view.

STEPS FOR PHOTOGRAPHING WINE BOTTLES AND OTHER REFLECTIVE OBJECTS

1. **Clean the surface.** Polish the glass/
 metal free of fingerprints. When
 shooting bottles, select one that
 does not have a glass seam run-
 ning through the label.

2. **Create a black set.** As the reflec-
 tions of light and dark define the
 shape of reflective objects, you
 need to minimize random room
 reflections. The easiest way to
 do this is to work in a window-
 less room where you can dim the
 lights. For this shoot, I worked in
 a friend's garage. In **Figure 5.23**,
 you can see what happened when
 I left the garage door up. Those

Canon 5D Mk III
ISO 200
1/5 sec.
f/11
88mm
Ambient light

FIGURE 5.23
When shooting
reflective objects, it
is best to work in a
dark environment.
The reflections
in this shot were
created because I
rolled up the door
of the garage where
I was shooting.

crazy reflections in the center of the bottle are the door, yours truly, and the world outside.

3. **Use a tabletop seamless.** A large sheet of poster board or stiff paper will suffice. Review how I created the seamless in the previous section.

4. **Set up a large diffusion panel close to the bottle.** Hang it slightly below the edge of the table to create a flush edge.

5. **Position your light away from the diffusion panel.** The role of the light is to illuminate the diffusion panel (not the object itself). Be sure that the light does not spill around the diffuser and illuminate bits of the room. If needed, use the zoom feature on your flash.

6. **Position a reflector in as close as possible opposite the diffuser.** For this shoot, I used a vee-flat of white foam core immediately outside the camera's field of view on the left (**Figure 5.24**). It's important to use a tall sheet as the curved shoulders of bottles look up rather than sideways.

7. **Experiment with the front/back position of the diffuser and reflector.** Once you have squeezed the diffuser and reflector in close, you should experiment with their front/back position until you get the panels to reflect as you want them to. By pulling the diffuser forward a bit, I was able to create the black edge on the right side of the bottle as shown in Figure 5.21.

FIGURE 5.24
The important details to note in this set shot are how close the foam core and diffuser are to the bottle and how far the flash is from the diffuser. The foam core and diffuser were squeezed in tight to create reflections that run the entire length of the bottle. The flash was pulled back so that it would cover as much of the diffuser as possible.

Chapter 5 Assignments

Bring in the Clouds

On a sunny day, walk outside with a diffuser disk. Observe how the quality of light changes when you place it very close to an object and then begin to pull it away. Now photograph the same object with the diffuser at increasing distances. Do your photographs have the same quality of light that you saw?

Be Selective About What You Light

Move a flash or a continuous light source in close to an object. Adjust the power until you get an acceptable photograph. Now modify the light so that only a portion of the scene is lit. Try to keep your camera in the same spot (use a tripod if you can). How would you describe the difference in the feeling of the image as the light and shadows change?

Rim Light/Backlight

Using a small light source and then a large light source, make a series of photographs as you move the light in a circle around an object (i.e., around the lighting compass). Can you create backlight with the small source? Can you create rim light with the large source? What positions are best for rim light and for backlight?

Share your results with the book's Flickr group!

Join the group here: flickr.com/groups/lightingfromsnapshotstogreatshots

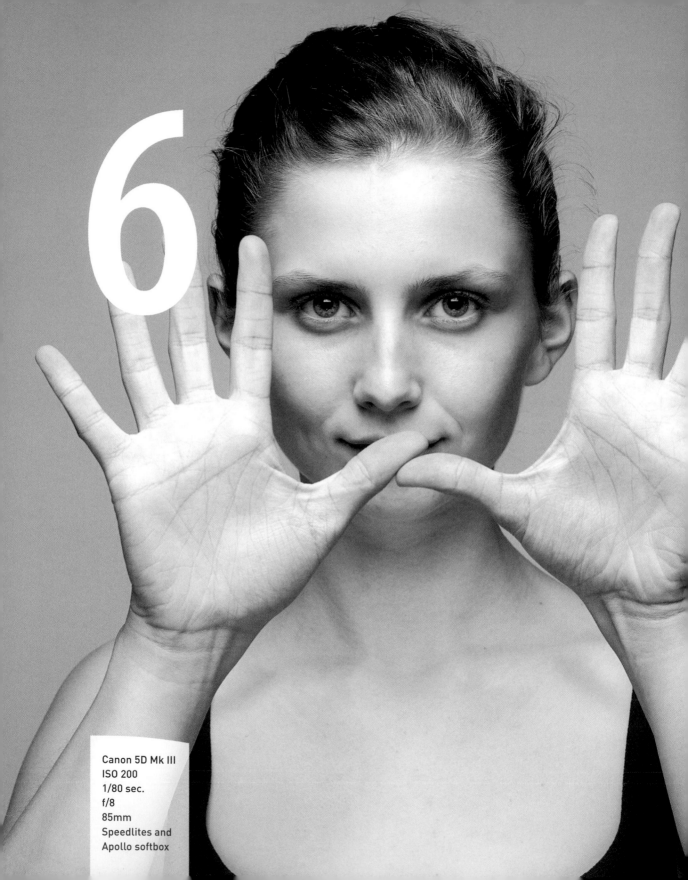

6

Canon 5D Mk III
ISO 200
1/80 sec.
f/8
85mm
Speedlites and
Apollo softbox

Lighting Fundamentals for Portraits

GETTING STARTED WITH PORTRAITS

Most people are fascinated with people photographs. We love to look at shots of people like us, people different from us, people doing things that we wish we could do, etc. Not surprisingly, for most photographers, knowing how to make people photographs is their main interest, or at least one of their main interests. Portraits can be direct—where the subject is looking straight at the lens. Portraits can be candid—where the subject is secretly captured with no direct connection to the photographer. In this chapter, we'll start applying what we've learned so far about lighting to shooting portraits.

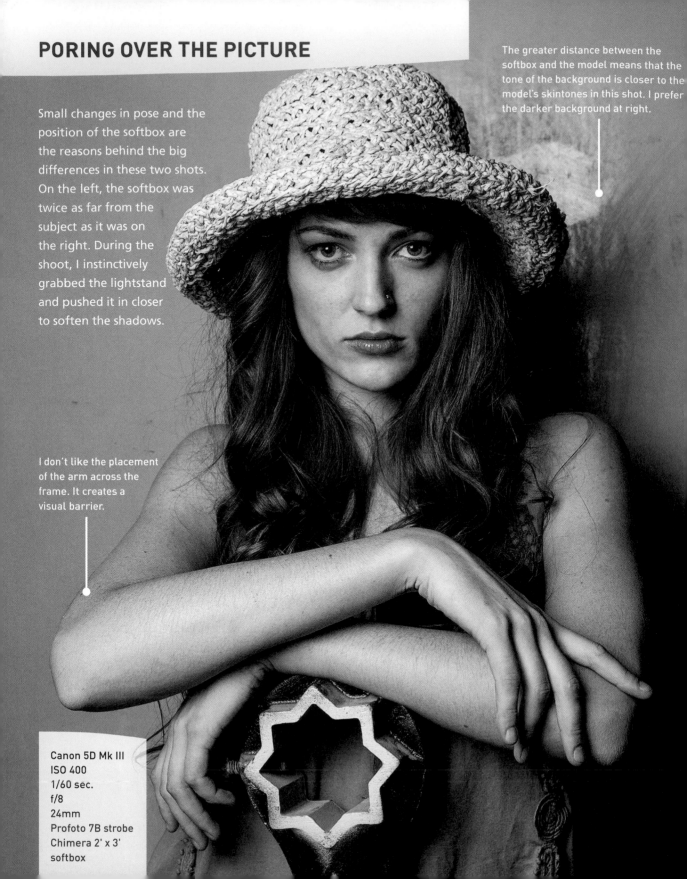

PORING OVER THE PICTURE

Small changes in pose and the position of the softbox are the reasons behind the big differences in these two shots. On the left, the softbox was twice as far from the subject as it was on the right. During the shoot, I instinctively grabbed the lightstand and pushed it in closer to soften the shadows.

The greater distance between the softbox and the model means that the tone of the background is closer to the model's skintones in this shot. I prefer the darker background at right.

I don't like the placement of the arm across the frame. It creates a visual barrier.

Canon 5D Mk III
ISO 400
1/60 sec.
f/8
24mm
Profoto 7B strobe
Chimera 2' x 3'
softbox

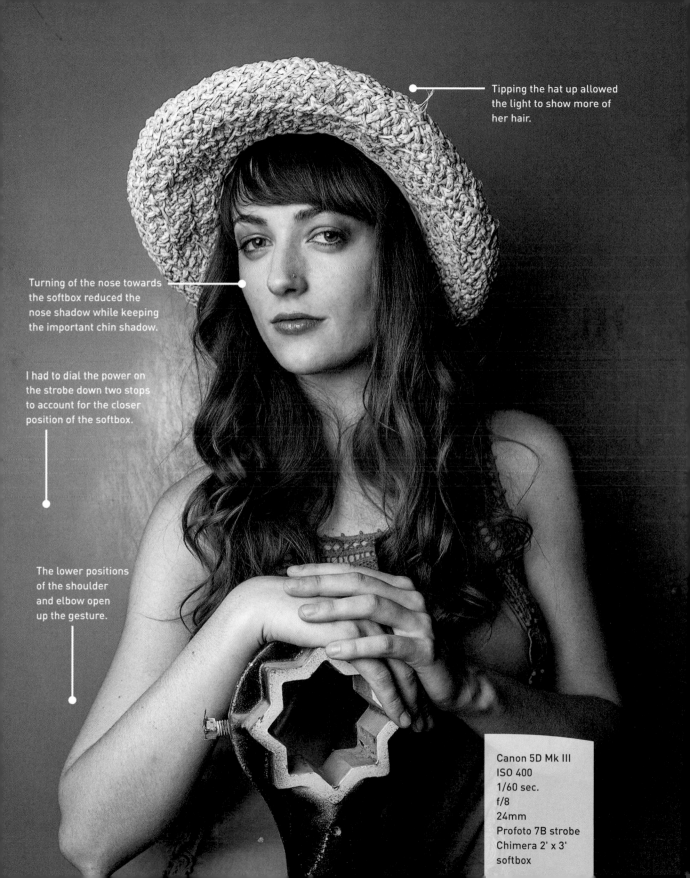

Tipping the hat up allowed the light to show more of her hair.

Turning of the nose towards the softbox reduced the nose shadow while keeping the important chin shadow.

I had to dial the power on the strobe down two stops to account for the closer position of the softbox.

The lower positions of the shoulder and elbow open up the gesture.

Canon 5D Mk III
ISO 400
1/60 sec.
f/8
24mm
Profoto 7B strobe
Chimera 2' x 3' softbox

PORING OVER THE PICTURE

This distracting reflection is the window behind me.

I did not like how the strap ran into the model's face. So I flattened the collar of his straightjacket.

Subtle changes in the lighting and position of the model create two related, but distinctly different, images. On the left, the image is shot with hard light. On the right, the image is shot with soft light. In both shots, the eye on the right is in the same position. Note how the tilt of the model's head and the lowering of the camera put him in a dominant position.

The shadows reveal that this was lit with a relatively small light source.

Canon 5D Mk III
ISO 100
1/160 sec.
f/8
24mm
Profoto 7B strobe
bare bulb

I directed the model to
lower his chin until his
pupil was just above
the edge of the frame.

The softbox used to light
this shot reached around the
model and filled the shadows.

Canon 5D Mk III
ISO 100
1/160 sec.
f/8
24mm
Profoto 7B strobe
Chimera 9" x 36"
stripbox

QUICK LOOK—SHOOTS AND CONCEPTS

By this point in *Lighting for Digital Photography*, I'm sure you've anticipated that I'll say "the difference between a good portrait and a great portrait often boils down to the lighting." It's true. All other things being equal—focus, composition, gesture, etc.—the shot with the more interesting light and shadows will be the better photograph.

So, in this chapter, we'll roam through a wide range of lighting concepts and techniques that involve using natural light alone or with one photographic light—sometimes solo and sometimes with a modifier. Then, in Chapter 7, *Advanced Lighting for Portraits*, we'll add additional lights.

- **Shoot 1—Think About the Ambient First.** My portrait workflow begins with an understanding of how the camera sees the ambient light, and the exposure settings I change to make the ambient light look the way that I want it to.

- **Shoot 2—Be Lazy, When You Can.** It is not always necessary to add light to your portraits. Embrace great light when you happen upon it.

- **Shoot 3—Open Light.** When you don't see good light at the beginning, sometimes knowing where to find good light is all that you need.

- **Shoot 4—Big Equals Soft.** Soft light is a mystery to many photographers. Yet, it is easy to create with basic modifiers like umbrellas and softboxes.

- **Shoot 5—Shutter and Flash Synergy.** The shutter is a powerful tool in flash photography, as it allows you to dim or brighten the appearance of the ambient light independently of the flash.

- **Shoot 6—Finding Light in the Shadows.** It is nearly impossible to create an attractive photo by using one light on both your subject and the background. In dim environments, you can pull light out of the shadows by using a tripod and long shutter speeds.

- **Shoot 7—Dancing with the Sun.** You have many options for how you use the sun. When you have a reflector or a flash, the sun can be the key light, the fill light, or even the hair light in your shots.

- **Shoot 8—Accuracy Matters.** Crafting a portrait with deep shadows and rich blacks requires close attention to where you place your light and, as importantly, where you do not.

- **Shoot 9—Over Under for Beauty.** Shadowless glamour light is easy to create with one flash in an umbrella or softbox; a reflector; and the knowledge of where to put all of them.

- **Shoot 10—Sync About It.** Our cameras have the ability to slice time very thin. They also have the ability to give us a sense that the subject is in motion. Second-curtain sync is a flash technique that enhances that sense of motion.

THINK ABOUT THE AMBIENT FIRST

You'll recall that there are two types of light—the light that's already there (ambient) and the light that you create (photographic). I always think about the ambient light first before I turn on my photographic lights. If I can do something about the ambient light—like throw a switch—then great, I'll do that first. Most often, especially outdoors, there is little that I can do to change the ambient light. So I have to deal with it via my camera settings.

MY EXPOSURE AND LIGHTING WORKFLOW

1. **Set an aperture.** Aperture controls depth of field. So, I set the aperture first and generally stick to one of the following three options: the least amount possible (lens wide open), something in the middle (f/8), or as much as I can get (lens stopped all the way down). As for all those other numbers—like f/3.5, f/7.1, or f/19—I don't worry about or use them much.

2. **Pick an ISO setting.** Next, I'll pick an ISO setting—as low as I think I can get so as to minimize digital noise from my camera. For each of my cameras, I have a rough idea what the max ISO is for a "clean" image. Above this number, I know that I will have to reduce noise either in Lightroom or, for really tough images, via the Imagenomic Noiseware plug-in for Photoshop.

3. **See what shutter speed comes about for a "normal" exposure.** By setting the aperture and ISO, I've left the shutter speed to float. I want a quick baseline shot of the ambient light (**Figure 6.1**). An easy way to get to the shutter speed is to set your camera in Aperture Priority mode (Av/A) and take a test shot. If you prefer to work your camera in Manual mode (M), then set the aperture and ISO, as described, and adjust the shutter speed up or down until the metering indicator settles on zero.

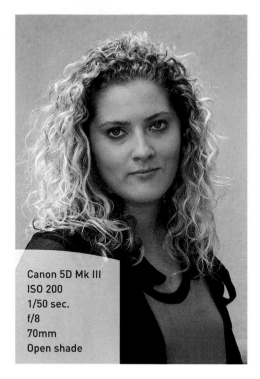

FIGURE 6.1

This is the shot that the camera wanted to make. Placing Jordan in the open shade on the north side of a building created the soft light. While this is a nice headshot, the light is flat. I want more highlights and shadows on Jordan's face.

Canon 5D Mk III
ISO 200
1/50 sec.
f/8
70mm
Open shade

CAMERA MODE: MANUAL VS. APERTURE PRIORITY

I prefer to shoot my camera in Manual mode so that the exposure settings will not change when I recompose the frame (for instance, when I switch from horizontal to vertical or shoot wide after shooting in tight). If you prefer to shoot in Aperture Priority, then use Exposure Compensation to adjust the shutter speed. Just be mindful that if you zoom in and fill the frame with dark tones and then pull out so that the camera sees a bunch of light-colored tones, then the camera will likely change the exposure (which is why I prefer to shoot in Manual).

4. **Adjust the exposure to get the ambient light the way that I want it.** Based on the "normal" exposure that the camera gave me, I will think about how I want the ambient light recorded. In the shoots that follow, you will often read how I dimmed the ambient slightly or significantly by using a faster shutter speed. You will also read occasionally that I lifted the ambient by using a slower shutter speed. Take a look at **Figure 6.2**, and note the difference between Figures 6.1 and 6.2: I wanted the background to be a bit darker, so I dimmed the ambient by changing my shutter speed one stop in Figure 6.2.

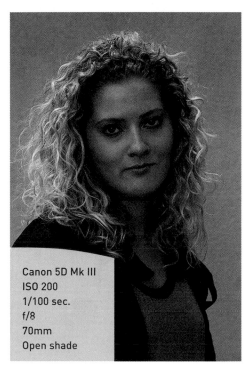

FIGURE 6.2
Since I know that I'll add light onto Jordan, here I'm looking only at the space around her—which will be lit by ambient light only. I wanted the background to be darker, so I increase the speed of my shutter one stop, from 1/50" to 1/100".

Canon 5D Mk III
ISO 200
1/100 sec.
f/8
70mm
Open shade

5. **Confirm that my settings for the ambient exposure will work.** If the ambient light is bright, then the shutter speed might be very fast—in which case I have to consider whether it's faster than the sync speed if I'm shooting flash. If the ambient light is dim, then the shutter speed might be very slow—in which case I consider whether a tripod is necessary and whether the shoot can be done with the camera locked down. If there is a problem with the shutter speed, I can adjust the ISO up or down to solve it. Generally, I will not change the aperture unless I know that the subject is beyond the infinity point for my lens (in which case the subject will be in focus regardless of the aperture).

6. **Turn on the light(s) and start testing/modifying**. Once I have my ambient exposure managed, I turn on my light(s) and start thinking about the type of light that I want to create. Depending upon the subject, the purpose of the shot, my mood, etc., I might use a large modifier to create soft light (**Figure 6.3**) or I might aim my light directly at my subject to create hard light (**Figure 6.4**). (See **Figure 6.5** for the setup for the image shown in Figure 6.4).

I'll soon get into the details about how and why I do various types of lighting. For now, focus on how I first work with the ambient light and then do something about the lighting.

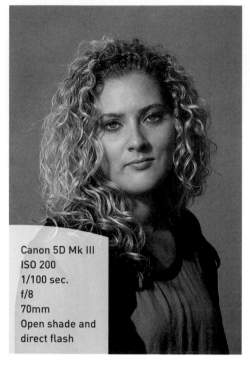

Canon 5D Mk III
ISO 200
1/100 sec.
f/8
70mm
Open shade and
direct flash

Canon 5D Mk III
ISO 200
1/100 sec.
f/8
70mm
Open shade and
softbox

FIGURE 6.3

I fired a Profoto strobe with an 8" reflector directly at Jordan to create the hard light in this shot. Note how it creates dramatic shadows and reveals the texture of her blouse. If I had used a small hotshoe flash, the edges of the shadows would have been even harder.

FIGURE 6.4

By switching out the reflector for a 2′ x 3′ Chimera softbox, I wrapped Jordan's face in beautiful, soft light. Note how the large modifier reaches around and opens up the shadows nicely.

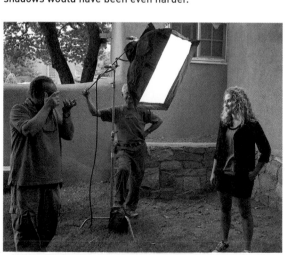

FIGURE 6.5

Set shots are a great way to remember later where everyone and everything was positioned. Here you can see the space in which we were shooting, where I held the camera, and the soft-box used to light Jordan in Figure 6.4. Photo: Zach Doleac.

SELECTING A PORTRAIT LENS

Your choice of a portrait lens should be based upon the shot that you want to make. If you are shooting a portrait on location that shows the subject's environment, then a wide-angle lens would be a good choice. However, if you push a wide-angle lens in close for a head-shot, you will find that it distorts the portions of the subject that are closest to the lens. Compare the headshots in **Figure 6.6** to see this effect. A better choice for headshots are lenses in the slightly telephoto range—70mm to 135mm on a full-sensor camera or 45mm to 85mm on a camera with a 1.6x crop sensor. Also, remember that as focal length increases, the depth of field gets shallower. This can be helpful when you want a portrait that has a blurry background.

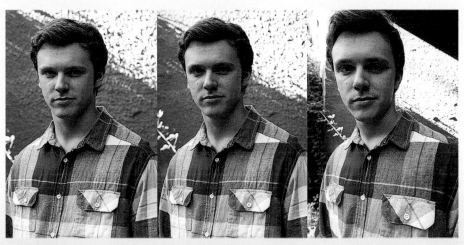

FIGURE 6.6
From left to right: 105mm, 50mm, and 24mm on a Canon 5D Mark III (a full-sensor camera).

BE LAZY, WHEN YOU CAN

Sometimes great light just happens. When you walk into it, take the photo. Then offer up a word of thanks for the freedom from having to break out the lighting gear. As a guy who loves to light, I celebrate those moments when there is nothing for me to do but make a great shot using just my camera. Of course, as a guy who loves to light, it is not always obvious to me on the front end that my lighting expertise is not needed.

This portrait of my friend Donald (**Figure 6.7**) was made in one of those magic moments when I walked into a patch of incredible light. It happened during a workshop in Santa Fe, when I strolled into an old barn and found Donald sitting against an adobe wall in a streak of golden hour sun coming through a gauze-covered window. He was having a conversation with one of my students about light. No surprise. Donald has spent decades in and around the picture-making business. I believe that he's forgotten more about lighting than most photographers ever know. I also believe that he has the ability to attract amazing light.

For me, the sight of Donald's distinctive face in the stream of golden light was too much to pass up. For a few minutes, I made a series of shots—about 20 total—of Donald in the incredible ambient light. As the breeze pushed the curtain around, the shadows flowed up and down across the wall and onto Donald's face. My desire to push the shutter button at the perfect intersection of light, shadow, and expression was the reason that I kept shooting.

Eventually, of course, as a guy who lights, I grabbed the nearby light stand that my student had been using with a 24" Apollo softbox on top. I pushed the softbox up to the wall and asked Donald to look towards it (**Figure 6.8**). He probably thought, "Syl, this is a really stupid idea," but kept quiet about it, as wise cowboys typically do.

After six frames with the flash, I realized the obvious—that I was just throwing my light on top of the perfectly beautiful light that was already there (**Figure 6.9**). The scene did not need any additional help from me. All my light did was suck out the warmth of the sun and flatten dramatic gestures in the shadows. So, once again, I reminded myself that it's okay to be lazy, when I can. The lesson is that when you can get a great shot without any lighting gear, take the shot.

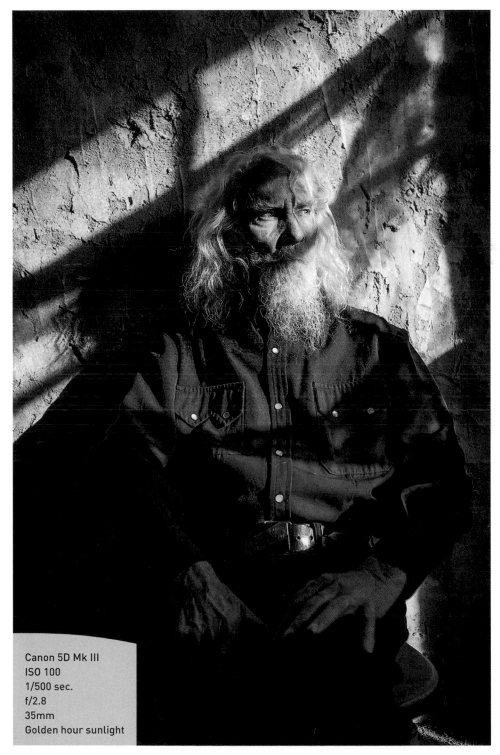

Canon 5D Mk III
ISO 100
1/500 sec.
f/2.8
35mm
Golden hour sunlight

FIGURE 6.8
As a guy who lights, I eventually pushed a softbox in close to Donald and started to use a bit of flash.

FIGURE 6.9
When the addition of my flash sucked the beauty out of the golden hour light, it became obvious that this scene did not require any additional help from me. This is nice light, but it lacks the impact of the hero shot.

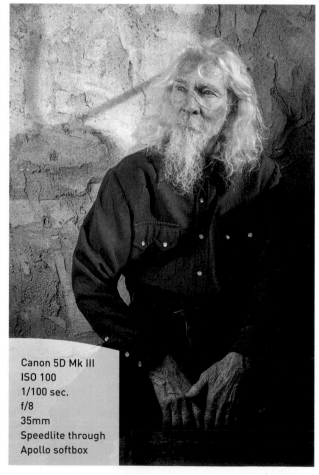

Canon 5D Mk III
ISO 100
1/100 sec.
f/8
35mm
Speedlite through
Apollo softbox

FOCUS ON THE EYES

The key to a great portrait is to focus on the eyes—especially when shooting at a wide aperture to create a shallow depth of field. If the nose or the ears are slightly soft, it is not a big deal—as long as the eyes are sharp. If the eyes are soft, then the shot is lost. To be precise with your focus in portraits, select the focusing point in your viewfinder that is placed on the closest eye. (Typically, there is a way to roll the selection of the focusing point by turning a dial on your camera. Check your manual.) Later, as you become a more advanced shooter, sort out how to switch the focusing pattern permanently to the center point and how to use your camera's custom functions to move the auto-focus from the shutter button to the auto-focus (AF) button (typically on the back of the camera, says AF-ON or AE-Lock [**Figure 6.10**]). Then, to focus on the eyes, you center the lens on the closest eye, press the AF button to focus, let go of the AF button to lock in the focus, recompose the frame, and shoot. This way, the focus stays locked in until the AF button is pushed again. The downside of this technique is that you have to remember to push the AF button every time you want to focus. Your camera will no longer focus when you push the shutter button down halfway. Like I said, this is a technique for advanced shooters—one that leads to great success with portraits.

FIGURE 6.10

OPEN LIGHT

The next step beyond just walking into a patch of great light is knowing how to look for an available light situation that is easy to work with. My hero shot (**Figure 6.11**) is an example of how I took advantage of a huge, open light source to illuminate my subject while he stood in front of a dark area into which the camera could not see. This is a simple recipe—frame your indirectly lit subject against a dark background— that is so easy to use when time is short, such as when you are traveling.

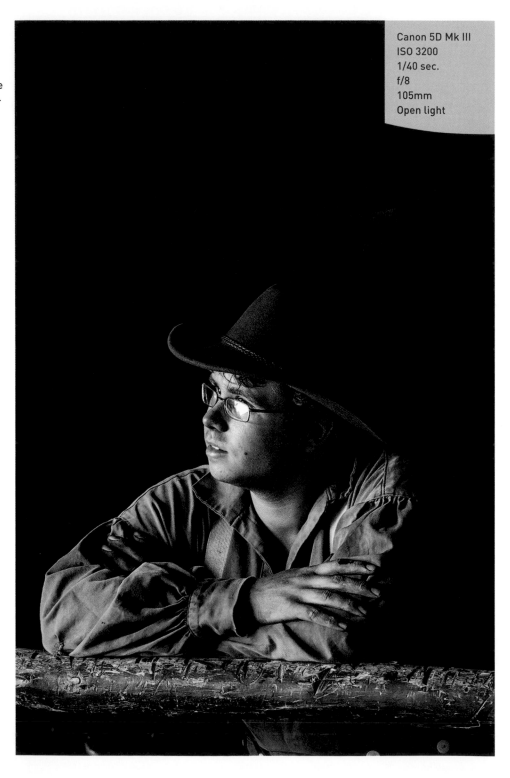

FIGURE 6.11
Framing your subject in front of a dark background is a quick way to make a great shot—especially when a large field of open light lights him softly.

Canon 5D Mk III
ISO 3200
1/40 sec.
f/8
105mm
Open light

FIGURE 6.12
My set for this
portrait was the
seating area for
a demonstration
forge at a living
history museum.

Take a look at the set shot in **Figure 6.12**. It's the seating area outside a demonstration forge at a living history museum. This is a great space for creating this type of available light portrait. The large opening on the left side of the ramada provided a huge field of open light—light that is coming indirectly from a wide range of angles through a large opening.

Open light describes the quality of the light and not the quantity of it. You will find open light just inside of doorways and under large overhangs. Often, though, the amount of open light is low—because it is coming indirectly. So, be prepared to use a high ISO and a slow shutter when shooting in open light.

By asking Jason, a young blacksmith, to stand at the front of the forge, he was lit handsomely by the open light from the left and framed against the shadows in his forge. Forges, as it turns out, are dark for a reason. Blacksmiths tell the temperature of their metal by its color. If the ambient light is too bright, they cannot see the color. Given that iron reaches 1000° before it begins to glow, being able to see that first bit of glow is important.

The opportunity provided by the open light source and the black background is what I mean by "knowing how to look for an available light situation that is easy to work with." The light is already there, but its beauty does not come out until it is contrasted against a dark background.

The key is to pull your subject away from the dark background so that he is lit by another light source—in this case, the open light bouncing in from the courtyard—while the background falls off to blackness. By having two light sources (the light on your subject and the dimmer light on the background), you are exposing for the highlights on your subject and letting the camera's limited dynamic range send the shadow details to black.

To make this work, you need to prevent the camera from peering too deeply into the shadows. The easiest way to do this is to back up and use a longer focal length. To make this shot, I took several steps backwards in the seating area and zoomed my lens to its maximum (105mm).

Figure 6.13 shows what happens when you push the camera in too close. If allowed, the camera will change its settings and make a shot with the little light that lurks in the shadows. In this case, I had my Canon 5D Mark III set to Auto ISO and it did not hesitate to run the ISO all the way up to 12,800.

While it is amazing to be able to shoot in extremely dim situations, the photo that resulted was nothing like the scene I saw in front of my lens. Our cameras have no idea what they are seeing. Rather, they just follow the programming in their chips. So, in this case, the camera automatically dialed in settings that collected too much light from the forge.

FIGURE 6.13
Pushing the camera inside the forge, where the light was very dim, caused the camera to use a slow shutter and a high auto ISO to capture a shot—which looks much brighter than the light I saw.

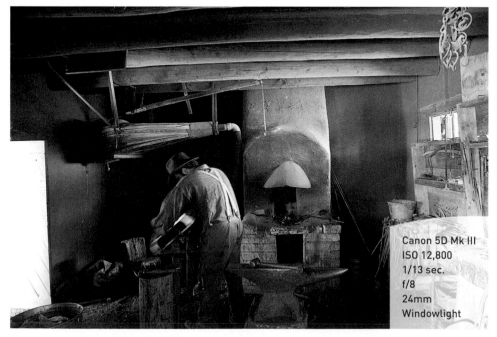

Canon 5D Mk III
ISO 12,800
1/13 sec.
f/8
24mm
Windowlight

Later in this chapter we will talk about "Finding Light in the Shadows." For now, just know that I had to dial in an Exposure Compensation setting of –2 stops to get an interior shot that resembled the light as I saw it when I stepped up to the edge of the forge (**Figure 6.14**). Again, forges are dim places for a reason, and this is an important aspect to communicate if you are making a photo of the forge itself. But, I've digressed away from the topic of open light portraits.

As you continue to shoot portraits, there will be a few instances where great light is already there (like the previous portrait of Donald) and many more instances (like this one) where you can make a great shot by taking advantage of open light and a dark background. But the reality is that the vast majority of your portraits will be improved by knowing how to add your own light and how to control the shadows. So let's continue on that path.

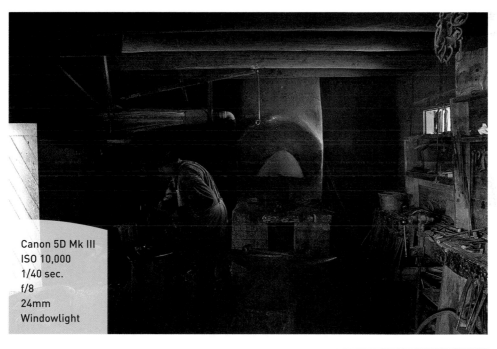

Canon 5D Mk III
ISO 10,000
1/40 sec.
f/8
24mm
Windowlight

FIGURE 6.14
I dialed in an adjustment of –2 stops of Exposure Compensation to get an image that more closely resembled the light as I saw it.

CAN'T MOVE THE SUBJECT? THEN MOVE YOUR CAMERA

For those times when you cannot move the subject in front of a dark background—such as when taking candid portraits without your subject's participation—move your camera (and yourself) to reframe the subject against a dark spot.

BIG EQUALS SOFT

Soft light is beautiful because the transition from highlight through midtones and into shadow is gradual rather than abrupt (**Figure 6.15**). Hard light, with its sudden transition between light and shadow, is not ugly—it's just different (**Figure 6.16**). Just like candy comes in sweet and sour flavors, both soft and hard light have their place.

Women and children typically look better when lit with soft light. Men, on the other hand, are often made more distinctive by the use of hard light, as the hard shadows define the weathering on their faces (which is exactly why hard light typically is not preferred by women). Of course, you can create striking portraits of women with hard light and of men with soft light—so you should explore all of your visual options.

"How do I create soft light?" is the question I am asked most often by novice photographers—especially those taking their first steps with flash. The mystery behind soft light is understandable since most of the time they are using relatively small hotshoe flashes bolted to the tops of their cameras. In previous chapters, we talked about a number of topics related to the creation of soft light. (See the sidebar for a listing of those topics.) In this section, we will explore the options to create soft light. Then, throughout the rest of the book, you will read about many shoots in which I create soft light with both Speedlites and strobes.

EARLIER REFERENCES TO SOFT LIGHT

- Diagrams of Diffused Light and Reflected Light—Chapter 1, Figures 1.5 and 1.6
- Diffusing Sunlight—Chapter 3
- Filling Shadows with Bounced Sunlight—Chapter 3
- Skylight/Open Shade, Deep Shade, Windowlight—Chapter 3
- How to Bounce Flash—Chapter 4

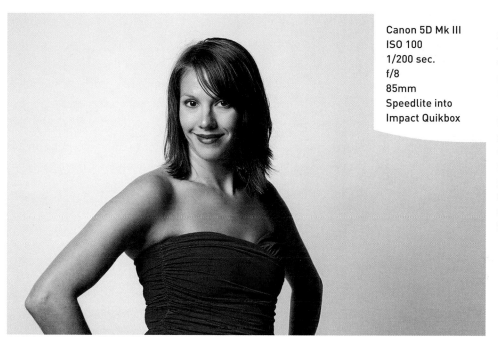

Canon 5D Mk III
ISO 100
1/200 sec.
f/8
85mm
Speedlite into
Impact Quikbox

FIGURE 6.15
Soft light happens when the size of the light source is larger than what it's lighting. Here, I fired the Speedlite into a large, white reflective umbrella to create soft light. Note how the light reached around Kea to create a nearly shadowless tone on the background.

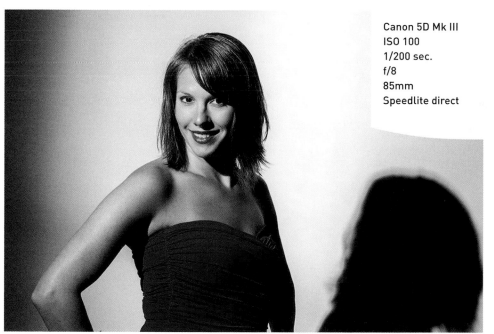

Canon 5D Mk III
ISO 100
1/200 sec.
f/8
85mm
Speedlite direct

FIGURE 6.16
Hard light happens when the size of the light source is smaller than what it's lighting. Here, I fired a Speedlite directly at the model to create hard light. Note the distinctive shadows on the background.

HOW BIG IS BIG?

The quick answer to "how to make soft light" is to use a bigger light. Sometimes we can actually use a bigger light—for instance, think of exchanging a single CFL for a panel of long fluorescent tubes. At other times, we have to modify our light so that it appears bigger. For instance, firing a Speedlite through a translucent "shoot-through" umbrella is one way to make it appear bigger (**Figure 6.17**).

There is no specific size that makes a light soft. Since soft light happens when the light source is larger that what it's lighting, Einstein would have said, "The size of a soft light is relative to the size of the subject." For example, it takes a much smaller light source to create soft light on a golf ball than it does to create soft light on an elephant.

There are two basic approaches to making a light appear bigger—you can bounce it off of something or you can shine it through a translucent fabric. Let's use these two criteria as a way to survey the main types of modifiers used to create soft light.

FIGURE 6.17
A shoot-through umbrella sits between the flash and the subject.

GEAR: UMBRELLAS

An umbrella is a good modifier for taking your first steps with soft light. They resemble their weather-repelling kin, except that they do not have handles on the shafts (which facilitates their attachment to swivel adapters on lightstands, as shown back in Chapter 4, Figure 4.17). Know that either you will eventually outgrow it or it will break. Umbrellas are just that way. In either instance, it's okay as they are among the least expensive of modifiers.

Depending upon the fabric, an umbrella can be either translucent or reflective. The term "shoot-through" is used for an umbrella made of diffusion fabric (Figure 6.17). The term refers to what happens to the light and does not describe where you put the camera. Reflective umbrellas (**Figure 6.18**) come in the standard white, silver, and gold variations. (See the appendix for my specific umbrella recommendations.)

FIGURE 6.18
The flash sits between the subject and a reflective umbrella.

GEAR: SOFTBOXES

When you become hooked on soft light, you will eventually migrate to using a softbox—which is exactly as it sounds, a collapsible box that has a diffusion panel on one side.

The advantage of softboxes is that they are more durable than umbrellas and, more importantly, that they provide more control. With a softbox you can keep the light from flying all over because the light does not fly sideways as it does with an umbrella. See the "Feathering" sidebar later in this chapter for more insights about this.

If the flash mounts to the back of the box and fires forward (like the Impact Quikbox or the Lastolite Ezybox), the box will have two layers of diffusion fabric. If the flash mounts on the inside (like the Westcott Apollo shown in **Figure 6.19**), then you face it backwards and fire it into the reflective silver fabric.

Softboxes come in a range of shapes—from square, to wide rectangle, to strips, to octagons, and so on. They also come in a range of sizes—from the very handy 8" Lastolite Ezybox Speed-lite that straps onto the head of your flash all the way up to elephant-sized boxes that will accommodate multiple strobes. (See the appendix for my specific softbox recommendations.)

FIGURE 6.19
Reflector disks and softboxes are both modifiers that increase the apparent size of the light source—making it appear softer. Shown here: a 5-in-1 reflector disk and a Westcott 28" Apollo softbox.

GEAR: DISKS AND PANELS

Bouncing light off a flat surface is one way to make it appear bigger and, hence, softer. As you know, we have already looked at many ways to do this. For instance, in Figure 3.14, we looked at how to fill shadows by bouncing sunlight with the white fabric of a Scrim Jim. Rather than bounce sunlight, you can do the same thing with a light (continuous or flash).

If you have a 5-in-1 reflector set (Figure 3.15), you can create soft light by firing your flash into the white, silver, or gold fabric and bouncing that light onto your subject. The choice of fabric will affect the color of the light and how much you get back. White and silver keep the light neutral. Gold warms it up. White bounces softer light back. Silver and gold sent the light back with a bit of snap.

Sending hard light through the diffusion fabric of a disk or panel is another way to create soft light. In Figure 3.11, I used a diffuser panel over the head of my model to soften the sunlight a bit. You can do the same thing with a light (again both continuous and flash). So, if you have the 5-in-1 reflector set, pull the fabric cover off and fire your flash right through the diffusion panel, as I did in Figure 5.24.

If you are going to shoot soft light on a regular basis, it is more convenient to have an umbrella or softbox. For occasional soft light, a 5-in-1 reflector is fine—but you will need an assistant or a lightstand with an arm to hold it in place. (See the appendix for my specific disk and panel recommendations.)

White sheets of foam core are also handy as large bounce panels. You will recall that we built a house of them in the previous chapter (Figure 5.18). You will see in a number of shoots that follow how I used foam core to bounce light into the shadows.

DECIDING BETWEEN REFLECTION AND DIFFUSION

So how do I decide between reflection and diffusion? If I want to throw light some distance, such as when I'm lighting a group, then I will use a reflective modifier (specifically a big, silver umbrella in the case of lighting a group). If I am working in tight, such as when I'm shooting a headshot, then I prefer the softer nature of diffusion fabric. Generally, I have both options in my kit.

GEAR: STRAP-ON, SPEEDLITE-SIZED MODIFIERS

There is a wide range of soft light modifiers designed to strap onto a small flash. I think that many of them, such as the plastic bowl-sized contraptions that send light in 360°, are gimmicks—usually because they throw light everywhere, which is not a good thing if you are outdoors and there is nothing for the light to bounce back from. That said, there are a couple of modifiers that I find to be indispensable. I've mentioned both before, but they deserve to be listed here as well.

The first is the Rogue FlashBender Large—which measures 10 x 11" (**Figure 6.20**). I have several in my Speedlite kit. With its trio of bendable rods, the FlashBender can be shaped many ways. I use it angled as a bounce card, rolled as a snoot, and flat as a flag (black side to the light!). Rogue makes smaller sizes too. I have not found them to be as versatile. So, stick with the Large.

The Lastolite Ezybox Speed-lite (**Figure 6.21**) is an 8" softbox that straps to the head of your flash. It creates beautiful light for headshots, folds flat in an instant, and travels well. When paired with a 3' coiled ETTL/ITTL cord, this Ezybox creates great off-camera light when held out at arm's length—very handy in crowded spaces.

FIGURE 6.20
The Rogue FlashBender Large is a versatile modifier for small flash. Here it is strapped on to create a reflective bounce card. It can also be used as a flag and as a snoot—both of which block stray light.

FIGURE 6.21
The Lastolite Ezybox Speed-lite is an 8" softbox that straps directly to a small flash. It creates beautiful soft light and folds flat for travel.

DISTANCE REDUCES APPARENT SIZE

Keep in mind that the farther away an object is from you, the smaller it appears. The same is true for modifiers. The closer it is to the subject, the larger it appears. The farther away it is, the smaller it appears. If you want the softest light possible, push your modifier into the camera's field of vision, and then pull it away so that it is just outside the frame. The reason that you first push it into the frame is so that you know you have it just outside the frame when you pull it out.

In the shots here (**Figures 6.22** and **6.23**), look at how the nose shadow changes as I move the umbrella away from my model. When it is just outside the camera's view—four feet from Sandra—the light comes from a wide range of angles, and the shadows are soft (Figure 6.22). When the umbrella is pulled back to 16 feet away, the apparent size of the modifier gets much smaller and the edge of the shadows becomes harder (Figure 6.23).

The key thing to remember here is that for the softest light, you have to push your modifiers in as close as you can. You won't know that they are in close enough until you see that they are in too close. So push your modifier in until you can just see it in the corner of the viewfinder and then move it back a bit.

Canon 5D Mk II
ISO 400
1/60 sec.
f/7.1
100mm
Speedlite into white
reflective umbrella

Canon 5D Mk II
ISO 400
1/60 sec.
f/7.1
100mm
Speedlite into white
reflective umbrella

FIGURE 6.22
(left) This was shot with a reflective umbrella 4' away from the model.

FIGURE 6.23
(right) This was shot with the umbrella 16' away (and the power on the flash dialed up accordingly).

FEATHERING

Feel free to spin your modifiers so that they do not point directly at your subject. This is called *feathering*. Let's say that you are using a reflective umbrella and want to keep the light off of the background. You can feather your light forward by twisting the lightstand so that the center of the umbrella aims in front of your subject. (With umbrellas, you can actually use the shaft as a way to see where the light is pointing.) Much of the light will fly past your subject, but the light landing on your subject will still be soft. In addition to feathering to keep the background dark, you could also feather a light away from your subject so that you could catch the light flying by and bounce it off of a reflector into the shadows—as I did in Figure 6.19.

TEST YOUR MODIFIERS

Every modifier has a distinct look with regard to how it spreads and transitions from light to dark. The easiest way to get to see these unique patterns is to photograph them. It's actually quite easy if you have a way to fire an off-camera flash.

Find a large white wall that you can access at night. The larger the better—about 10' x 10' would be the minimum. Then lock your camera onto a tripod and position it about 15' from the wall. Set up a lightstand so that your flash is centered in your viewfinder. The reason for the tripod and lightstand is so that you will have consistency from frame to frame.

Set your flash to Manual mode and adjust the power so that you can see a bit of detail in the wall at the center of the

FIGURE 6.24

frame (**Figure 6.24**). As you change modifiers, you will have to adjust the power. Generally, the wider the spread of the modifier, the higher the power will have to be to keep the center illuminated at the same level.

All of this information—how the light spreads, how it transitions to darkness, and how much power is consumed by a specific modifier—will help you understand what your gear does and does not do. This in turn will help you be more informed when you make creative decisions.

SHUTTER AND FLASH SYNERGY

When you are confronted with the challenge of making a portrait in a setting that offers an unflattering background, think about creating a synergy between your camera's shutter and flash. Specifically, take advantage of the fact that a faster shutter speed will dim the ambient light: the faster the shutter, the more the background dims. Then use your flash to add light back onto your subject. As you can see in **Figure 6.25**, the combination can be quite lovely.

Canon 5D Mk II
ISO 400
1/160 sec.
f/5.6
100mm
Canon 600EX-RT
Speedlite through
Impact 24" Quikbox

FIGURE 6.25
To minimize the dull background (grass, bare soil, and a wood fence), I increased my shutter speed to significantly underexpose the late afternoon sun and then lit my model with a 24" softbox.

GETTING CREATIVE WITH AMBIENT LIGHT

Since I seldom shoot documentary photographs, I typically have little interest in making images that represent the world as it appears in front of my lens. Rather, I'm often interested in portraying the ambient light in a manner that communicates the subject's environment without overpowering the subject.

If the ambient light is bright, I will often use a fast shutter speed to dim the ambient slightly or a lot. In either case, I know that I will have to add light to my subject. The question of how much I dim the ambient is largely a matter of what is in the background. If it's a mess and I want to make it go away, then I can make it go away with a three-stop underexposure via the shutter speed. If I just want to reduce its brightness a bit so that the viewer concentrates on the subject, I might underexpose it by just a stop. See the sidebar a little later in this chapter for the details about how shutter speed does and does not affect flash.

If the ambient light is dim, I can use a slow shutter speed so that the camera records more of the ambient light and the image appears brighter than the scene in front of me. This is especially useful on cloudy days. As to whether I do anything about the light on my subject depends upon the specifics at the moment. If the subject blends in with the background, then a slice of rim light coming from a flash placed behind the subject might help. If the subject appears too bright and there is a nearby wall that's acting as a giant fill card, then I might use something to block the light bouncing off that wall.

The common link between all of these situations is that I focus upon how the camera records the ambient light first—using my exposure settings as needed—and then I do something about the light on my subject.

Let's start at the beginning—with the late afternoon sun setting behind my model. As you can see in **Figure 6.26**, the sun has blown out the highlights in her hair, yet both the background and her face lack any punch as everything appears equally lit in the flat light. Also note that the background consists of grass, bare soil, and a wood fence. This is one dull photo.

In terms of my lighting setup, it's the part of this shoot that changed the least. I had a single Speedlite, Canon's 600EX-RT, firing through an Impact 24" Quikbox on a lightstand just outside of the camera's view on the right. In terms of height, the softbox was centered slightly below the model's head (so that it would cover her torso and head). The box was angled in at about 45°. There was no need to feather the box as there was nothing in the background that I wanted to keep the light off of—the fence was too far away, so the extra light just flew away. I operated my flash in ETTL with high-speed sync activated so that the flash power would adjust automatically as I increased my shutter speed beyond the camera's sync speed.

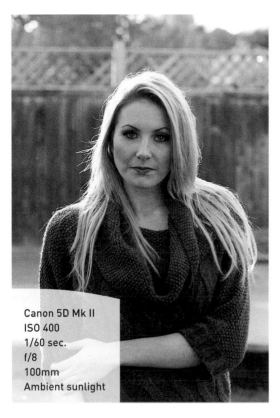

FIGURE 6.26
This is the natural light shot—late afternoon sun that blows out the highlights in the model's hair while everything else flattens out in the shade.

Canon 5D Mk II
ISO 400
1/60 sec.
f/8
100mm
Ambient sunlight

When it comes to creative lighting, you should feel free to use your camera's settings to change the way that it records the light in front of you. As you will soon see, the shutter can be a powerful tool to reshape the ambient light. In this case, we're going to dim it so that the background disappears. So, two questions come to mind—how to change the shutter speed and by how much?

The way that you adjust your shutter speed depends upon the mode of your camera. Here's a quick rundown.

CAMERA MODE	YOU SET	CAMERA SETS	CHANGE SHUTTER BY
Program = P	ISO	Aperture and Shutter	Exposure Compensation dial on camera—the change is split between both shutter and aperture
Aperture Priority (Canon = Av, Nikon = A)	ISO and Aperture	Shutter	Exposure Compensation dial on camera
Manual = M	ISO, Aperture, and Shutter	Nothing	Dialing shutter speed directly

WHY SHUTTER DIMS AMBIENT BUT NOT FLASH

For shutter speeds up to your camera's sync speed, dialing in faster shutter speeds dims the ambient light but not the flash because the duration of the flash is so much faster than the shutter speed. For most flashes, the longest flash duration is 1/800" second. So, it does not matter if your shutter is 1/60", 1/125", or 1/250"—the burst of flash will fit into any of those gaps. Switching the shutter from 1/60" to 1/250" takes out two stops of ambient light. As you can see here (**Figure 6.27**), there is plenty of time for the flash to fire, even at 1/250".

Using flash at speeds faster than your camera's sync speed requires the use of a dedicated flash that offers high-speed sync (HSS). In HSS, the camera changes the way your flash fires. Rather than put out one pop of light, it fires an ultra-fast series of flash pulses that turns the flash into a continuous light source for a brief period of time. So, in HSS, the flash is slightly longer than the duration of the shutter speed. This is why we can literally turn noon to night with a fast shutter and HSS.

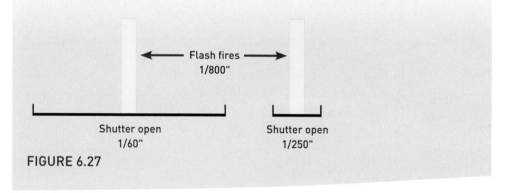

FIGURE 6.27

Now the other question remains: how much of a reduction is needed? The definitive answer is, "It depends." The proper amount of ambient reduction depends upon your photographic vision—which varies shoot by shoot and photographer by photographer. For some shoots, a one-stop reduction is sufficient. For other shoots, the reduction might be three or more stops. The common thread is that you just have to start shooting and see what happens. So, let's take a look at three one-stop reductions in ambient (**Figures 6.28–6.31**). Again, our starting point is Figure. 6.26.

So which shot do you like best? For me, the winner is the three-stop reduction shown in Figure 6.30. The fast shutter did a great job of minimizing the background while the flash and 24" softbox created beautiful light that added depth to my model's face.

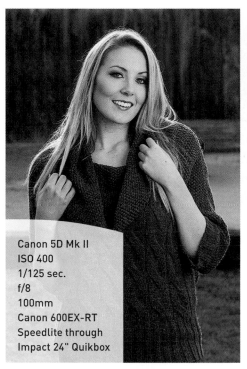

Canon 5D Mk II
ISO 400
1/125 sec.
f/8
100mm
Canon 600EX-RT
Speedlite through
Impact 24" Quikbox

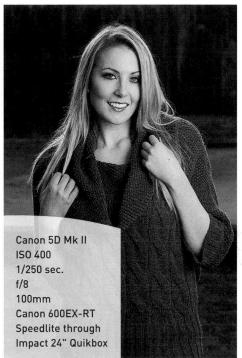

Canon 5D Mk II
ISO 400
1/250 sec.
f/8
100mm
Canon 600EX-RT
Speedlite through
Impact 24" Quikbox

FIGURE 6.28
(left) Increasing the shutter speed from 1/60" to 1/125" is a one-stop reduction in the ambient light. I am now lighting the model with an off-camera flash that is firing through a 24" softbox.

FIGURE 6.29
(right) Changing the shutter speed to 1/250" takes out another stop of ambient light. Since the sync speed for my camera is 1/200", I also had to activate high-speed sync on the flash.

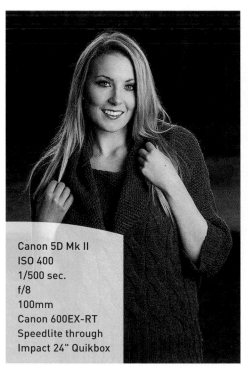

Canon 5D Mk II
ISO 400
1/500 sec.
f/8
100mm
Canon 600EX-RT
Speedlite through
Impact 24" Quikbox

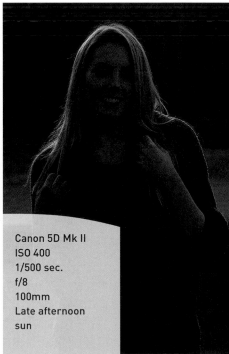

Canon 5D Mk II
ISO 400
1/500 sec.
f/8
100mm
Late afternoon
sun

FIGURE 6.30
(left) Changing the shutter speed to 1/500" takes out another stop of ambient light—for a total of three stops. This is the shot that I like best.

FIGURE 6.31
(right) For comparison, I turned my flash off and took another ambient-only shot. The difference between this frame and Figure 6.30 is all flash.

TIPS FOR USING FLASH WITH DIMMED AMBIENT

- **Use a dedicated flash**: As you will read below, it is a great help to have an automatic flash running in high-speed sync when you are aggressively dimming the ambient with your shutter. Generic flashes generally do not offer full compatibility with the advanced flash features of digital cameras.

- **Activate high-speed sync**: As you saw above, I quickly moved my shutter past my camera's sync speed. Activating HSS meant that I could change my shutter speed as needed and the flash would follow. Below the sync speed, the flash fired in normal mode. Above the sync speed, it fired in HSS.

- **Run your flash in ETTL/ITTL**: Even though the distance between the model and the light remained constant, using an automatic flash mode automatically increased the flash power when the shutter speed crossed into high-speed sync territory. If you shoot the flash in Manual mode, then you will have to continuously make changes to the flash power as the shutter speed changes in HSS.

- **Push your light(s) in close or use multiple lights**: when your flash fires in HSS, it consumes much more power to create the ultra-fast series of pulses. So, in HSS the maximum power of your flash will be reduced by about 2.5 stops—the price we pay for the ability to shoot at higher shutter speeds. If you have only a single flash, then you will need to push it in as close as you can. If you have additional lights and your modifier is large enough, you can use several flashes together to make up for the light loss of HSS.

- **Know if/how Exposure Compensation and Flash Exposure Compensation are linked on your camera**: Break out your user manual and study the details. This is important info to know. On Canon cameras, EC and FEC work independently. So you can use EC to dial the ambient up/down and separately use FEC to dial ETTL flash power up/down. On most Nikon cameras, a change to EC will also apply to any FEC setting. The one exception is Nikon's flagship D4 camera, which has the ability to separate EC and FEC in the manner that Canon does.

FINDING LIGHT IN THE SHADOWS

Several times already, we have talked about how the dynamic range of your camera is more limited than your vision—about how your camera cannot record details in the shadows when the ambient light is very bright. Well, the same is true when the ambient light is very dim. When you expose for your subject, even with flash, there is often not enough light to provide any clues about what is in the background.

Take a look at **Figure 6.32**—a senior portrait I shot of my son Vin in the tunnel where the San Luis Creek flows underneath the plaza in downtown San Luis Obispo. This serpentine tunnel is long enough that it takes several minutes for your eyes to adjust after walking in. At times, I've seen bats flying during the day while shooting there.

FIGURE 6.32

Even though Vin is lit almost entirely by flash, the soft quality of the light from the Apollo Orb softbox blends nicely with the dim light in the background. A long shutter speed is what allows us to see into the shadows.

Canon 5D Mk III
ISO 800
1/2 sec.
f/8
45mm
Deep shade and Speedlite into Apollo Orb softbox

For this shot, I placed an Apollo Orb softbox just outside of the frame on the left. This provided a handsome field of light on Vin. However, the background behind him was completely black at "normal" shutter speeds—meaning speeds that can be handheld, typically 1/60" for most people and as slow as 1/15" for shooters with very steady hands and image-stabilized lenses. In order to get this shot, I had to lock my camera down on a tripod and use a very long shutter speed—in this case 1/2"—in order to collect enough light from the dark areas of the background. My goal with the shutter is not to make the background as bright as my subject. Rather, I am just trying to reveal something of the light and shapes in the space behind Vin.

This phenomenon of the black background is one that is often seen with snapshots (**Figure 6.33**). Point-and-shoot cameras are programmed to make "good" pictures. So, the camera will prioritize getting to a shutter speed that can be handheld over using a shutter speed that will draw enough light from the background. In Figure 6.33, the background is black because 1/60" is just not long enough to collect any light from the dim background. In order to get the shot with some hint of the background (**Figure 6.34**), I had to override the camera settings to allow for a long exposure (see the sidebar below). By the way, can you calculate the difference in stops between 1/60" and 1/2"? It's a change of five stops: 1/60" > 1/30" > 1/15" > 1/8" > 1/4" > 1/2".

FIGURE 6.33
When the shutter speed is set to a "safe" speed that can be handheld (1/60"), the background is lost to black.

Canon 5D Mk III
ISO 400
1/60 sec.
f/4
40mm
Deep shade and Speedlite into Apollo softbox

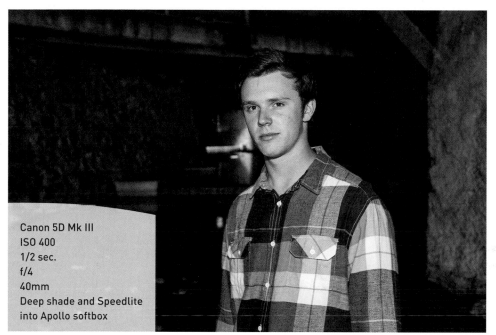

FIGURE 6.34
To bring out the detail in the shadows, I switched my shutter speed to 1/2", which meant that I also had to lock my camera onto a tripod. The difference between 1/60" and 1/2" is five stops.

Canon 5D Mk III
ISO 400
1/2 sec.
f/4
40mm
Deep shade and Speedlite into Apollo softbox

If you do not have a tripod, there are other options. If you have a lightstand and a swivel adapter, you can thread your camera onto the 1/4"-20 threads of the spigot. A lightstand is not as sturdy as a tripod, for sure, but it is better than not getting a shot at all. If you do not have a stand, look for a nearby surface on which to rest your camera. Then switch your camera into its self-timer mode. This will give the camera 2–10 seconds to stop vibrating after you press the shutter button.

FLASH SYNC SPEED IN APERTURE PRIORITY MODE

If you find that your flash photos continually have black backgrounds, the reason could be that your camera is set to limit the shutter speed with flash to a range of 1/60" or faster. Check your camera's user manual for something along the lines of "Flash sync speed in Av/A mode" (**Figure 6.35**). This is a custom function that can be changed to allow for longer shutter speeds outside the range that can normally be handheld. Keep in mind however, that if you use long shutter speeds, then you might also have to use a tripod.

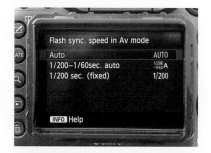

FIGURE 6.35

DANCING WITH THE SUN

Many photographers avoid shooting portraits outdoors in full sun. I encourage you to not be among them. The key is to think of the sun as a light source and to assign it a task—key light, fill light, rim light, etc. Once you compartmentalize the sun's role into one category, you can easily sort out what other types of light you need to add to the shot.

Since you cannot move the sun on command, you will want to think about where you position your subject and the camera in relation to the fiery orb. If the sun is behind your subject, then it will be a hair/rim light. If the sun is lighting the front of your subject, then it can be the key or fill light. The sun can also be the background light—which can be helpful or create challenges. We'll talk about sunlight on the background at the end of this section.

SUN AND BOUNCE PANEL AND FLASH

Compare **Figures 6.36** and **6.37**. In each, Ariana was in roughly the same spot. The dramatic difference between the two shots is that I added fill flash and bounced sunlight in for Figure 6.36. Whereas, in Figure 6.37, I was shooting "natural light only."

Figure 6.37 is the test shot that I describe in Step 3 of my Lighting and Exposure Workflow at the beginning of the chapter. While this is a "nice" natural light portrait, I think that Ariana's eyes and skin would benefit from more light and a bit of shadow. So, I started as I often do, by dimming the ambient light. In this case, since I could use a bit more depth of field, I changed the aperture by two stops from f/2.8 > f/4 > f/5.6 to get **Figure 6.38**.

I then turned on my flash, a Canon Speedlite, and fiddled with the power through a few test shots. Eventually, I ended up with the light in **Figure 6.39** with my Speedlite serving as the key light. Again, you have to be very careful with nose shadows on women—especially when shooting hard light. So, my solution was to add fill light from the sun (**Figure 6.40**). My friend, Hicks, on the left, used a California Sunbounce (a pro reflector system) to capture a bit of sunlight and bounce it into the shadow to get the hero shot shown in Figure 6.36.

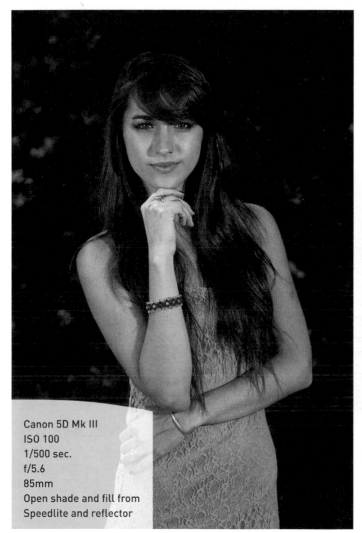

Canon 5D Mk III
ISO 100
1/500 sec.
f/5.6
85mm
Open shade and fill from
Speedlite and reflector

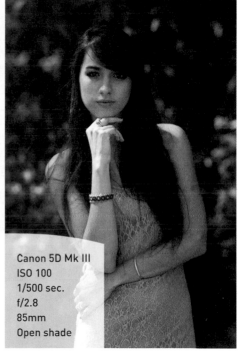

Canon 5D Mk III
ISO 100
1/500 sec.
f/2.8
85mm
Open shade

FIGURE 6.36
This daytime shot combines underexposed background light, flash from a Speedlite, and sunlight bounced in on the left from a gold-silver reflector.

FIGURE 6.37
Here is the shot that my camera is programmed to make—good but not great. Ariana is lit by open shade with a bit of direct sunlight crossing her shoulder and hands.

FIGURE 6.38
(left) As I was working with only one flash and a reflector, I underexposed the ambient light by two stops. This makes it easier for me to add light back to Ariana.

FIGURE 6.39
(right) Turning my Speedlite on provided the key (main) light. The shadows on the left are too dark and, hence, unflattering. Fill light is needed.

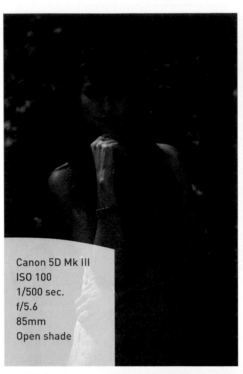

Canon 5D Mk III
ISO 100
1/500 sec.
f/5.6
85mm
Open shade

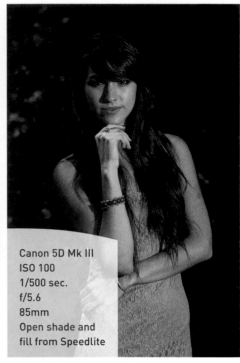

Canon 5D Mk III
ISO 100
1/500 sec.
f/5.6
85mm
Open shade and
fill from Speedlite

FIGURE 6.40
A white California Sunbounce panel was used to capture sunlight and bounce it in as fill from the left. At the upper right corner of this set shot, you can see the position of the Speedlite.

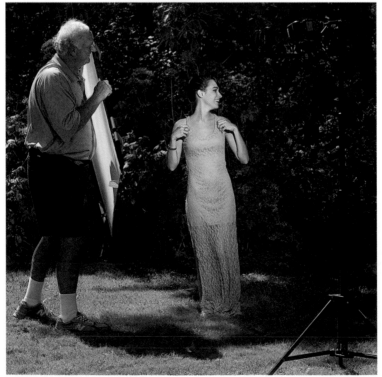

NO FLASH—SUN AND BOUNCE PANEL ONLY

When you do not have or do not want to use flash, it is still easy to create a beautiful shot in sunlight, as shown in **Figure 6.41**. The main difference between this shot and the previous hero shot (Figure 6.36) is that I asked Ariana to step forward from the open shade into the direct sun.

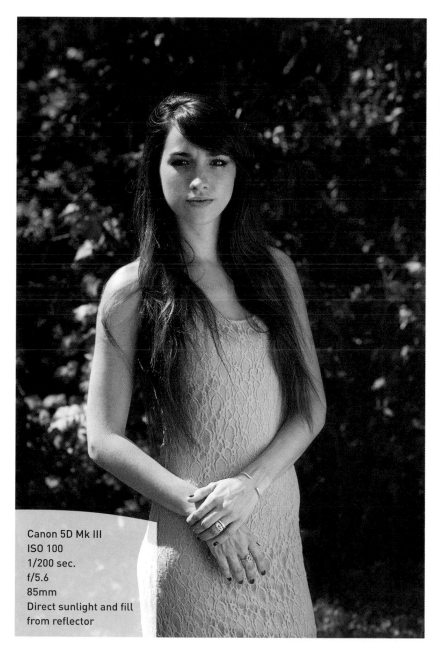

Canon 5D Mk III
ISO 100
1/200 sec.
f/5.6
85mm
Direct sunlight and fill
from reflector

FIGURE 6.41
The sun provides all of the light in this shot. It comes directly from behind Ariana to create the hair and rim light. A white California Sunbounce panel bounced sunlight back in as fill from the right.

I often try to put the sun behind my subject—but not straight behind. An angle of 135° or so is helpful. (Review the Lighting Compass in Figure 1.1 for a refresher, if needed.) When the sun is behind my subject, it becomes a hair and rim light (**Figure 6.42**).

The key to making this rim light work is to not overexpose the frame, which your camera may try to do if it is metering mostly in the shadows. You want to be able to see details in the hair highlights, skin tones, and fabric. If there are no details in the important highlights, then you need to dial the exposure down—preferably via the shutter and/or ISO. If you dial the exposure down via the aperture, then you will be increasing depth of field, which may allow the background to compete visually with the subject.

Once you have your exposure set so that the rim light is managed, then you need to explore your options for creating fill light—either by bouncing light in with a reflector or by adding fill light from an off-camera flash. The advantage of the reflector panel is that you can see the effect of the light without taking a shot. The advantage of the flash is that it will not cause your subject to squint.

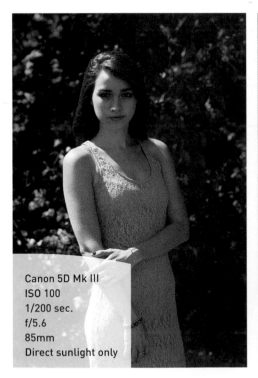

Canon 5D Mk III
ISO 100
1/200 sec.
f/5.6
85mm
Direct sunlight only

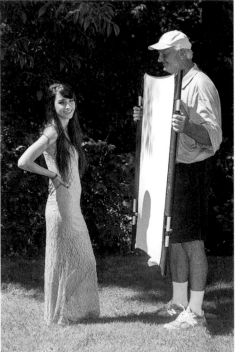

FIGURE 6.42
With the sun behind Ariana, it creates lovely hair and rim light. However, without a source of fill light, her face is too dark.

FIGURE 6.43
The California Sunbounce panel was positioned opposite the sun and slightly to the side so that it would catch the sunlight flying past Ariana and bounce it back as fill light.

The hero shot above of Ariana, Figure 6.41, was made by using the white side of a California Sunbounce panel (**Figure 6.43**). (If you have the 5-in-1 disk set, then use the white cover. A piece of white foam core will also work.) When using a bounce panel, I like to reflect the light onto the ground in front of me and watch the fill light move as I angle the panel as needed to place the light where I want it. Note how close the panel is to Ariana—literally right at the edge of my camera's vision.

WATCH THE BRIGHTNESS OF THE BACKGROUND

When dancing with the sun, another consideration is the brightness of your subject compared to the brightness of the background. If the background is lit by full sun, then it may be too bright. Take a look at **Figures 6.44** and **6.45**. In Figure 6.44, Ariana is standing in front of sunlit foliage. See how the background competes? Now look at Figure 6.45 and compare the effect of the dark background. The main difference between the shots was my awareness of the situation. I simply asked Ariana to move a few feet to her right and then reframed the camera to look into the shaded foliage.

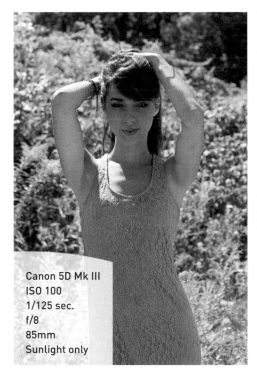

Canon 5D Mk III
ISO 100
1/125 sec.
f/8
85mm
Sunlight only

FIGURE 6.44
By framing Ariana against a bright background, she is lost against all of the distractions.

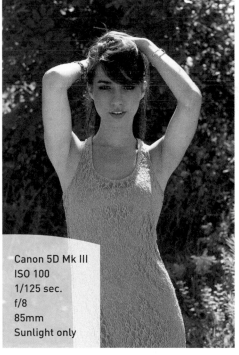

Canon 5D Mk III
ISO 100
1/125 sec.
f/8
85mm
Sunlight only

FIGURE 6.45
By moving Ariana just a few steps away, I am able to frame her against a shaded patch of foliage. Now she stands out clearly in the shot.

ACCURACY MATTERS

The power of the light in the paintings of the Dutch masters (such as Rembrandt and Vermeer) is that your eyes are guided to the faces of their subjects through the artful balancing of light and shadow. Likewise, they revealed the drape and texture of the clothing through the shadowing of the fabric. Inspired by the Dutch masters, I used a single flash to create this portrait of Peter (**Figure 6.47**), a veteran actor. The most important element was to limit the amount of light falling on the background.

LIGHTING FOR LOW KEY PORTRAITS

The term *low key* refers to images where the majority of tones are dark. The opposite of low key is *high key*—where the majority of the tones are light. Both low and high key images benefit from having a full range of tones—meaning that true blacks and true whites appear in the image. Without a full range of tones, an image appears flat.

In this portrait, the lightest tones are restricted to the face—ranging from the specular highlight in the eyeglasses to the skin tones of the forehead and cheeks. As for the darks, well, this is where a delicate balance must be achieved between the tone of the background and the tone of the turtleneck. For my shot, I wanted the blacks to be in the shirt; which meant that the background would have to be charcoal grey rather than pure black.

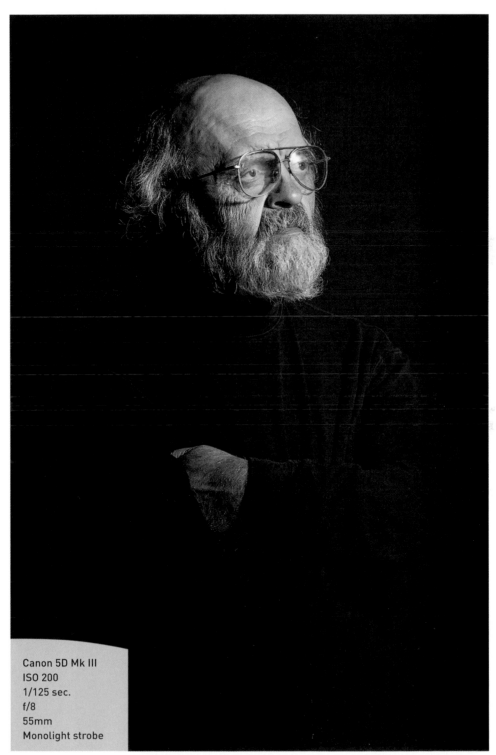

FIGURE 6.47
The handsomeness
of this shot comes
from the lighting,
which encourages
you to study the
character of Peter's
face. There is just
enough difference
between the dark
tones of the shirt
and that of the
background that
they do not merge.

Canon 5D Mk III
ISO 200
1/125 sec.
f/8
55mm
Monolight strobe

The trick to lighting a low key portrait is that you have to light the most important part of the frame (the face) properly. If you have only one light, then that light must also be adjusted to light the background. To create the set for this shoot, I hung a large sheet of black paper (called *seamless*) behind my subject. So, the challenge was to allow the right amount of light to spill onto the backdrop. This situation reminds me of Goldilocks—not too much and not too little. In **Figures 6.48** and **6.49**, you can see the effect of too much light spilling onto the background.

FIGURE 6.48
When light spills onto the background, it becomes lighter. In this shot, I think the background is too light for the desired look of the portrait.

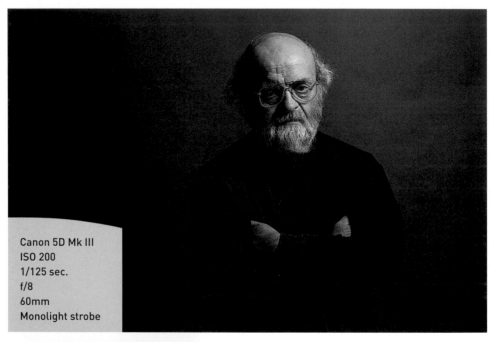

Canon 5D Mk III
ISO 200
1/125 sec.
f/8
60mm
Monolight strobe

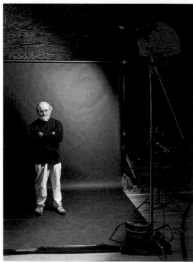

FIGURE 6.49
The large reflector on the strobe (upper right corner) is the reason that so much light spilled onto the background.

Now that we've seen what too much background light looks like, let's consider what happens when there is too little background light. As you can see in **Figure 6.50**, Peter quite nearly merges into the background. Yes, we can see some detail in his shirt, but the shadows on his head are essentially the same value as the background. The danger here is that Peter's head will float unnaturally in the frame.

Regardless of the light source that you use—continuous or flash, large or small—the key to lighting a low key portrait is to manage the light on the background. (See **Figure 6.51** for the final set shot of the hero image shown in Figure 6.47.) So let's explore options for limiting where our light flies. If you are shooting small flash, there are four principle ways that you can limit the spread of light: zoom, flag, grid, and snoot.

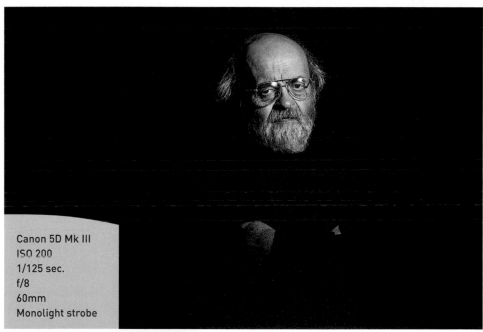

Canon 5D Mk III
ISO 200
1/125 sec.
f/8
60mm
Monolight strobe

FIGURE 6.50
In this shot, there is no light on the background. As a result, I think that the details of the shirt merge too deeply into the background.

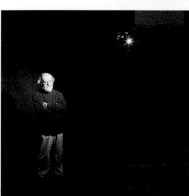

FIGURE 6.51
By changing the reflector on the strobe to a smaller size, I focused the light on the subject. Then I was able to turn the stand slightly to get the edge of the light onto the background, which was just enough for the hero shot in Figure 6.47.

GEAR: ZOOM/REFLECTOR SIZE AND POSITION

If your flash has a zoom button, explore how the light changes as you manually zoom the light to various settings. As discussed in the "Test Your Modifiers" sidebar earlier in this chapter, a convenient way to see this is to park your flash on a light stand and your camera on a tripod. Then photograph the flash as it fires against a wall at various zoom settings (**Figure 6.52**). Larger strobes do not have a zoom button, but they often have several reflectors available—wide-angle, normal, and long-throw are typical options.

FIGURE 6.52
Use the zoom button on your flash to tighten the pattern of the light. Top row, left to right: 20mm, 35mm, 50mm. Bottom row, left to right: 80mm, 105mm, 200mm.

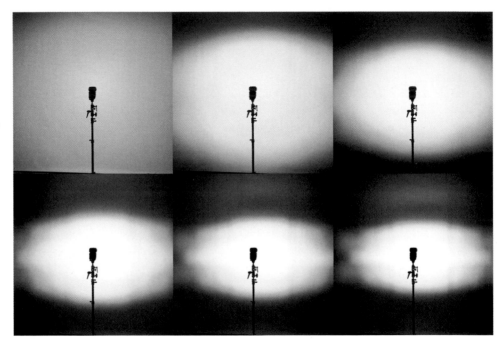

GEAR: FLAGS

A flag is any flat surface used to block light on one side of the source. You can tape a piece of cardboard to your flash as a flag or, as shown in **Figure 6.53**, you can strap on Rogue's large FlashBender (keeping the black side towards the light). In a pinch, you can also ask someone to hold their hand against the flash head for a couple of shots.

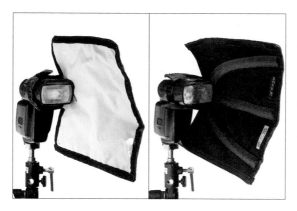

FIGURE 6.53
I find the Rogue FlashBender to be a versatile tool for small flash. Left: When mounted with the white side towards the flash, light will bounce sideways and may reflect back into your shot. Right: When I need a flag, I prefer to mount the FlashBender so that the black side faces the flash.

GEAR: GRIDS

Grids are my favorite way to limit the spread of light coming from my flash. In particular, a honeycomb grid changes the light from a rectangular pattern into a circular pattern. I prefer grids that are held out in front of the flash head, such as the Strobros system (shown in Chapter 5, Figure 5.8). The Strobros system has three grids with cell diameters of roughly 1/16", 1/8" and 1/4", and each has a unique look (**Figure 6.54**).

FIGURE 6.54
The Strobros grid system is designed to work with their mini beauty dish. While I have no interest in a Barbie-sized beauty dish, it does make a great holder for the Strobros grids. So, I remove the center reflective panel and throw it away. Top left: The Strobros Mini-Beauty Dish without a grid. Top right: with the 1/4" grid. Bottom left: with the 1/8" grid. Bottom right: with the 1/16" grid.

GEAR: SNOOTS

When you are looking to create a tiny circle of light, reach for a metal snoot, like the Strobros. As I show in Chapter 5 (Figure 5.8), the Rogue FlashBender can be rolled into a snoot—although the pattern is not as tight as the Strobros. In a pinch, a piece of foil can be pressed around the flashhead and formed into a cone. The key among all of them is that it limits the flash to a pattern that is tighter than the maximum zoom (**Figure 6.55**).

FIGURE 6.55
Left: A Canon 600EX-RT zoomed to 200mm. Center: the Rogue Flash-Bender rolled inside out (black on the inside) as a snoot. Right: the Strobros metal snoot.

OVER UNDER FOR BEAUTY

Beauty lighting is a unique lighting style that emphasizes light and minimizes shadow. Essentially, the light surrounds the subject's face. When facial shadows are minimized, the skin softens and wrinkles become less obvious. So beauty lighting is a perfect approach to lighting headshots of women (**Figure 6.56**).

While there are many approaches to creating beauty light, you need not have a studio full of gear to get started. For this shoot, I used a single Speedlite, a softbox, a silver reflector, and a couple of stands. It helps if you have arms on your stands to hold the softbox and reflector (see the sidebar below), but the arms are not essential.

Canon 5D Mk III
ISO 200
1/80 sec.
f/8
85mm
Speedlite and Apollo
softbox overhead, silver
reflector below

FIGURE 6.56
Beauty lighting
surrounds the face
with light—which
minimizes shadows
and softens skin.

The unique aspect to the lighting of this shot, as you can see in **Figure 6.57**, is that the light comes from above and below rather than from each side. For virtually every other shoot we have covered, the light has come in from the side to some degree. Note also how the camera looks between the softbox and the reflector. Often this arrangement is called a "clamshell" setup.

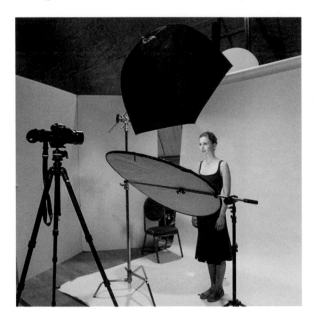

FIGURE 6.57
This set shot shows why this lighting style is nicknamed "clamshell lighting." Note how the camera looks between the softbox and the reflector.

GEAR: DISK HOLDERS

If you shoot by yourself frequently, you will appreciate the convenience provided by a collapsible disk holder. My favorite is the Manfrotto RH353 Reflector Holder (**Figure 6.58**). It uses two rubber blocks to hold the disk, extends to 68", collapses down to 28", and has a sturdy bracket that mounts it onto a lightstand.

FIGURE 6.58

In beauty light, surrounding the subject in light is key, but the shadows are still important. The amount of the chin shadow is determined by the placement of the reflector. When the reflector is in close, the light coming from below will be brighter than when the reflector is farther away.

Take a look at **Figures 6.59** and **6.60**. In Figure 6.59, the reflector is so close that it adds light to Ana's throat, chin, and cheeks. The additional light on her cheeks is fine, but I think there is too much light on her throat because her chin merges with it. Put another way, I prefer to see a bit more chin shadow—like in Figure 6.60—which was created by pulling the reflector out a few inches.

An easy approach to clamshell lighting is to set the power of the upper light first and then to position the reflector to add light from beneath as needed. If you see that the lower reflector adds light to the face, then you may need to reduce the power of the upper light a bit.

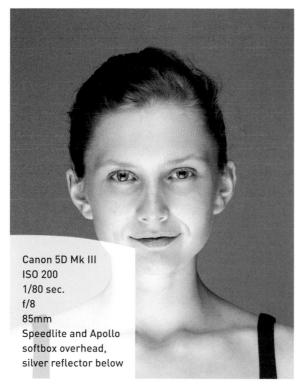

Canon 5D Mk III
ISO 200
1/80 sec.
f/8
85mm
Speedlite and Apollo
softbox overhead,
silver reflector below

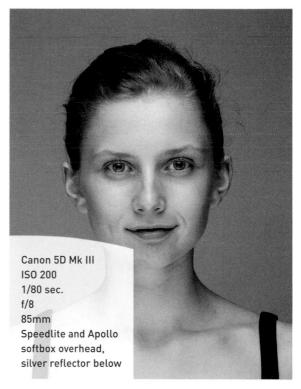

Canon 5D Mk III
ISO 200
1/80 sec.
f/8
85mm
Speedlite and Apollo
softbox overhead,
silver reflector below

FIGURE 6.59
The light coming up from the reflector is too strong in this shot—Ana's chin merges into her throat.

FIGURE 6.60
By moving the reflector down a few inches, the shadow on the throat deepens, which helps balance the shot.

USING A SECOND LIGHT DOWN BELOW

Another option for clamshell lighting is to use a second softbox on the bottom instead of a reflector (**Figure 6.61**). The advantage of the second softbox is that you can fine-tune the chin shadow by dialing the power up or down rather than by having to adjust the height of the reflector. An easy approach is to keep the power in both boxes at the same level until you have a nice overall quality to the light and then adjust the power of the lower light down, as needed, to create the contrast that you want.

When using two softboxes, angle each at about 45°. In terms of vertical spacing, compose your shot, then push the softboxes together until they just appear in the frame, and pull them out just enough so that you do not see them. You're looking to create the softest light possible here, so you want your subject as close to the modifiers as possible. With two softboxes, it also helps to have your subject step into the bottom softbox a bit. The fabric sides will flex around her.

FIGURE 6.61

SYNC ABOUT IT

The timing of when your flash fires can be used as a creative tool when shooting moving subjects with relatively long shutter speeds (1/15" or longer). Most of the time, your camera fires the flash as soon as the first curtain is fully open. This is called "normal" or "first-curtain" sync. Most DSLR cameras offer another setting—called "second-curtain sync" by Canon and "rear-curtain sync" by Nikon.

As the name suggests, second-curtain sync fires the shutter just before the second curtain begins to close. **Figures 6.62** and **6.63** will help us sort out the difference. Specifically, look at the difference in the blur. Figure 6.62 is first-curtain sync and Figure 6.63 is second-curtain sync.

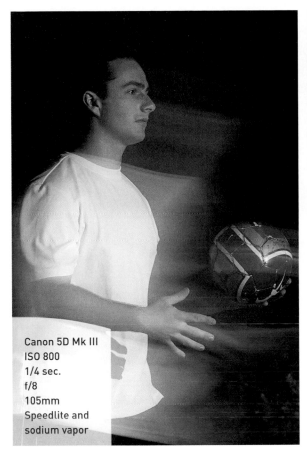

Canon 5D Mk III
ISO 800
1/4 sec.
f/8
105mm
Speedlite and
sodium vapor

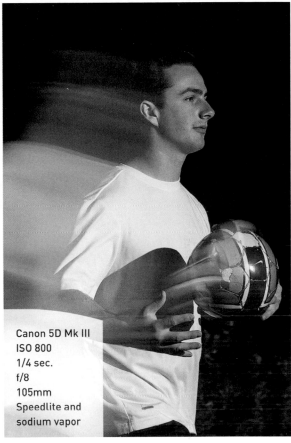

Canon 5D Mk III
ISO 800
1/4 sec.
f/8
105mm
Speedlite and
sodium vapor

FIGURE 6.62
With first-curtain sync, the ambient-lit portion of the
moving subject extends in front.

FIGURE 6.63
With second-curtain sync, the ambient-lit portion of the
moving subject trails behind the subject.

What's the big deal? Well, let's say that it has to do with the difference between
seeing a ghost (first-curtain) and seeing motion blur (second-curtain). In both sync
modes, the blurry part of the image is created by ambient light on the moving
subject. So, in first-curtain sync, the flash freezes the subject and then the ghost is
created as the subject moves during the rest of the exposure. As you can see in Figure
6.62, the ghost moves out of the body. This is great if you are creating an image to
accompany a scary story. It's not so great if you are photographing the bride and
groom during their first dance. (Think back to "Finding Light in the Shadows" earlier
in this chapter and you'll understand why you might use a slow shutter at a wedding
reception.) With second-curtain sync, as shown in Figure 6.63, the motion blur is cre-
ated first by the subject moving in the ambient light, and *then* the subject is frozen
when the flash fires.

Again, when the flash fires is the difference between first- and second-curtain sync (**Figures 6.64** and **6.65**). Each frame in the diagram represents a small segment of time during the operation of a 1/8" exposure. In Figure 6.64, the flash fires just after the first curtain opens. In Figure 6.65, the flash fires just before the second curtain closes. The stylized figure represents the position of the subject as it moves during the exposure.

FIGURE 6.64 First-Curtain Sync

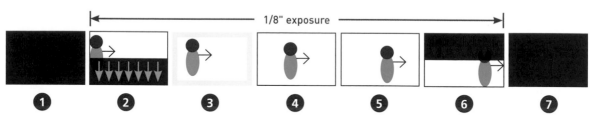

1 Camera ready to fire—first curtain closed.
2 First curtain opening—subject in motion.
3 First curtain fully open—flash fires—subject continues to move.

4 Shutter remains fully open—subject continues to move.
5 Shutter remains fully open—subject continues to move.
6 Second curtain closing—subject continues to move.
7 Second curtain closed.

FIGURE 6.65 Second-Curtain Sync

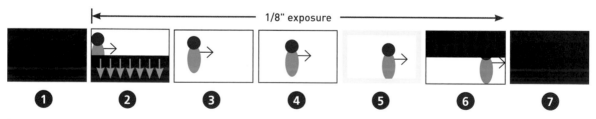

1 Camera ready to fire—first curtain closed.
2 First curtain opening—subject in motion.
3 First curtain fully open—subject continues to move.
4 Shutter remains fully open—subject continues to move.

5 Shutter remains fully open—flash fires—subject continues to move.
6 Second curtain closing—subject continues to move.
7 Second curtain closed.

HOW SHUTTER SPEED AFFECTS SECOND-CURTAIN SYNC

There are two reasons why shutter speed is an important consideration when shooting in second-curtain sync. First, if your shutter is too fast, there won't be any motion blur at all. (Another way to think about this is that the slower your shutter speed, the wider the motion blur will appear.) How slow do you need to go? It depends upon the speed that your subject is moving. If your subject is moving extremely fast, then you might get a wide streak of motion blur at 1/15". Likewise, if your subject is moving relatively slowly, then there might be very little motion blur at 1/15". So, you just have to experiment with the shutter speed until you get the motion blur that you want. Remember that you can shift the ISO and/or the aperture in the opposite direction to keep the ambient exposure where you want it.

The second consideration about shutter speed and second-curtain sync is that every camera has a shutter speed above which it will shift back to first-curtain sync, even if you've activated second-curtain sync (**Figure 6.66**). So break out your user manual and look up this number.

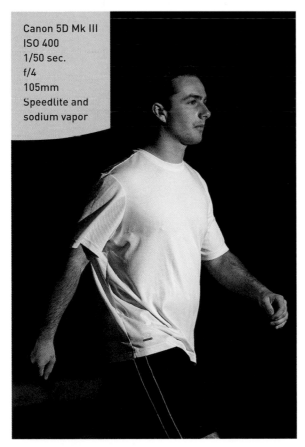

Canon 5D Mk III
ISO 400
1/50 sec.
f/4
105mm
Speedlite and
sodium vapor

FIGURE 6.66

If your shutter speed is too fast, the effect of second-curtain sync will not be apparent. On my camera, at shutter speeds faster than 1/30", the camera fires in first-curtain sync even if I activate second-curtain sync.

Here are some second-curtain sync tips:

- Look in your camera's user manual for information on flash sync. Your camera controls when the flash fires, not the flash itself.

- The subject must be lit by some ambient light. If the flash is providing all the light on the subject, then you will not see the effect.

- The subject must be in motion. If the subject is standing still, then no blur (ghost or motion) will be created.

- Like most types of flash photography, second-curtain sync benefits from having the flash off-camera rather than right above the lens.

OFF-CAMERA, SECOND-CURTAIN SYNC FOR CANONISTAS

For reasons that I do not know, Canon disables second-curtain sync when shooting with its built-in wireless system. Nikon has wireless second-curtain sync. Canon does not. As you can see in **Figure 6.67**, when the wireless system is activated, second-curtain is not available on the menu. So, over the years, I've come up with a workaround:

Use an extra-long ETTL cord to move a single Speedlite off-camera. The camera does not sense the cord, so it thinks that the flash is still in the hotshoe. If you want to fire additional flashes, you will have to operate the corded

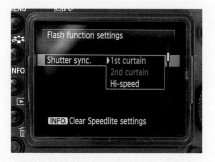

FIGURE 6.67
When the wireless system is activated on Canon cameras, second-curtain sync is disabled.

flash in Manual mode and use the JJC JSYK-3A optical slave for Canon underneath each of the other Speedlites. This small adapter will fire the other Speedlites when it sees a flash of light. If the other flashes are not Canon Speedlites, then check to see if they have old-fashioned optical slave sensors built in. Nikon calls this "SU-4" mode.

Chapter 6 Assignments

Control the Ambient, Control the Flash

Run through this four-step workflow: 1. Take a "normal" exposure. 2. Change the shutter speed to adjust the ambient light to your taste. 3. Turn on your flash and take a test shot. 4. Adjust the flash power to your taste.

Think About the Background

Frame your subject against a bright background and take a shot. Now, without having your subject move very far, reframe the shot against a dark background.

Hard Light, Soft Light, Hard Light

Fire your flash directly at your subject to create a headshot with hard light. Now, modify the flash to create soft light. Then, move the modified light out and adjust the power as needed to see how the light gets harder as the distance to the subject increases.

Flag and Feather

Set up a portrait so that a bit of your light flies behind your subject and onto the background. Now use a flag (FlashBender, cardboard, etc.) to keep the light off the background. Remove the flag and feather the light away from the background.

Share your results with the book's Flickr group!

Join the group here: flickr.com/groups/lightingfromsnapshotstogreatshots

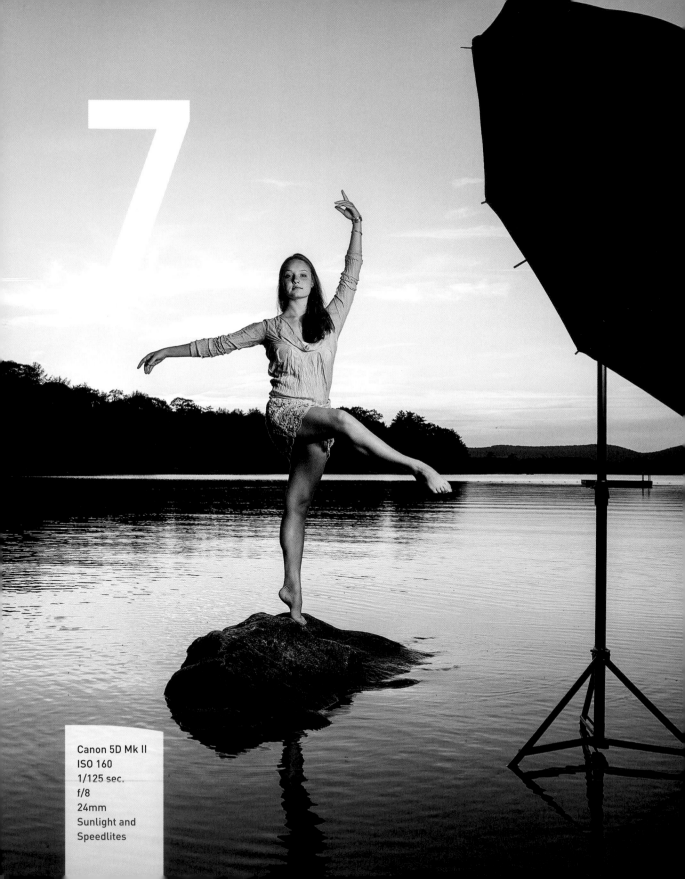

7

Canon 5D Mk II
ISO 160
1/125 sec.
f/8
24mm
Sunlight and
Speedlites

Advanced Lighting for Portraits

ADDING DEPTH AND DRAMA TO YOUR PORTRAITS

Once you grasp the fundamentals of lighting portraits with natural light and then with one flash, the addition of more lights and larger modifiers enables you to push the boundaries of your photography. For instance, with a giant umbrella, you can create a huge patch of soft light. Or with additional speedlights you can create areas of light and shadow with precision in your portraits. The key is to not become obsessed with the accumulation of gear—rather, it is to continue be obsessed with light and learn new ways to craft it with the gear that you have.

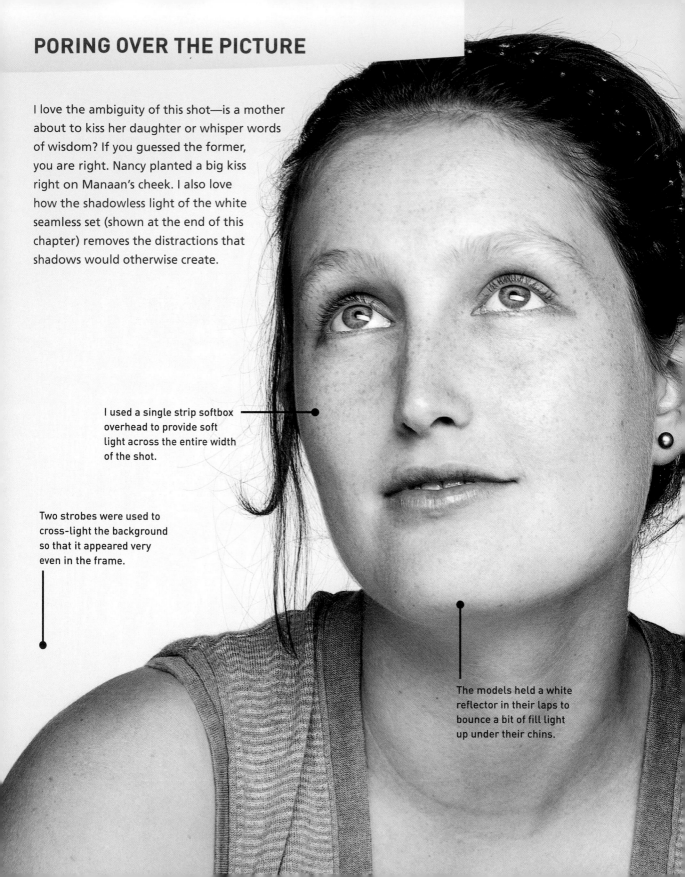

PORING OVER THE PICTURE

I love the ambiguity of this shot—is a mother about to kiss her daughter or whisper words of wisdom? If you guessed the former, you are right. Nancy planted a big kiss right on Manaan's cheek. I also love how the shadowless light of the white seamless set (shown at the end of this chapter) removes the distractions that shadows would otherwise create.

I used a single strip softbox overhead to provide soft light across the entire width of the shot.

Two strobes were used to cross-light the background so that it appeared very even in the frame.

The models held a white reflector in their laps to bounce a bit of fill light up under their chins.

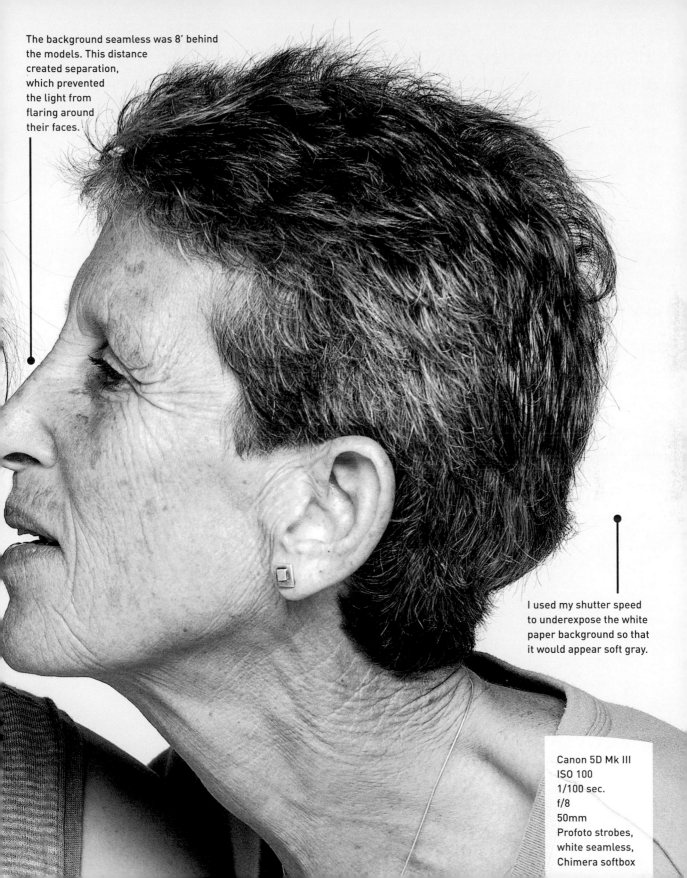

The background seamless was 8' behind the models. This distance created separation, which prevented the light from flaring around their faces.

I used my shutter speed to underexpose the white paper background so that it would appear soft gray.

Canon 5D Mk III
ISO 100
1/100 sec.
f/8
50mm
Profoto strobes,
white seamless,
Chimera softbox

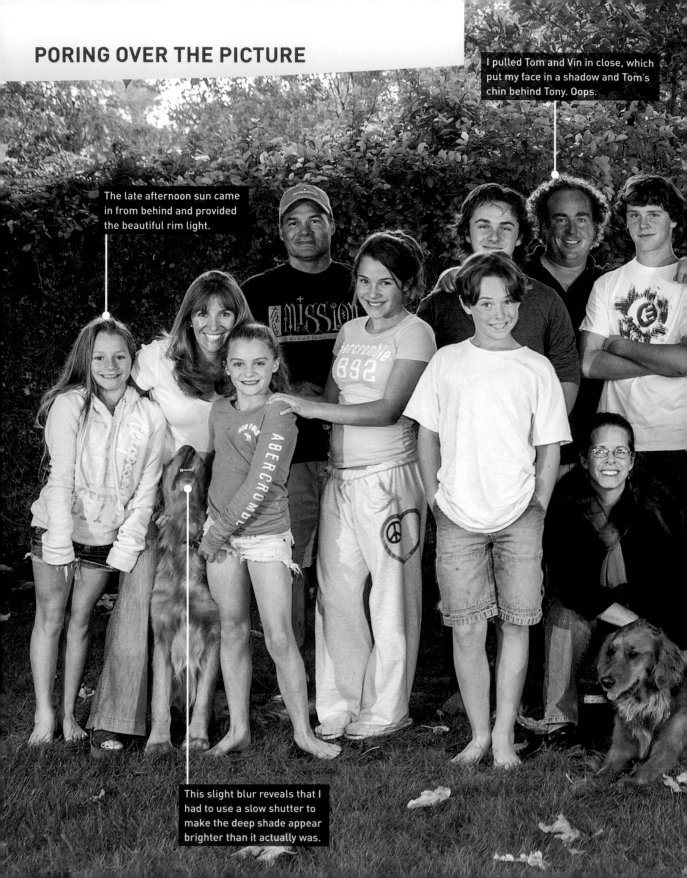

PORING OVER THE PICTURE

I pulled Tom and Vin in close, which put my face in a shadow and Tom's chin behind Tony. Oops.

The late afternoon sun came in from behind and provided the beautiful rim light.

This slight blur reveals that I had to use a slow shutter to make the deep shade appear brighter than it actually was.

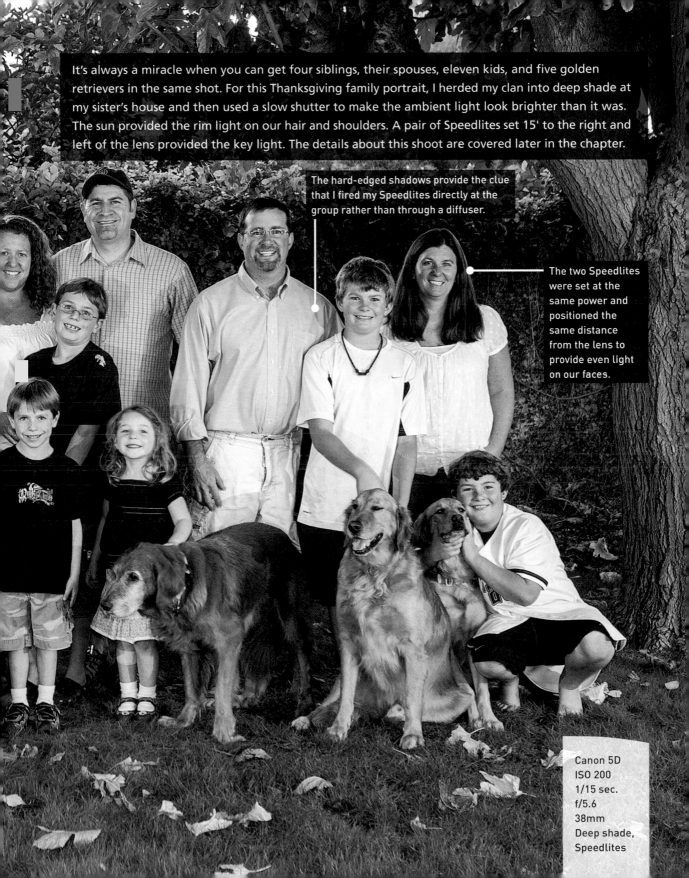

It's always a miracle when you can get four siblings, their spouses, eleven kids, and five golden retrievers in the same shot. For this Thanksgiving family portrait, I herded my clan into deep shade at my sister's house and then used a slow shutter to make the ambient light look brighter than it was. The sun provided the rim light on our hair and shoulders. A pair of Speedlites set 15' to the right and left of the lens provided the key light. The details about this shoot are covered later in the chapter.

The hard-edged shadows provide the clue that I fired my Speedlites directly at the group rather than through a diffuser.

The two Speedlites were set at the same power and positioned the same distance from the lens to provide even light on our faces.

Canon 5D
ISO 200
1/15 sec.
f/5.6
38mm
Deep shade,
Speedlites

QUICK LOOK—SHOOTS AND CONCEPTS

When adding more lights and larger modifiers to your kit, it is important to remember that you are building on (and not replacing) the fundamental lighting concepts that you've worked hard to learn. DICCH is still DICCH. If you're firing two lights and one is filling the shadows for the other, remember that the shadows are still there. They are just being reduced or hidden by the other light.

Also remember to change only one thing at a time—the position of a light, the power of a light, the modification of a light, etc. Changing two or three things at once will make it difficult to understand why you did not get the results you expected. By moving forward in small, systematic steps you will quickly learn what works the way you think that it does and what sends you in unexpected directions.

- **Shoot 1—Concealing and Revealing**. Your ambient exposure and lighting will hide certain elements and emphasize others so that you can inform the viewer about the persona and environment of your subject.

- **Shoot 2—The Firing Line**. When you add a second light to your kit, an easy setup is to place your subject right between two lights firing at each other. If you put the lights in other positions, you will also get great shots.

- **Shoot 3—Three Heads Are Better Than One**. Three lights—a key, a fill, and a rim/hair light—enable you to craft light and shadow with great precision. If you only have two lights, you can achieve a similar look by adding a reflector.

- **Shoot 4—Syncing in Broad Daylight**. On sun-drenched days, dimming the ambient by one stop will saturate the colors a bit. You will then need to add light back to your subject. If you are using a wide aperture to keep the depth of field shallow, take advantage of your Speedlites' ability to fire in high-speed sync.

- **Shoot 5—Family, Friends, and Strangers**. Group shots need not be a challenge to light. The keys are to use two lights arranged symmetrically across the lens and to space everyone far enough apart to avoid standing in a shadow.

- **Shoot 6—Circus of Color**. Color effect gels are used in theaters to provide color on stage. With a couple of flashes and bits of colored plastic, you can turn a mundane setting into a dramatic environment.

- **Shoot 7—Creating Sunset**. Color correction gels are used to make one type of light look like another type of light. With CTO gels on your flash, you can make it appear like a setting sun by firing in to a room through a window.

- **Shoot 8—A Field of White**. Knowing how to shoot white seamless properly will save you from doing a lot of work later in Photoshop. You will need at least three lights and space to spread everything and everyone out.

CONCEALING AND REVEALING

If you think of the ambient light as being separate from the photographic light you add to your photo, you can use them independently to conceal some elements while revealing others. In situations with bright ambient light, one of my favorite techniques is to underexpose the background and then use flash to focus the viewer's attention on my subject (**Figure 7.1**). Further, by creating dramatic shadows with hard light or by reducing the shadows with soft light, I can provide hints to the viewer about the persona of my subject.

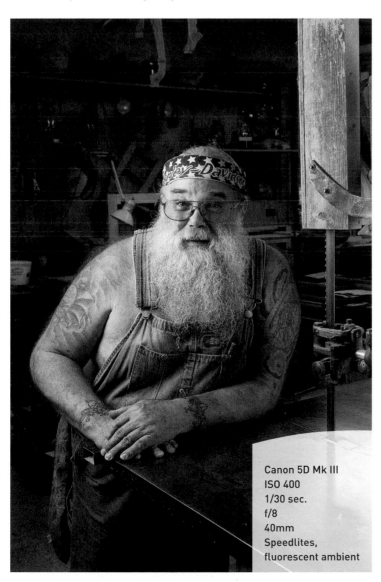

Canon 5D Mk III
ISO 400
1/30 sec.
f/8
40mm
Speedlites,
fluorescent ambient

FIGURE 7.1
I used my shutter to reduce the ambient light in the background of this location portrait and then lit my subject with a pair of Canon Speedlites. The combined effect is that you focus on the subject while still getting an understanding of his environment.

FOCUSING THE VIEWER'S EYE

As viewers, when we first see a photo, our vision locks onto the brightest element, then scans around to decode the image, and finally returns to the brightest element. So a simple strategy as a portraitist is to make sure that the subject is among the brightest elements in the frame.

Initially, this means that we need to think about the brightness of the subject in relationship to the background. If the background is very dark, then the job is easier. If the background is relatively bright, then we will have to dim the ambient light—which means that we will likely have to add light back onto our subject. We discussed this basic idea—using the shutter to dim the ambient and adding light to your subject—under "Shutter and Flash Synergy" in Chapter 6. So, for this shoot we'll connect the idea of dimming the ambient to the idea of how a subject's personality and environment are communicated through lighting and composition.

I've spent a lot of time in woodshops and know them to be cluttered spaces even when they are clean and organized. So, to meet my goal of focusing my viewer's attention on Hippy (as he is lovingly called by everyone), I chose to use the shutter to underexpose the ambient fluorescent light by three stops. You'll see the difference between the background light in **Figures 7.2** and **7.3**.

I put Hippy between two fields of light because I wanted to show the massiveness of his arms and the details of his tattoos. I went with soft light over hard light (which can work in many portraits of men) because the soft light fit Hippy's persona better. A big, tatted guy with harsh shadows conveys one message. A big, tatted guy with soft shadows conveys a completely different message.

In terms of lighting details, I used a pair of Canon 600EX-RT Speedlites and controlled them via Canon's new ST-E3-RT radio transmitter. This gave me the ability to control both lights from the back of my camera—which was very convenient, given that I was sandwiched between machinery and stacks of lumber.

As this was a stationary set, one where my subject and lights stayed put, I ran the flashes in manual mode rather than ETTL. Again, the advantage of Manual mode is that you get the same amount of light in each shot—even if you change the composition, which gives the camera a reason to re-meter the scene.

If you have a very basic flash kit, one with flashes that only have manual mode and no wireless connectivity, you can create the same light. You'll just have to walk back and forth as you adjust the power up and down during your test shots.

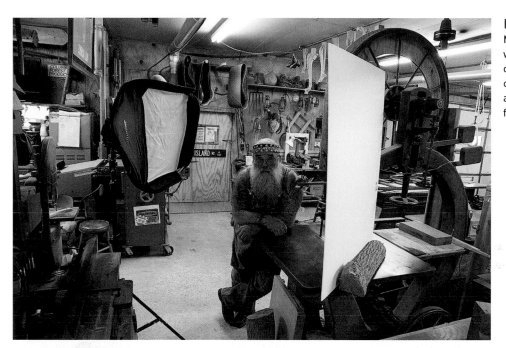

FIGURE 7.2
My set was a typical woodshop: very organized, slightly cluttered, and abundantly lit with fluorescent lights.

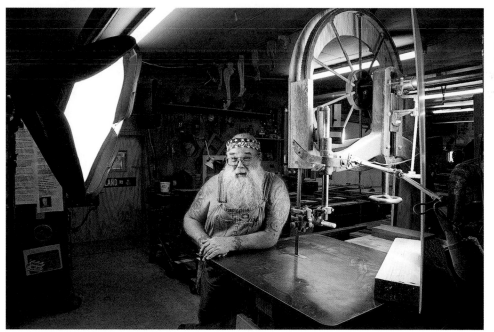

FIGURE 7.3
By increasing my shutter speed three stops, I dimmed the ambient fluorescent light. Then I brought light to my subject so that he would be the brightest element in the frame.

CONVEYING PERSONA AND ENVIRONMENT

As I said above, I used two Speedlites for this shoot. One is firing through the 24" Impact Quikbox on the left. Did you spot the other one? Look carefully in Figure 7.3. You will see that I balanced the second Speedlite in the wheel of the saw (look for the blue tape). It is firing at the sheet of white foam core (which can be seen more easily in Figure 7.2). Foam core is an inexpensive alternative to buying a second softbox. The main difference is that you cannot feather the edge of light coming off of foam core as easily as you can with a softbox.

Compare **Figures 7.4** and **7.5** to see the role that the second Speedlite and foam core played in creating the fill light. In Figure 7.4 the flash on the right was not used. See how the right side disappears into shadow? There's no doubt that this shot conveys Hippy's strength. I think, however, that it fails to convey his gentle nature. In Figure 7.5 the nearly even light on both sides hides nothing and the mood of the image shifts from strength to gentleness.

Now let's explore how lighting and composition inform the viewer about the subject. There is no question from the environmental clues provided in my hero shot at the opening (Figure 7.1) that the subject is a woodcraftsman. The saw blade in the foreground and the tools hanging in the background create this awareness.

Now compare the opening hero shot to Figure 7.5, which lacks the saw in the foreground. You still see the tools and such on the wall in the background, but will the viewer easily understand from this shot that Hippy is a woodsmith? I was there, I know. I told you, you know. But, a viewer who only sees Figure 7.5 might not easily make the connection that Hippy was in a woodshop—some sort of shop, yes, but not necessarily a woodshop. If this was an important element of the photo—say, because it was to accompany a story about Hippy's work with wood—then the lack of the saw as an accessible clue reduces a potentially great shot to a merely good shot.

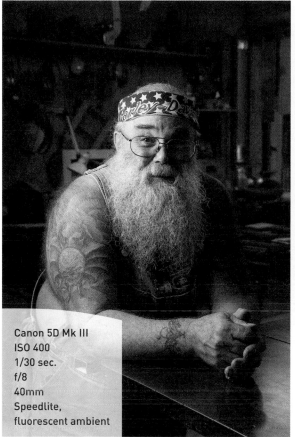

Canon 5D Mk III
ISO 400
1/30 sec.
f/8
40mm
Speedlite,
fluorescent ambient

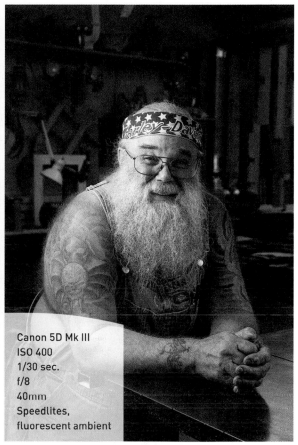

Canon 5D Mk III
ISO 400
1/30 sec.
f/8
40mm
Speedlites,
fluorescent ambient

FIGURE 7.4
Without the fill flash on the right, the shadow causes the focus to shift to the left side of the image. This mood of this shot conveys strength.

FIGURE 7.5
With nearly equal lighting on the left and right, there is nothing about Hippy that is hidden in this shot. The additional light shifts the mood from strength (which is still present) to gentleness.

Let's take the discussion one step farther. Take a look at **Figure 7.6**, which was shot with both the fluorescent shop lights and right-side Speedlite turned off. In terms of light, this is a very strong image, one that I'm quite fond of. But the lack of detail in the background provides no context about Hippy's environment. Again, if the connection to his woodshop is important for the purpose of the photo, then this shot fails. If, however, you're out to make a handsomely lit image, then the dark background contrasts nicely with the lighting.

We still have plenty to talk about in this chapter. So, for now, know that in so many ways, the decisions we make about creating light and shadow, and the decisions we make about composition and when we push the shutter button greatly influence how our viewers perceive the subjects of our portraits.

FIGURE 7.6
This shot was lit with a single Speedlite firing through the 24" Impact Quikbox on the left. The fluorescent shop lights and the right-side Speedlite were shut off to create the dark background. How does this change of lighting affect your understanding of the subject's environment?

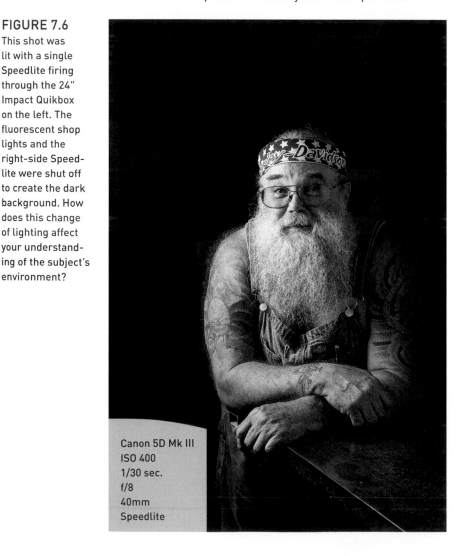

Canon 5D Mk III
ISO 400
1/30 sec.
f/8
40mm
Speedlite

SHOOT ALTERNATE COMPOSITIONS

When shooting portraits on location, I typically spend 80% of my time working on my ambient exposure and setting up my lighting. Once this is all dialed in manually on my camera and flashes, it is very easy to shoot many alternate compositions. So, if I'm asked to shoot a tight, vertical headshot, I will also shoot the opposite—a wide horizontal. This gives publication designers more options to use my photographs. For instance, in **Figure 7.7**, I made sure that there was nothing of importance in the center line of the frame—which means that it can be used as a two-page spread (which is called a *double truck*).

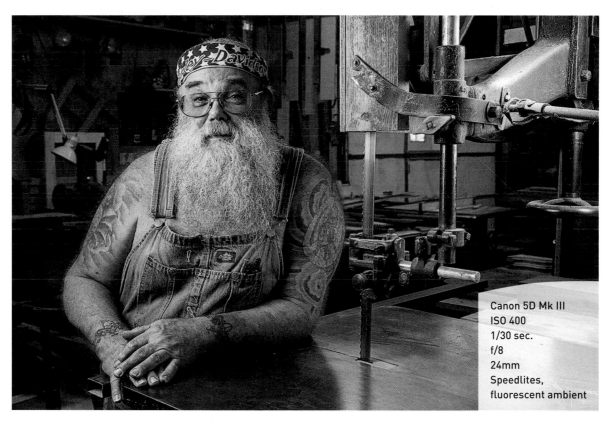

Canon 5D Mk III
ISO 400
1/30 sec.
f/8
24mm
Speedlites,
fluorescent ambient

FIGURE 7.7

THE FIRING LINE

One of my favorite lighting setups is to place my subject right between two lights firing straight at each other. By moving my camera in an arc around my subject, I can find a wide range of lighting styles.

For the hero shot (**Figure 7.8**), the key light on the left was in front of Manaan. As you can see in the set shot (**Figure 7.9**) I used an Einstein E640 monolight firing through a 30" x 60" softbox. For the rim light, I placed another Einstein E640 firing through a 10" x 36" stripbox behind Manaan.

Quick tip: I used a relatively fast shutter speed (1/125") and a low ISO (100) to make sure that I had no ambient light in the shot. I wanted to create all of the light in the frame with my strobes. A simple paper seamless behind Manaan assured that the background would be black.

Canon 5D Mk III
ISO 100
1/125 sec.
f/8
55mm
Strobes into
softboxes

FIGURE 7.8

I positioned two strobes to fire directly at each other. The key light on the front left was created by a 30" x 60" softbox. The rim light on the right came from a 10" x 36" stripbox placed behind my model.

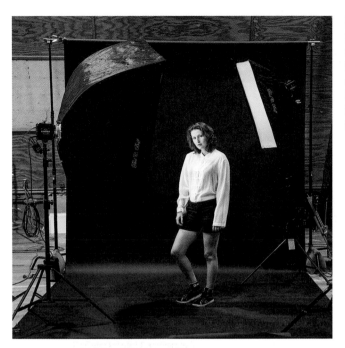

FIGURE 7.9
My set was rather cramped with both softboxes pushed in right to the edges of my camera's field of vision. Note how large the key light is on the left relative to the size of the rim light on the right.

NOSE TO THE LIGHT

Nose to the light is a simple way to stay out of trouble with portraits. Look what happened when I asked Manaan to turn to the side so that her nose faced away from the key light (**Figure 7.10**). Half of her face was lost in deep shadow because the rim light was just a narrow strip and could not reach around her cheek. If the fill card had been in place, then her nose would still be pointing towards a light source (the card) and the bounce would have filled the shadowy side. So when you want to play it safe, especially when photographing a woman, make sure that her nose is pointing towards a light source.

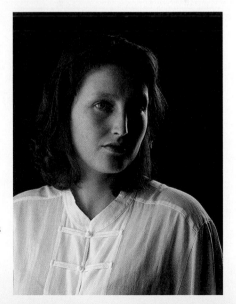

FIGURE 7.10

While the key light creates lovely, soft light, the rim light from the narrow stripbox is what makes this image work. Compare **Figures 7.11** and **7.12**. One has rim light (Figure 7.11) and the other does not (Figure 7.12). The key light in both shots is the same. Without the rim light, Manaan's hair merges into the black background and the shot is lost.

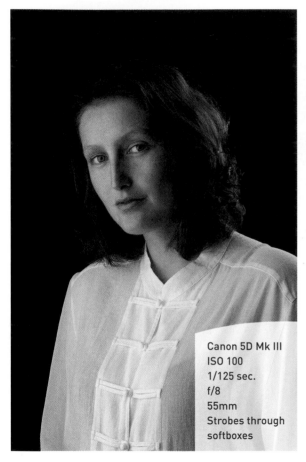

Canon 5D Mk III
ISO 100
1/125 sec.
f/8
55mm
Strobes through
softboxes

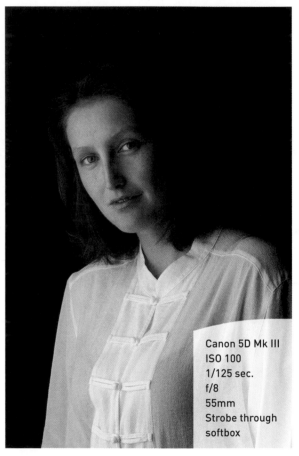

Canon 5D Mk III
ISO 100
1/125 sec.
f/8
55mm
Strobe through
softbox

FIGURE 7.11
The rim light provides a critical line of separation between my model and the black background.

FIGURE 7.12
Without the rim light, Manaan merges into the blackness and the shot is lost.

Another consideration for a two-light shoot is whether additional fill light would be beneficial. The quick answer is, "You won't know unless you try." Check out how the additional fill light in **Figure 7.13** creates an even field of light all the way across Manaan's face. I added this light by having my friend Skip hold a sheet of white foam core just outside the camera's field of vision (**Figure 7.14**). If you want slightly less fill light, then pull the card out a bit and shoot again.

It's largely a matter of taste. I happen to prefer the hero shot (Figure 7.8). I like how the shadow between the key and rim lights reveals the curve of Manaan's cheek. You may prefer the openness of the light created with the fill card (Figure 7.13). The main point to remember is that even with two lights, you still have additional options by using reflectors.

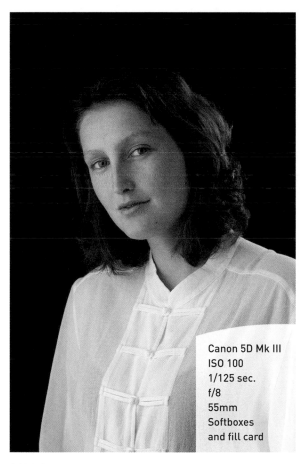

Canon 5D Mk III
ISO 100
1/125 sec.
f/8
55mm
Softboxes
and fill card

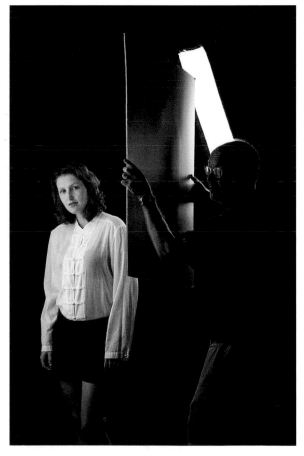

FIGURE 7.13
The cheek shadows between the key and rim light are filled with light bouncing off a sheet of foam core.

FIGURE 7.14
I added the extra fill light by having my friend Skip hold a sheet of foam core just outside the camera's field of vision.

STRATEGIES FOR USING TWO LIGHTS

When you start sketching out the possibilities for using two lights, you'll quickly find that the variations are nearly endless. Let's take a look at five main scenarios. In each, the green light is the key light. The red light's function varies among fill, rim, and background. Even though Speedlite icons are used in these diagrams, you could easily use strobes. If you want to create soft light in any of these situations, add a modifier.

- **Lights symmetrical and angled at subject**—This is a very standard arrangement for novices (**Figure 7.15**). If both lights are at equal power, then the light will be very flat and nearly shadowless. Think of a driver's license photo and you will know what this lighting looks like. When you increase the power on one side then the shadows will become more apparent on the other side. Adjust the power of each light to move the contrast from one side to the other.

- **Lights firing at each other**—This is the arrangement of the lights in the shoot described in this section (**Figure 7.16**). You can set the two lights to exactly face each other, put your subject in the center, and work the camera around the circle to find many different styles of light. When one light is behind the subject, it will create rim light. If both lights are on either side of the subject (at 3 o'clock and 9 o'clock) then you have hatchet light—which puts a menacing shadow down the center of your subject's face.

FIGURE 7.15
With two lights arranged symmetrically, you move the contrast from left to right by adjusting the power of the lights.

FIGURE 7.16
This versatile combination can be used to create a wide range of interesting light. Be sure to work the camera around the circle to explore the many options.

- **Two lights on the same side**—Many types of beauty lighting are built on the idea of lining up two light sources, one above the other (**Figure 7.17**). Soft lights work very well in this configuration (clamshell lighting). Adjust the power above and below to control the intensity of the shadows.

- **One light at subject, other towards background**—This combination is used as an alternative to rim light when you need to create a visual separation between your subject and the background (**Figure 7.18**). If you gel the background light, then you'll have a pool of color behind your subject.

- **One light at subject, other bounces off wall onto subject**—The bounce increases the apparent size of the light, which makes it appear softer (**Figure 7.19**). So this is a handy combination if you want to have a hard key light and a soft fill light, but lack a modifier.

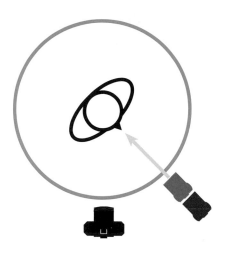

FIGURE 7.17
Firing two lights from the same side, one above the subject and the other below, is the classic configuration for beauty lighting.

FIGURE 7.18
Firing a light at the background can make the scene more interesting. It can also be used to create a visual separation of the subject from the background.

FIGURE 7.19
Bouncing one of the lights off of a wall is a quick way to create soft light when you do not have a suitable modifier close by.

THREE HEADS ARE BETTER THAN ONE

The three-light portrait is a classic lighting technique that is as suitable for business headshots as it is for social media avatars (**Figure 7.20**). The setup uses three lights—a key light, a fill light, and a rim or hair light—which gives you the ability to fine-tune the amount of light that each is providing in the shot (**Figure 7.21–23**). (In case you do not have three lights, I'll provide some ideas for two-light setups at the end of this section.)

FIGURE 7.20
The three-light headshot is a classic portrait setup. Here, the three lights—key, fill, and hair—work together.

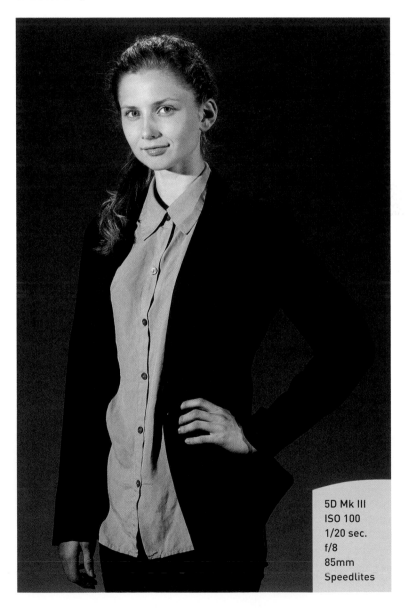

5D Mk III
ISO 100
1/20 sec.
f/8
85mm
Speedlites

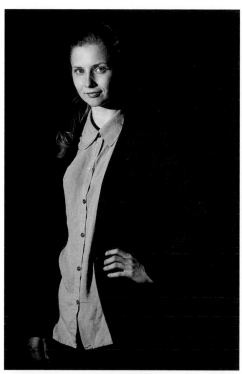

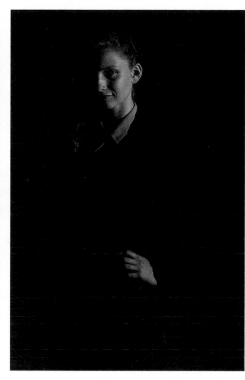

FIGURE 7.21
(left) Key light
only—this light
provides the
majority of the
light on Ana.

FIGURE 7.22
(right) Fill light
only—notice how
dim it appears
compared to the
key light.

FIGURE 7.23
Hair light only—although it
lights only a small area, this
is an important accent light.

The three-light portrait is easy to learn (**Figure 7.24**). Here is my workflow (which I hope is looking familiar to you by now):

1. Set your aperture for the depth of field you want—shallow, medium, or deep.

2. Set your ISO and shutter speed to give you the ambient exposure that you need—for the background especially.

3. Position, modify, and test your key (main) light. You are looking for enough light on your subject's face.

4. Keep your key light on. Position, modify, and test your fill light. You are looking to have enough fill light so that you can see into the shadows to the degree you want.

5. Keep the key and fill lights on. Position, modify, and test your rim light. Lights coming from behind the subject typically need less power than lights positioned in front.

6. Turn all three lights off. Then take test shots with each one on individually so that you can learn what each is contributing to the shot (Figures 7.21–23).

FIGURE 7.24
For this shoot, I used three Speedlites. The key light was on the left. Both the key light and the fill light are flagged with Rogue FlashBenders to keep their light off the background. A Speedlite on a tall stand behind the backdrop created the rim light.

In terms of light position, start with the key and fill lights symmetrically arranged on each side of the lens. Place your lights slightly above the eyes of your subject. At the start, you might not even know which is going to be the key (main) light until you begin testing. Dial the power up and down on each as needed so that you have the brightness in the highlights and the details in the shadows that you want. The brighter of the two lights is the key light.

The question of hard versus soft light applies to this type of lighting as much as it does for portraits with one light. The decision is largely a matter of how crisp you want the shadows on your subject. There is also the issue of how shadows look on the background. If there is not much space between your subject and the background, then hard light (flash aimed directly at your subject) will cast shadows into the frame. If this is an issue, and soft light will work on your subject, then use umbrellas or softboxes to modify your key and fill lights. You will see a significant reduction in the background shadows with soft light.

Another interesting difference, if you compare the left side of **Figure 7.25** (hard light) to the right side (soft light) is that the larger modifiers also reach around the subject and throw a lot of light on the background. So, if you want to keep the background dark when shooting soft light, you will need to pull your subject away from the background or use large cards as flags to block the soft light from the background.

FIGURE 7.25
The use of hard or soft light creates subtle differences in light and shadow. As shown on the left, the hard light created by firing the Speedlites directly at Ana reveals more shape to the face as the shadows are more distinct. On the right, I used a pair of Apollo softboxes to create soft light. Notice how the softboxes threw more light around Ana and created a different background tone.

As for the rim/hair light, position it high above and behind your subject. A steep angle of 45° to 60° will assure that the camera sees the edge created by this light. Centering the rim light right above your subject will provide more even illumination on both shoulders. If you want one side to be lit more than the other, shift the light towards that side.

Also, check that the rim light does not flare into the camera lens. If the camera can see the flash, this light will reduce the contrast of the shot. Attach a FlashBender or a piece of cardboard to the top of the flash so that it angles down and blocks the light flying towards the lens. You want light on your subject, but not light heading straight into your camera.

DOES THE HAIR LIGHT REALLY DO ANYTHING?

If the main difference between a two-light and a three-light portrait is the hair/rim light, it is a fair question to ask if it really does anything. As you can see in **Figure 7.26**, the addition of a hair light on the right makes a small but distinctive contribution to the shot.

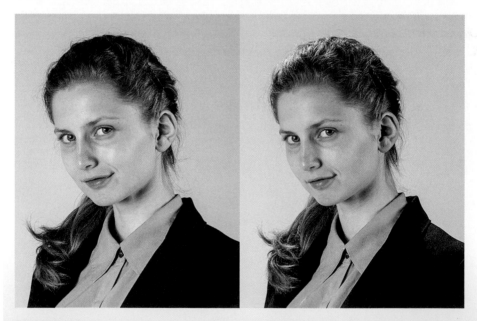

FIGURE 7.26

IF YOU ONLY HAVE TWO LIGHTS

If you only have two lights, you still have options. For instance, if you have a large bounce panel or piece of white foam core, you can angle it in so that it catches excess key light that is flying in front of or behind your subject. If you cannot bounce the fill light in, you may be able to adjust the ambient exposure so that it reveals enough details in the shadowy areas of the subject. Both of these options give you less control than a trio of lights will.

SYNCING IN BROAD DAYLIGHT

Giving assignments to yourself is an efficient way to grow as a photographer. Rather than just go out and *take* photos, a self-assignment creates a set of boundaries in which you *make* photos. For this shoot, my self-assignment was "spring fever". I decided to pursue this theme by focusing my camera on my son Vin's passion for snowboarding—at a time when spring was raging in its full glory around our house (**Figure 7.27**).

My goal was to create visual irony between the spring foliage and a snowboarder who practices on a pile of junk during the off-season. Lighting the set was my challenge. Foliage looks best when backlit (because leaves and petals are translucent). Putting the sun behind the snowboarder (my son Vin) meant that I'd have to create a tall column of fill light. Since I wanted shallow depth of field, I had to use a wide aperture—which meant that I also had to use a shutter speed faster than my camera's sync speed. Fortunately, the high-speed sync function on my Speedlites enabled all of this to happen.

Of course, I started my test shots with an exploration of how the camera saw the ambient light (**Figure 7.28**). When shooting outdoors in full sun, I find that slightly underexposing the ambient a bit helps saturate the colors. So, in **Figure 7.29** you can see the effect of my increasing the shutter speed from 1/320" to 1/800"—which is a 1 1/3-stop change.

FIGURE 7.27
Created as a self-assignment on the theme of "Spring Fever," this is my interpretation of my son Vin's passion for snowboarding. Since I used the sun to backlight the landscape, I had to create a tall field of fill flash on Vin. I also wanted shallow depth of field. So, I had to use a wide aperture with a fast shutter. Fortunately, high-speed sync enabled me to fire the Speedlites above my camera's sync speed.

Canon 5D Mk II
ISO 100
1/800 sec.
f/4
24mm
Sunlight and
Speedlites
into softboxes

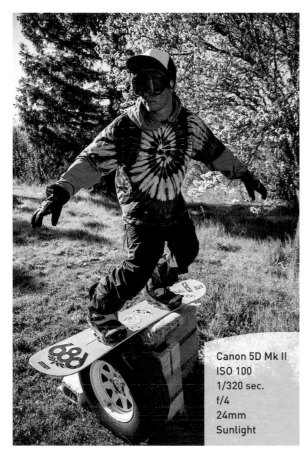

Canon 5D Mk II
ISO 100
1/320 sec.
f/4
24mm
Sunlight

Canon 5D Mk II
ISO 100
1/800 sec.
f/4
24mm
Sunlight

FIGURE 7.28
In terms of lighting, this is where the shoot started—with the late-afternoon sun behind Vin's back. This is the ambient-only test shot as my camera wanted to make it in Aperture Priority mode.

FIGURE 7.29
By increasing the shutter speed from 1/320" to 1/800", I underexposed the ambient, which helps saturate the colors. Of course, it also deepens the shadows on my subject.

Why 1 1/3 stops? Most likely because my finger slipped and I moved the dial on my camera four clicks rather than three while I focused on something else. Typically, I keep my moves in whole-stop increments until I get so close that I just need to "salt the soup a bit"—at which time I will make third-stop moves.

Now that I have managed the exposure for the ambient light, I hope that you anticipate my next move—to create fill light for the shadows I created by positioning my camera to look towards the backlit foliage. The sun is to Vin's back. So, yes, I next turned on my Speedlites. Did you also sort out that the flashes have to be in high-speed sync because the shutter speed is faster than the camera's sync speed? I hope so.

Why not just slow the shutter down to 1/200" and sync normally? Well, the change from 1/800" > 1/400" > 1/200" would require an offsetting two-stop change in the aperture from f/4 > f/5.6 > f/8.

At f/8 on a 24mm lens, the entire background would be in sharp focus. So, to keep the background slightly soft (another visual technique to force the viewer to concentrate on the subject), I had to use a wider aperture and accept the shutter speed that went along with it.

Continuing on—how do you get flash to sync with a 1/800" shutter speed? You use high-speed sync on dedicated hotshoe flash. See the sidebar for the reasons why larger strobes are more difficult to use in this situation.

USING STROBES IN BROAD DAYLIGHT

There are a lot of advantages to using strobes over small flash. For instance, they fill up large umbrellas and softboxes more efficiently than speedlights do. Also, they recycle much faster so you can fire off another shot very quickly. But one big downside to strobes is that they will not do high-speed sync. Speedlights literally change the way they fire in high-speed sync. (Review Figure 4.36 for the details.) Strobes cannot make this shift.

So, when you are using strobes outdoors to create fill flash, you must slow the shutter down into normal sync territory. If you also want to use a wide aperture to reduce depth of field, you cannot dial your ISO low enough to make all of this work. So what do you do?

The option that strobe shooters resort to in this situation is to use a neutral density (ND) filter over the lens—which is like putting on a pair of sunglasses (**Figure 7.30**). It darkens the entire scene, which then allows you to use a wider aperture and yet still have a shutter speed that can fire at sync speeds that will work with the strobes. ND filters come in various densities. Some, like the Vari-ND filter that I carry, provide two to eight stops of ambient-killing density in a single, variable filter. The downside of ND is that it is very hard (and sometimes impossible) to focus or follow action through the lens when a piece of black glass is threaded onto the front.

FIGURE 7.30

STACKING SOFTBOXES TO CREATE A COLUMN OF LIGHT

The job of my lighting in this shoot was to create a column of fill light. It literally had to cover from the top of Vin's head all the way down to the grass. Often I let my light fall off towards the edges so that it creates a natural vignette. That strategy does not work in this shot.

As I said in the "Concealing and Revealing" section at the beginning of the chapter, the photographer must reveal important clues to the viewer. As it is not a typical sight to see a snowboarder teetering on a stack of junk, these details become very important for the success of the image. If the viewer does not easily decode the blocks and the tire, then the shot fails. To reveal them meant that I had to create a tall column of fill light.

So this is where it gets tricky. Remember that in high-speed sync there is a 2.5-stop loss of power? This power loss is exactly the reason that I could not take one flash and pull it way back to provide the head-to-grass coverage. Using HSS often means that you have to push your lights in as close as possible.

Now, pushing a single light in close to Vin's head means that it is far enough away from the blocks to create significant fall-off. Pushing it in close halfway down the frame means that his middle is too bright while his head and the grass are too dark. Like I said, it's tricky.

My solution, as shown in **Figure 7.31**, was to use a pair of Westcott Apollo softboxes. I had two Speedlites firing in the top box and a single Speedlite firing in the bottom box. Note also that I spaced them vertically so that the top box lit Vin's head and torso while the lower box lit the blocks and tire. Vin's black pants caught enough of the fill light and also reflected the backlight from the sun nicely—so they retained their texture even though I did not light them directly.

FIGURE 7.31
The set as seen from the photographer's perspective. I stood on the third step of the ladder to get a slightly downward angle on Vin.

TRIGGERING FLASHES INSIDE OF SOFTBOXES

Choosing the right vantage point from which to shoot Vin was another important part of creating this shot. I stood on the third step of the ladder shown in Figure 7.31 so that I would have a slight downward angle on my 24mm lens. This perspective accentuated that Vin was up in the air. Standing on the ground and angling the camera up made him seem very grounded against a large sky.

Note that the ladder is behind the softboxes. So the old-school method of putting a master Speedlite in the hotshoe and firing instructions to the slaves would not work because the sides of the Apollos would have blocked the signals. So what to do? Four options come to mind:

• Manual radio triggers, like the inexpensive Yongnuo RF-603 or the pro-grade PocketWizard Plus IIIs, mean that you have to adjust the power on each flash individually by hand every time you want to make a change. They also wouldn't work for this particular shoot since manual radio triggers cannot fire in high-speed sync.

• ETTL/ITTL radio triggers, such as PocketWizard's Mini TT1 and Flex TT5, provide the ability to adjust the flash power from the camera. However, a TT1 transmitter and three TT5 tranceivers would run about $800.

• Using an extra-long ETTL/ITTL cord to move the master to a spot where the slaves can see it provides the most bang for the buck. By using a cord that maintains the full communication path between your camera and master Speedlite, you can move it to a good spot and still control the slaves from the convenience of your camera's LCD panel. The cord costs about $65, but you have to dedicate another Speedlite to be the master.

• Radio Speedlites—As I've said elsewhere, Canon's new 600EX-RT Speedlite and ST-E3-RT transmitter have radio built in. They cost a bit more than their predecessors, but the updated user interface and convenience of built-in radio make the new system much easier to use in situations like this shoot—which is why I used them for this shoot.

YEP, THAT'S A BIT OF PHOTOSHOP

Lastly, did you catch in the ambient and set shots that there was a block on the left side of the tire and that it is not there in the hero shot (Figure 7.27)? It was not possible for Vin to get the board to overhang the tire without the tire rolling. So, I did the shoot with the block in place knowing that I'd have to take it out later in Photoshop. Sometimes I have to be a retoucher, but I always focus on being a photographer first so that I have great files to work with in post-production.

FAMILY, FRIENDS, AND STRANGERS

Virtually every one of my students wants to know how to light group shots. Take a look at the group shot of my family at the beginning of the chapter (the second Poring Over the Picture). This photo proves that you can light a large group with a couple of Speedlites, a well-managed exposure, and a bit of luck. Here are the two most important tips about lighting groups that I have: create balanced light from both sides of the lens, and spread everyone out to avoid shadows. In response to the guy who always asks, "How do I light a group of 50 with one small flash?," I say, "You can't—at least not very well."

When lighting groups, take advantage of whatever ambient light you have. For our Thanksgiving family portrait, I chose a deeply shaded spot in my sister's yard so that my two Speedlites would not struggle to been seen. As you can see in **Figure 7.32**, the light was very flat with a bit of rim light coming in from over the hedge. Also note how blue the light appeared to my camera when it was set in Daylight white balance. Based on this test shot, I switched the white balance to Cloudy (which warmed up the colors) and added the light from two Speedlites aimed directly at the group.

Canon 5D
ISO 200
1/15 sec.
f/5.6
38mm
Deep shade

FIGURE 7.32
Asking everyone to see if the light on my left was firing kept them distracted while I did my initial test shots. The distraction kept them from milling about too much. Here you can see the true depth and blueness of the shade in which we stood.

If your subjects stand in really bright light, then your small flashes might not be strong enough to make a big difference. So, unless you are working with large strobes (which are more powerful than small speedlights), keep your group out of direct sunlight when possible. If you have to be in bright light, place the source behind your group as a rim light and then use your lights to create fill flash.

Remember that there are no exceptions to the rules of physics when lighting groups. The inverse square law says that (and I paraphrase here) as light travels it spreads out, and as it spreads out it appears dimmer. You can see this effect in **Figure 7.33** where the light came in from a single Speedlite on the right. While the light is at a good level in the middle of the frame, it is too bright on the right and too dim on the left. For groups, the easiest fix to this challenge is to add an identical light coming in from the same spot on the other side of the lens. By identical, I mean same light, same power, same modifier, and same distance.

FIGURE 7.33
It is really difficult to light a group with only one light coming in from the side. Notice how the light is too bright on the right and too dim on the left. Adding an identical light on the left and then lowering the power of both gave me the lighting used in my hero shot.

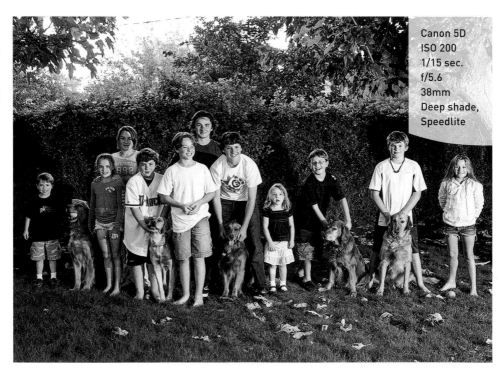

Canon 5D
ISO 200
1/15 sec.
f/5.6
38mm
Deep shade,
Speedlite

TIPS FOR GROUP SHOTS

- **If you have a group and only one light**—It is tough, but not impossible, to get useful light for a group shot from a single flash. When you find yourself in this situation, think along the lines of using the flash to enhance the ambient light (which will be the main light on the people in the shot). If you are indoors and there is a light-colored wall nearby, turn the power on your flash all the way up and bounce it into a corner to create a bit of soft light coming towards the group from one side. Another option, indoors or outside, is to use the one flash behind the group to create a line of rim light across their heads and shoulders. In both cases, try not to push your light in close to one side of the group.

- **Use the width of the group as a guide on light placement**—Use the width of the group as a measure for the distance between the group and your lights. Unless I'm working in a tiny space, I like to pull my lights out at least one group width. For instance, if the group is 15' across, then my lights are at least 15' away from the closest member of the group. This distance helps keep the light more even across the width of the group. If I am in a small space that prevents this spacing, I will try to bounce my lights off of light-colored walls instead.

- **Soft light and groups**—One way to avoid shadows on faces is to use soft light rather than firing your flashes directly at the group. Soft or hard is largely a matter of how much light you have to throw around. If you have only a couple of small flashes, then you will likely need to fire them directly at the group because too much light will be lost filling a couple of large umbrellas. However, if you have many speedlights or a couple of large strobes, then you can use large, silver umbrellas to create soft light that will reach around the sides of the faces. For large groups, I'm very fond of the 72" silver umbrellas made by F.J. Westcott.

- **Spread everyone out to avoid shadows**—When you can, spread everyone out so that they are not shaded by the people in front. One way to test for good spacing is to have everyone look at the camera, then ask them to continue facing the camera and shift their eyes to look at one of the lights (the actual flash and not the umbrella). If they cannot see the flash, then they are standing in the shadow of their neighbor. Then repeat this for the other light. If you have to have everyone stand close together, then anticipate that you will have to bring your lights in closer toward the camera so that they fire more frontally at the group.

A CIRCUS OF COLOR

Adding color gels to your flashes is an easy way to take a mundane set and turn it into a theatrical set (**Figure 7.34**). In this shoot, I started in a narrow, stone-walled hallway of an old fort. As soon as I saw the studded door leading to an adjacent room, I knew that I had found a great set to gel.

The formula for this shoot was very basic. I first determined my composition with a series of ambient test shots (**Figure 7.35**). Then I changed up my camera settings to eliminate the ambient tungsten light from the frame. Specifically, I dialed my aperture to f/8 so that I would have a moderate amount of depth of field. I dialed the shutter to 1/100" because I knew that I could easily handhold that shutter speed. I then changed the ISO from Auto to 800 and took another ambient test shot (**Figure 7.36**). As you can see, the changes to my camera settings, roughly seven stops, confirmed that I eliminated the ambient light.

This is a simple two-light shot. I had one Speedlite in the camera's hotshoe and a slaved Speedlite on a lightstand in the adjacent room. I zoomed and aligned the head of the slaved light so that it would fire straight through the door frame—which is what casts the shadow of Scott across the door (**Figure 7.37**).

To control the slave, I used the radio features of Canon's 600EX-RT Speedlite. I'm sure that I also could have controlled the slave optically. Past experience in spaces like this tells me that the instructions from the master would have bounced off the stone and the door adequately for the slave eye to see them.

With my hotshoe master (blue) and the slave (red) positioned perpendicular to each other, the surfaces that face the camera are lit in blue, and the surfaces that face to the right are lit in red. With color gels, you have to remember that the lower the power, the more saturated the color becomes (see the sidebar "How Flash Power Affects Gel Color" below). So, my manual power settings on each light were dialed in to give me rich colors.

While there are no hard and fast rules for gelling with color, I can offer these tips:

- **Warm/cool color combinations** are an easy way to create dramatic color.

- **Light clothing** reflects the colors of the gels more vividly than dark clothing.

- **Experiment and play** until you find a general idea that speaks to you visually. Then fine-tune your flash settings until you have the color relationships that you want.

- **Color effects gel sets** are an easy way to get started. They contain a basic rainbow of theatrical gels.

- **Position your gels on the flashes with care.** You do not want to allow gaps between the gel and the flash, as they will throw white light into your shot.

FIGURE 7.34
Two gels provided the color for this shot. The master 600EX-RT Speedlite in the hotshoe had the blue gel. The slaved Speedlite, firing through the door on the right, had the red gel.

Canon 5D Mk III
ISO 800
1/100 sec.
f/8
35mm
Gelled Speedlites

FIGURE 7.35
(left) The set was a narrow hallway lit by a single tungsten bulb. For this shot, I set my camera to Auto ISO and the camera selected ISO 10,000. This gave me a starting point from which to dial down the exposure so that I could eliminate all ambient light from the shot.

FIGURE 7.36
(right) Here's the ambient light after I dialed in my exposure settings manually—roughly a seven-stop change.

Canon 5D Mk III
ISO 10,000
1/40 sec.
f/4
35mm
Ambient

Canon 5D Mk III
ISO 800
1/100 sec.
f/8
35mm
Ambient

FIGURE 7.37
To confirm the coverage of the Speedlites, I fired the master and slave without gels. This shot was made at the same exposure settings as the dark ambient shot above.

Canon 5D Mk III
ISO 800
1/100 sec.
f/8
35mm
Speedlites

HOW FLASH POWER AFFECTS GEL COLOR

When you want more color out of your gels, turn the power down, not up. This is the opposite of what most people think. The more light you push through your gel, the thinner the color becomes. In the comparison shown here (**Figure 7.38**), I have increased the flash power two stops in each step from left (low power) to right (higher power). As you can see, the color gets thinner as the power increases.

FIGURE 7.38

ATTACHING GELS TO YOUR FLASHES

There are a number of ways to attach gels to your flashes and strobes. The simplest is to tape the gel to the flash with a bit of gaffer's tape. Stay away from systems that require precise alignment of the gel to your flash—they take too much time and a small gap will throw white light into the scene. See **Figure 7.39**, which shows a gel from two different kits in use: my favorite gel kit for Speedlites is the Honl Photo system (shown on left) because the oversized gels can be changed in a split second; another popular gel kit is the Rogue Flash Gel Kit from ExpoImaging (shown on right).

FIGURE 7.39

CREATING SUNSET

Okay. I'll just come right out and say it. "The sun was not setting when I made that shot" (**Figure 7.41**). The truth is that it was raining outside during the shoot. I created the look of the setting sun by firing a pair of gelled Speedlites through the window. It's not hard. You just need a few gels and a way to trigger your flashes outside. But, I'm getting ahead of myself.

My first step, as you know, is to study and then manage the ambient light with my camera setting. **Figure 7.40** is my study shot. I'll agree that the sunlight—diffused by the clouds and then again by a lace curtain—is beautiful in the shot. But the feeling of this natural light image is neutral or even a bit cool. Further, I wanted the background to drop away a bit more.

So, I changed up my camera settings and sucked out all of the ambient light with a seven-stop move:

- shutter: 1/13" > 1/25" > 1/50" > 1/100" = 3 stops

- aperture: 1.4 > 2 > 2.8 > 4 > 5.6 = 4 stops

The result is that I had a completely black frame, which is important information to know. This meant that every bit of light in the shots after that big move was the result of my lighting. You can see a horizontal version of my hero shot in **Figure 7.42**.

FIGURE 7.40
This ambient-only shot, lit by sunlight on a rainy day, has beautiful light—but lacks the emotional warmth created by the look of the setting sun.

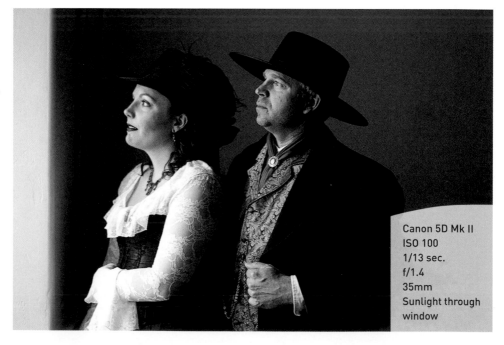

Canon 5D Mk II
ISO 100
1/13 sec.
f/1.4
35mm
Sunlight through window

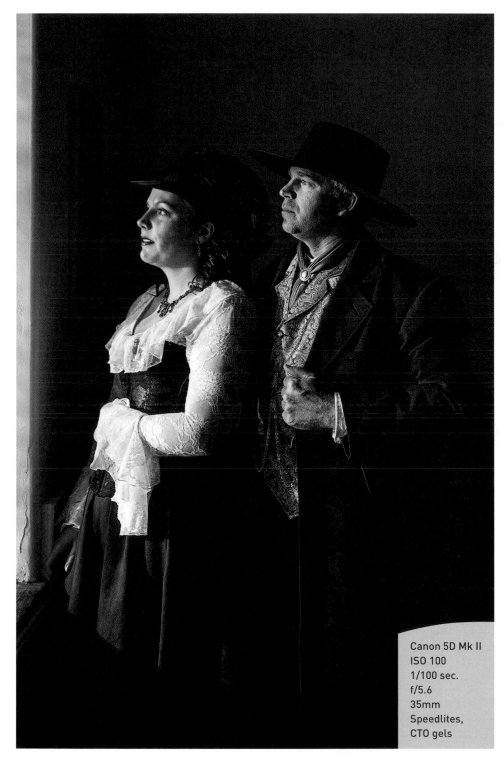

FIGURE 7.41
The beautiful late-afternoon sun in this shot was created with a pair of gelled Speedlites firing in through the window. At the time of the shoot, it was raining outside.

Canon 5D Mk II
ISO 100
1/100 sec.
f/5.6
35mm
Speedlites,
CTO gels

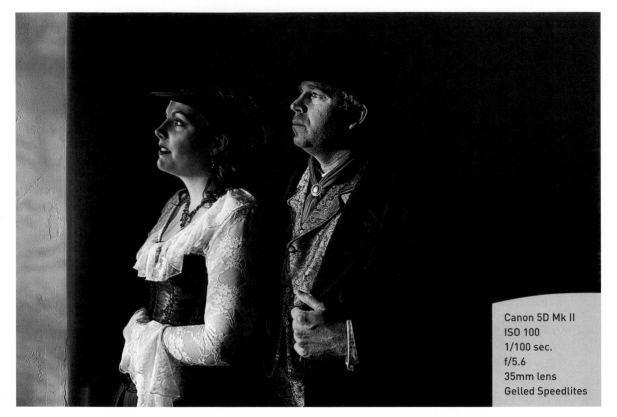

Canon 5D Mk II
ISO 100
1/100 sec.
f/5.6
35mm lens
Gelled Speedlites

FIGURE 7.42
By replacing the ambient sunlight with the light from my gelled Speedlites, I completely changed the emotional feeling of the shot.

CREATING THE LOOK OF SUNSET

There are three keys to creating the look of sunset: the color of the light, the angle of the shadows, and where the light originates. Let's look at each of them individually.

- **Color of the light**: The color of sunset depends upon where you are. In Los Angeles, the bits floating around in the air turn the sunlight very warm as the sun approaches the horizon. Yet, in Maine, I've observed that the color does not change that much before sunset. So the proper amount of color added to your light is largely up to you. As for the specific gels, the families of CTO (Color Temperature Orange) or CTS (Color Temperature Straw) are the ones to use. CTS is slightly more red than CTO, but either will get the job done. In my gel kit, I have 1/4, 1/2, and "full" cuts (densities) of each. I generally start with the 1/2-cut for my test shots. If I want less or more color, then I'll switch to another gel as needed.

- **Long, horizontal shadows**: We intuitively know that when the sun is close to the horizon then the shadows become very long and raking. To create these shadows, you have to place your lights at the same level as or just slightly above your subject. You do not want the light angled steeply down at your subject. Also, since you're looking to create shadows, you'll want to use hard light rather than soft light.

- **Light coming from outside**: There is a subtle but important quality to creating the look of windowlight. The final secret is in the way that the light ripples and creates little shadows as it passes through a window pane. So, if you want your sunset to be believable, you need to fire your light in through a real window. For this shoot, I placed the light stand 15' from the building and zoomed the Speedlites so that they concentrated their light on the window frame.

As you can see in **Figure 7.43**, I used a pair of Speedlites on a flat Wizard Bracket (WizardBrackets.com). Why two lights when there is only one sun? Recycling time—two flashes at half power recycle much faster than a single flash at full power (though you could certainly use just one light for this shot). The Wizard Bracket positions the lights close enough together that they don't create double shadows.

The final step in creating the look of a setting sun is to position the light away from the building. So, I set the stand about 15' away from the window. There's no sense in wasting flash power by lighting the outside of the building. So, I zoomed the flash heads manually to concentrate the light on the window frame.

FIGURE 7.43
I paired up two Speedlites on the Wizard Bracket because two flashes firing at half-power recycle much faster than one flash firing at full power. The Wizard Bracket keeps the flashes close enough together so that double shadows are not created. During the rainy portion of the shoot, I dropped a large poly bag over the lights to protect then from the water.

FIRING FLASHES OUTSIDE THE ROOM

What are the best options when firing flashes parked outside the room in which you are shooting? Well, there are two broad categories: use a long cord running to or out of the window, and radio triggers. In either case, you'll want to think about how much control you'll have or, put another way, how much running outside you'll have to do as you adjust the power.

For this shoot, I ran my master Speedlite (a Canon 580EX II) over to the window on a 33' ETTL cord (**Figure 7.44**). This gave me the ability to control both the flash mode and power of the slaved Speedlites outside from the LCD panel on the back of my camera. If you have only a single flash, then consider running the cord out through the window.

The other option, radio triggers, needs to be measured both in terms of price and functionality. Depending upon the make and model of trigger you use, the price to trigger two remote flashes might be $50 or it might be $500+. You also need to consider whether the triggers are Manual mode only (which most are) or ETTL/ITTL. If they are manual-only, then you will have to run outside every time you want to make a power adjustment (or shout instructions out to an assistant). If your triggers are ETTL/ITTL (which makes them very expensive), then you can adjust the power from inside.

Canon's new 600EX-RT Speedlite provides the convenience of radio as a feature built into the system. This Speedlite is more expensive than its non-radio predecessor (the 580EX II), but it's less expensive than buying a 580EX II and an ETTL radio trigger system.

FIGURE 7.44
I ran the master Speedlite on a long ETTL cord over to the window. This enabled me to adjust the power on the slaved Speed-lites from the LCD panel on the back of my camera.

DIRECTING YOUR SUBJECTS

Congratulations, after all of the work above, your feet are now in the starting blocks and you are ready to run the race. Specifically, now that you have your ambient exposure sorted out, your lights in position, their power adjusted, and their gels in place, you are now ready to start shooting. Again, don't be surprised if you spend 80% of your time setting up and testing, 15% of your time tearing down, and, let's see, that leaves 5% of your time actually shooting. This is a pretty typical ratio for my shoots.

So, be sure that once everything is dialed in that you make as many alternate hero shots as possible. Above, you can see my 3/4-length vertical shot (Figure 7.41) and my 1/2-length horizontal shot (Figure 7.42). I also created three alternate headshots (**Figure 7.45**).

None of this happened by accident. As I was shooting, I continually directed the couple and gave them specific references. This may seem like pretend time in school, but that's fine with me if I get a wide range of shots in a handful of minutes. Here are the prompts that I gave the couple for the three shots at right:

- To both: "Look out the window as if a weeklong storm has just broken."

- To her: "Look at me coyly." To him: "Look at her longingly."

- To both: "Look at me as if I just interrupted an intimate moment."

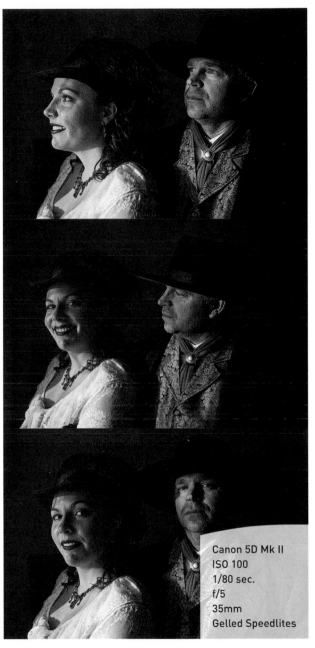

Canon 5D Mk II
ISO 100
1/80 sec.
f/5
35mm
Gelled Speedlites

FIGURE 7.45
During a portrait shoot, do not hesitate to direct the people in front of your lens. Each of these shots was in response to a specific reference that I gave the couple about where to look.

A FIELD OF WHITE

There are two paths to getting a portrait with a pure white background—you can spend far too much time in Photoshop, or you can learn to shoot white seamless (**Figure 7.46**). My preference, of course, is to spend my time behind my camera rather than in front of my computer. Shooting white seamless starts with an understanding of how to create a seamless set and then knowing how to independently light the set and the subject.

CREATING YOUR WHITE SEAMLESS SET

Here's what you need to create a white seamless set:

- **Lots of space**—You will want to have as much room as possible. Shooting at home or the office, where the ceilings are low and the walls are tight, is not an optimal situation. While you can make tight spaces work, it will be harder. For me, I consider a space 15' wide by 30' long to be a minimum. If I can get 20' by 40' or more, I'm happier. Having the space to spread out will mean that your lighting can be controlled more precisely; unwanted bounces off nearby surfaces will be minimized. Also, look for a ceiling height of at least 10' (12' or more is better). For this shoot, I literally set up shop in a school gymnasium.

- **Background**—You will need: two lightstands (10' is a good size), two Super Clamps attached to the top of the lightstands, a roll of white seamless paper (9' is a typical width), a long pole to support the roll of seamless (a wood clothes rod works fine), and two A-clamps to keep the paper from unrolling. You can see a detail of the assembly in **Figure 7.47**. Between shoots, store the seamless paper on its end so that you don't create wrinkles. Having a perfectly smooth background will minimize your work. If you must use a wall or a white sheet rather than a roll of seamless paper, plan on scrubbing the little shadows out of the background in Photoshop.

FIGURE 7.47
A detail of how the light stand, Super Clamp, clothes rod, and A-clamp work together to support the roll of seamless paper.

Canon 5D Mk III
ISO 200
1/160 sec.
f/8
82mm
Strobes,
white seamless,
softbox

- **Flags**—You will need a way to keep the background lights from spilling onto your subject directly. If you are shooting speedlights, you can tape large black cards to the camera-side of the flash heads. The black side of a large Rogue FlashBender works well for this, too. If you are shooting strobes (whose greater power makes the job easier), then you'll want to use a large sheet of foam core to block the light. In **Figure 7.48** on the left side, you can see how the foam core blocks the light spilling sideways out of the strobe. Without the foam core flag, this light would have flown directly onto my model.

FIGURE 7.48
As seen from behind my set, note how the foam core flag blocks the excess light of the background strobe. Without the flag, the light would directly illuminate my subject. Also, note the distance between the backdrop and my model—about 10'.

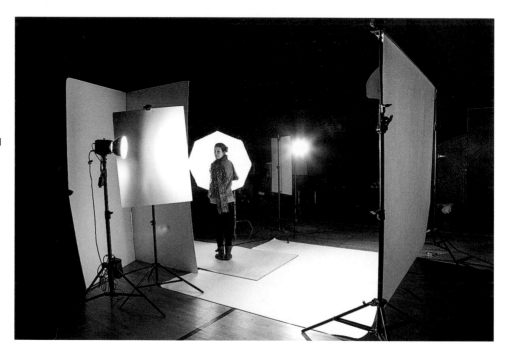

- **Floor boards**—If you are going to shoot full-length shots, you'll want to use white tile board (aka thrifty board) as a way to minimize footprints on your seamless paper. It also acts as a horizontal fill card and creates a cool reflection of your subject (**Figure 7.49**). You will find 4' x 8' sheets of tile board in the paneling departments at home improvement stores. Avoid the grooved and textured boards. You want the ones with the smooth, painted surface. Expect to pay less than $15 per sheet. For larger group shots, use multiple boards and set them so that the ones closer to the camera overlap the board behind. This hides the edge from the camera. (Thanks to my friend Zack Arias, the reigning master of lighting white seamless, for sharing this technique on his blog, ZackArias.com/blog.)

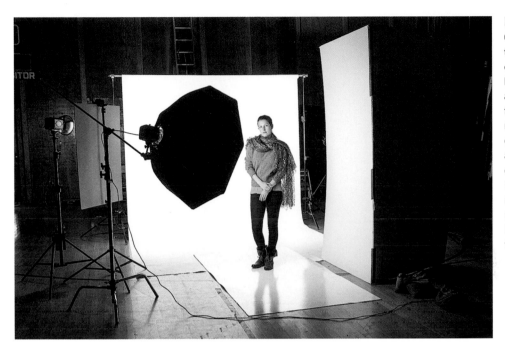

FIGURE 7.49
On the left edge of this set shot, you can see the other background light and its foam core flag. Then, in the middle are the octagonal softbox and the vee-flat of foam core that I used to light my model. Note how much of the tile board extends in front of her.

LIGHTING WHITE SEAMLESS

The key to lighting white seamless is to light the background and the subject independently of each other. In terms of lighting the background, you will want to have at least two lights. For your subject, you will want to have either one light and a reflector or two lights. You can use speedlights, but the job will be easier with the additional power that strobes provide. For this shoot, I used three Einstein E640 monolights, a 48" softbox, and a large foam core vee-flat.

The background lights should be set up on each side of the seamless so that they angle in at about 45°. This is why a wider space is handy—the lights are about 3' from the edge of the 9' wide seamless, for a total width of 15'. The idea is that you want to cross-light the background so that the coverage is very even. It's typical to have the stands for the background lights even with or slightly behind the position of your subject.

As for the light on your subject, you can use any lighting style that you like—soft light, hard light, etc. Generally, soft light is seen as more congruous with a white background than hard light. If you have only one light for your subject, then try to use a large modifier (softbox or umbrella) so that the light wraps around your subject. As you can see in the set shot above (Figure 7.49), I pushed in a large vee-flat of foam core on the right to act as a giant fill card. As you can see in **Figure 7.50**, without the fill

panel, the shadows on the off-light side were too harsh. If you have two lights for your subject, then you can use one as the key light and the other to control the contrast of the fill.

FIGURE 7.50
Before I pushed the tall vee-flat in on the right side, the shadows were too harsh for the quality of light that I wanted to create. If you have only one light on your subject, plan on using a reflector panel to add bounce light into the shadows.

Again, the key is to understand that you must light the background and your subject independently. Keep a good bit of separation between the two. Consider 6' to be a minimum. If the subject is too close to the background, then light will flare around the edges of the subject. A bit of this flare can be creative. Too much flare is a sign of inexperience. For this shoot, I had a 10' gap between Manaan and the seamless.

Now that you have the background lit independently of the subject, the final step is to set the power on each light system. I prefer to set the lighting on my subject first based on the aperture I've chosen to create the depth of field that I want. Then, I adjust the power on the background. For pure white, the power of the background lights should be 1.5 stops brighter than the light on your subject.

If you have a handheld light meter, this is a good time to use it (one of the few times I do). Put the handheld meter in front of your subject's face and take a reading. Let's say that it says "f/8." Now, place the meter on the background and adjust the power until it reads f/13.

If you don't have a handheld meter, dial the background power up slowly until the highlight warning on your camera LCD begins to flash. Then check the histogram to make sure that there is a spike on the right edge. These are both indications that portions of the shot are blowing out to pure white—which, in this case, is exactly what you are after.

The idea on the background light is that you want just enough power to make it appear white and no more. If the background lights are too bright, then the excess light will wrap around your subject and the shot will lose contrast. Compare my hero shot (Figure 7.46) to the right panel in **Figure 7.51** below—where I turned the power on my background lights up so that they were three stops brighter than the light on my model. See how she appears a bit washed out? This reduced contrast is from too much background light flying into my lens.

Conversely, if the background lights are too dim, then the background will appear as a shade of grey (as shown in the left panel of Figure 7.51). This is bad only since we're shooting a white seamless here. Underexposing the background means that you have to spend time in Photoshop to extract the subject off of the grey background. Of course, when you want to add tone to your background, turning the power of the lights down until you get the shade of grey that you want is much faster than changing out the background paper.

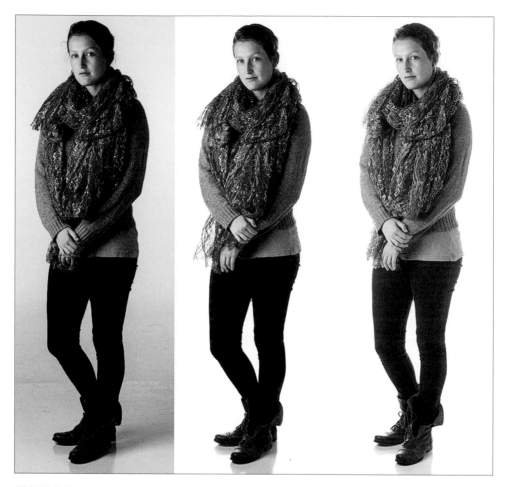

FIGURE 7.51

A comparison of background lighting. Left: background lights are equal to the light on the model—which means that I will have to clean up the grey background in Photoshop. Center: my hero shot—background lights are 1.5 stops brighter than the light on my model, just the right amount of light to create an even white field. Right: background lights are 3 stops brighter than the light on my model—which flares into the lens and reduces contrast.

Another way to check your lighting is to shoot a series of test shots in which you turn off all the lights and then turn on the groups individually (**Figure 7.52**). This will give you a good look at what each of the lights is and is not doing. By the way, this work-flow is so important to me that I try to remember to do it on all my shoots—as well as back up several steps to shoot the entire set (as you saw above in Figures 7.48 and 7.49). You might remember what each light did tomorrow, but you probably won't remember the details of the power settings or the placement of the lights six months from now. So, these study shots and set shots are a big help.

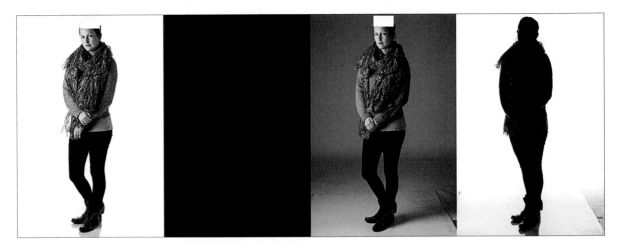

FIGURE 7.52
From left to right: subject and background lights; ambient light only; subject light only; background lights only.

SHOOTING WHITE SEAMLESS

This entire shoot happened in Manual mode—the monolights because they only have a Manual mode and the camera because I set it that way. Even if I was shooting Speedlites, I would have shot them in Manual rather than ETTL/ITTL to keep the light consistent throughout the shoot. Once I find the proper exposure—based around the aperture I need to create the depth of field that I want—I can lock the aperture, shutter speed, and ISO by switching my camera into Manual mode. The huge advantage of this is that the exposure will be consistent from frame to frame. Since the relationship of the lights to my model is not changing—because she is not moving around—I can push my camera in close or pull it out far without changing camera settings. All of the photos for this section where shot at the same camera settings: 1/160", f/8, ISO 200.

Once you have done all the labor of setting up the lighting and working out the exposure, make it a practice to create many different compositions with your camera. (See the sidebar for an important tip on expanding the frame.) Even if what you think you want is a full-length vertical shot, don't be afraid to shoot horizontal close-ups as well (**Figure 7.53**). The great advantage of lighting the white seamless properly is that, once everything is dialed in, you can shoot from a wide range of positions without having to change the lights or the settings on your camera.

FIGURE 7.53
Once you have the
settings for the
lights and camera
dialed in manually,
it is easy to make
many alternative
compositions, like
this tight headshot.

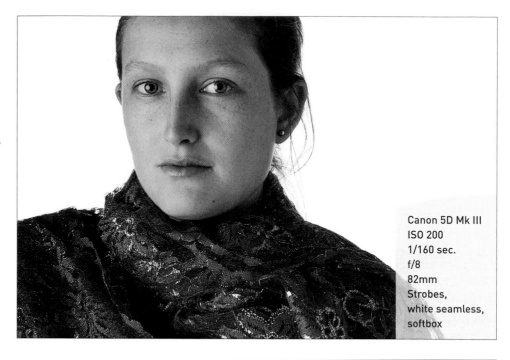

Canon 5D Mk III
ISO 200
1/160 sec.
f/8
82mm
Strobes,
white seamless,
softbox

EXPANDING THE FRAME IN PHOTOSHOP

Regardless of your final composition (vertical or horizontal), fill your viewfinder with as
much of the subject as you can. Specifically, if you know that you want a wide image with
the subject appearing only on the right, then shoot a tight vertical shot of the subject.
Later, in Photoshop, you can expand the canvas to create more space on the left. This way,
you will have maximized the details that the camera recorded of the subject. Here, I've
taken the hero shot, Figure 7.46, and expanded it into a wide frame (**Figure 7.54**).

FIGURE 7.54

Chapter 7 Assignments

To Fill or Not to Fill

Create a hero shot with a key and a fill light. A half-length portrait will do. Be sure to note your exposure. Now, turn off the fill light and take another shot at the same exposure. Repeat with the fill light on and the key light off. It helps to park your camera on a tripod so that the composition remains consistent. Compare the hero to each of the one-light shots. Can you see what the key light and the fill light are each contributing? Do you think the fill light is necessary?

Hail, Hail, the Gang's All Here

Round up a few of your photographer friends who also want to learn how to light groups. Have them bring their lighting gear too. Using at least two people to represent the right and left ends of a group (you decide upon the size), create an even field of light with light coming in from the right and left sides. To make it easy, put your gang in a shaded area. Once you get the hang of this, move one light in close to the camera and turn the other off (as if you only had one light for your shoot). Can you create pleasing light for your group with the light close to the lens? Does it help if you move the one light to the side?

Day Is Done

Round up the gear necessary to create the look of a setting sun: light stand, flash, CTO gel, and a way to trigger the outdoor flash. Find a large window and a patient friend to stand near the window. Position your flash away from and slightly above the center of the window. Take shots with and without the CTO gel. Does the light look real without the gel? Now try the same series with the flash inside the room. Do the shadows look real with the flash in this close?

Share your results with the book's Flickr group!

Join the group here: flickr.com/groups/lightingfromsnapshotstogreatshots

Appendix:
The Gear I Use

Gear is an essential part of making photographs—but don't shift your focus from crafting images to acquiring gear. Start with a few simple items and learn to use them well. Then add a few more bits of gear and learn to use them well. Ultimately, it is you, the photographer—not the gear—who makes the shot.

For the latest version of my gear list and links to sources, see pixsylated. com/blog/gear/.

KIT RECOMMENDATIONS

JUST STARTING OUT

- Hotshoe flash dedicated to your camera brand
- 3' ETTL/ITTL coiled cord
- Rogue FlashBender Large

ENTHUSIAST ESSENTIALS

Add to the above:

- Honl Gels (color correction and color effects)
- Strobros Grids and Holder
- Manfrotto 026 Swivel Adapter
- Manfrotto 5001B Nano Stand
- OCF Gear 33' ETTL/ITTL Cord
- Westcott 40" 5-in-1 Reflector Disk
- Westcott #2011 43" Convertible Umbrella

HOME STUDIO KIT

Add to the above:

- Additional flashes (1–3)
- Honl Gels kits for additional lights
- Another Strobros Grid Set and Holder
- Larger stands (9' is a good height)
- Additional Manfrotto 026 Swivel Adapters
- Manfrotto RH353 Reflector Holder
- Westcott Apollo Orb softbox
- Rechargeable batteries and charger

CAMERA GEAR

CAMERAS

- **Canon EOS Cameras**—I've long been a fan of the full-sensor 5D family and have owned every generation. The 5D Mark III is a great upgrade. I also carry the 60D for those times when I want a less-obtrusive camera. I also find the tilting screen on the 60D to be very handy. If you are just starting out, consider the Rebel T4i.

- **Canon Powershot Cameras**—On trips, I add the G12 and/or the S100 to my DSLR camera kit. Both the G12 and the S100 shoot RAW—which is important to me. Both also fit into my pocket, although I admit that I wear baggy pants in the case of the G12.

- **iPhone 5**—For set shots, snapshots, making visual notes, etc., I reach for my iPhone. The greatest feature about it is that I have it with me all the time.

LENSES AND FILTERS

- **Canon f/4 Zoom Lenses**—When I'm traveling, I carry three f/4 zooms—the 17–40mm, the 24–105mm IS (my absolute favorite), and the 70–200 IS. Compared to the f/2.8 versions, the f/4 lenses are much smaller and more affordable. I've rarely missed the extra stop of light that the weight and expense of the f/2.8 lenses provide.

- **Canon Macro Lenses**—I often have the 50mm f/2 Macro and the 100mm f/2.8L Macro in my bag. The 100mm macro is a great portrait lens as well as being superb for macro work.

- **Circular Polarizer**—A circular polarizer helps cut glare and saturates color. It will also take out about two stops of light. Buy one to fit your widest lens and use step-up rings to attach it to smaller lenses.

- **Variable Neutral Density (ND) Filter**—A variable ND filter combines two circular polarizers into a rotating frame that provides 2–8 stops of neutral density. Very handy when working with strobes for dimming the ambient light. Also a favorite of landscape photographers for creating dreamy scenes of moving water.

MAGNIFIER

- **Zacuto Z-Finder Pro 3x**—I am completely addicted to shooting with the Z-Finder (**Figure A.1**). It allows me to see my camera's LCD in full sun and to focus precisely in LiveView.

- **Zacuto Mounting Frame**—This is the magic piece that allows the Z-Finder to snap on and off the LCD monitor on your camera.

FIGURE A.1
Some of my must-have camera accessories are the L-Plates and Ballhead by Really Right Stuff and the Zacuto Z-Finder Pro.

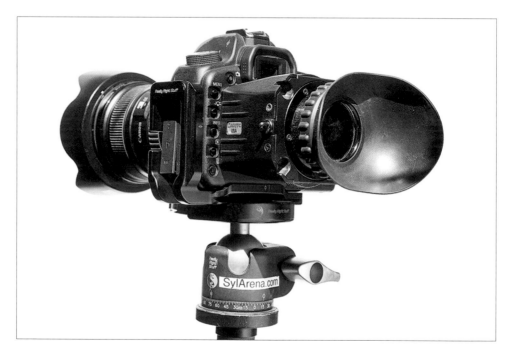

BALLHEAD, L-PLATES, AND TRIPOD

- **Really Right Stuff Ballhead BH-40**—This ballhead (Figure A.1) provides quick and smooth adjustment of my camera. Strong enough to hold with 70–200 f/2.8L zooms.

- **Really Right Stuff L-Plates**—When used with the RRS ballhead, I can switch my camera from vertical to horizontal in two seconds, literally. The L-Plates (Figure A.1) also provide robust protections for the bottom and left side of the camera body.

- **Carbon Fiber Tripod**—I've carried a Gitzo carbon fiber tripod for years. I greatly value the strength and light weight. For great value, check out Oben carbon fiber tripods. The CT-3520 has a cool feature where one leg unscrews to become a monopod.

FLASH GEAR

SPEEDLITES

- **Canon 600EX-RT Speedlite**—The flagship of the Canon Speedlites. I carry three in my kit and will add more as I retire my three 580EX IIs. Can be used as a master or a slave in either radio or optical wireless.

- **Canon ST-E3-RT Speedlite Transmitter**—Provides the same user interface as the 600EX-RT Speedlite without the extra weight and bulk.

- **Canon 580EX II Speedlite**—Recently replaced by the new 600EX-RT. Can be used as a master or slave in optical wireless.

- **Canon 430EX II Speedlite**—A great Speedlite for novices. Can be used as a slave in optical wireless.

- **Canon 270EX II Speedlite**—A small Speedlite that is great for travel. Can be used as a slave in optical wireless.

SPEEDLITE MODIFIERS

- **Honl Photo Gel Kits and Speedstrap**—I'm a fan of the Honl Photo Color Correction and Color Effects gel kits. They provide a good selection of colors and can be attached to the fuzzy Honl Speedstrap in just a second. Carry one set for each of your lights.

- **Impact 24" Quikbox**—A great value is Speedlite softboxes. Mounts the flash on the back for easy access. Folds flat for storage and travel.

- **Lastolite Ezybox Speed-lite**—This 8" softbox straps directly to the head of a Speedlite and folds flat for travel. Always in my flash kit.

- **Rogue FlashBender Large**—I carry three of these in my Speedlite kit. Use them as bounce cards, flags, or snoots. I'm not a fan of the smaller versions.

- **Strobros Grids and Snoot**—Buy the Strobros Portrait Kit and you'll have a sturdy metal snoot, a grid holder (aka, mini-beauty dish), and three grids.

- **Westcott Apollo Softboxes**—Sets up as easily as an umbrella. Creates beautiful light with 1-4 Speedlites. If you have to have only one, choose the Orb (43" across).

- **Westcott #2011 43" White, Collapsible, Convertible Umbrella**—A basic umbrella that double-folds like one of those tiny rain umbrellas, which makes it great for travel. The cover can be used as a flag.

MULTI-FLASH BRACKETS

- **IDC Triple Threat**—A triangular bracket that allows three Speedlites to be mounted together (**Figure A.2**).

- **Wizard Bracket**—A plate that holds a pair of Speedlites side by side.

FIGURE A.2
I use the IDC Triple Threat to mount multiple Speedlites inside the Westcott Apollo softboxes.

OFF-CAMERA FLASH CORDS

- **OCF Gear 33' ETTL/ITTL cord**—Even with radio built into my Canon Speedlites, I still carry and use an extra-long ETTL cord. I consider this to be a must-have for photographers just starting with off-camera flash.

- **OCF Gear 3' Coiled ETTL/ITTL cord**—Very handy when traveling light or when working in a crowded situation.

POWER

- **Eneloop**—These are my favorite rechargeable batteries. If you buy another brand, make sure that they are either "pre-charged, rechargeable" or "low-discharge, nickel metal-hydride."

- **Maha MH-C801D Charger**—This charger has an individual charging circuit for each battery. This feature is essential to maximize the capacity of your batteries.

- **Bolt CBP-C1 Compact Battery Pack**—Enables your Speedlites to recycle in less than half the time, great for events and action photography.

POLES

- **Lastolite Ezybox Hotshoe Extension Handle**—Extends to nearly 6'. A great and quick way to position a flash above your subject.

- **Kacey Pole Adapter on painter's pole**—This adapter enables the use of any standard painters pole with any standard swivel adapter.

REFLECTORS AND HOLDERS

- **Manfrotto RH353 Reflector Holder with Mini Grip Head**—Anything in my kit made of plastic will break eventually. This all-metal reflector holder has earned my respect. Attaches directly to the top of a light stand.

- **California Sunbounce**—This collapsible panel system packs small and assembles quickly into a frame that holds the fabric panel extremely tight. The Mini (3' x 4') is my favorite size.

- **Scrim Jim Panel System**—The modular Scrim Jim system can be assembled in 42" x 42", 42" x 72", and 72" x 72" sizes. A wide range of diffusion and reflective fabrics are available.

- **Westcott 40" 5-in-1 Reflector Disk**—A well-made and versatile disk system that provides a diffusion disk and a cover in gold, silver, white, and black fabrics.

- **Westcott #1131 14" Silver/White Reflector**—Very handy when you want to reflect just a bit of light into your subject's face. Folds up to fit in your pocket.

STANDS

- **Manfrotto 5001B Nano Stand**—This lightweight stand folds up to 18" and can easily be carried in a daypack. Great for travel. A good starter stand for small flash, but not big enough to support Apollo softboxes.

- **Manfrotto 1005BAC Ranker Stands**—These 9' stands fold flat and lock together for travel. I carry three in my travel kit. Large enough for strobes and big modifiers.

SWIVEL (UMBRELLA) ADAPTERS

- **Manfrotto 026 Swivel Adapter**—Use between light stand and flash, also used to hold shaft of umbrella or Apollo softbox.

- **Monoball Swivel**—Assemble it yourself by connecting a Manfrotto 014-38 Rapid Adapter to a Manfrotto 492 Micro Ballhead (**Figure A.3**). Then you will be able to position your flash quickly with just one knob—very handy when you do not need to mount an umbrella.

FIGURE A.3
I carry several monoball swivels in my Speedlite kit. With a quick turn of the knob, I can lock my flash into the exact position that I need.

TRIGGERS

- **PocketWizard Mini TT1 and Flex TT5**—Very popular with shooters who need radio ETTL/ITTL control. Now that I have radio built into my Canon Speedlites, I do not use them as much as I used to. However, they remain very useful when mixing speedlights and strobes (see below).

- **PocketWizard Plus III**—A versatile and durable manual-only radio trigger. Enables up to four groups to be used in combination or individually. Has the ability to send the signal from unit to unit, which greatly increases the range.

- **Yongnuo RF-603**—A very inexpensive manual-only radio trigger. Limited range, but great for those starting out.

UMBRELLAS (LARGE)

- **Westcott #2021 60" White Convertible Umbrella**—Full-length shots, use cover as flag to keep light off background.

- **Westcott #4633 7' Parabolic Umbrella (Silver)**—A big, but lightweight, umbrella for lighting groups and creating large fields of soft light for subjects that move.

STROBE GEAR

STROBES

- **Einstein E640**—A moderately priced monolight that offers a 10-stop power range and a wide variety of reflectors, softboxes, and other modifiers. Runs on AC power only.

- **Mini Vagabond Battery**—This 4-pound battery provides power for up to 200 full-power pops on the Einsteins when shooting on locations without AC power.

- **Profoto**—There is no finer light system. Of course, you get what you pay for. The D1 Air monolights come in handy kits with stands. Larger Profoto strobes, including battery-operated units for location photography, can be rented at any photo rental house. So, when you need the quality of Profoto light for a special shoot, it's affordable.

MODIFIERS

- **Chimera Softboxes**—I'm still using Chimera softboxes that I purchased more than 16 years ago. If you take a long-term view when buying gear, Chimera Super Pro Plus softboxes are a worthy investment. You will need a Chimera speedring with a brand-specific adapter to connect the softbox to your strobe. For use with Speedlites, Chimera makes a simple bracket adapter.

- **Gels**—Buy 20" x 24" sheets and cut pieces large enough to tape over the fronts of your strobe reflectors. The colors in the Honl color correction and color effects gel kits will guide you.

- **Grids**—Indispensible for limiting the spread of a strobe. Look for 10°, 20°, and 30° in diameters that fit your reflectors.

- **Reflectors**—I have wide angle, standard (8"), and long-throw reflectors for my strobes. They have a similar effect as using the Zoom button on a speedlight.

STANDS

- **Avenger C-Stand with Removable Base**—This heavy-duty stand is my favorite for strobes, especially when positioning lights overhead. When traveling, they can be rented in any major rental house.

OTHER

- **Gaffer's Tape**—This is the duct tape of the photography world. Keep a 2" roll handy.

- **Triggers**—I prefer PocketWizard triggers (covered above). If you want to mix small flash and strobes, use the AC3 Zone Controller with the Mini TT1 or Flex TT5.

- **Umbrellas**—Two large umbrellas (covered above) and two strobes are an easy way to light large groups.

INDEX

5-in-1 reflector set, 71, 169
45-degree angle lighting, 8
600EX-RT Speedlite, 96, 263

A

A-clamps, 248
Adams, Ansel, 21
Adobe Camera Raw, 49
Adobe Lightroom. *See* Lightroom
Adobe Photoshop. *See* Photoshop
alternate compositions, 217
ambient light, 60, 151–154
 creative use of, 174
 flash used with dimmed, 178
 group shots and, 235
 shutter speed and, 173–177
angle of light, 8–9
Aperture Priority mode, 47, 152, 175, 181
aperture settings, 37–40
 big/wide vs. small/narrow, 38
 depth of field and, 32–33, 37–40, 53
 equivalent exposures and, 43–45
 exposure workflow and, 151
 shutter speed and, 38
 whole stops of, 37
Arias, Zack, 250
artificial light, 60, 81–117
 assignments on using, 116–117
 built-in/pop-up flash, 94–95
 continuous sources of, 91–93
 examples of using, 82–85
 flash basics, 99–115
 fluorescent bulbs, 87–88, 92–93
 home and office light, 86–90
 hotshoe flash, 95, 96, 98–99
 incandescent/tungsten bulbs, 86–87, 91
 industrial vapor bulbs, 89–90
 LED bulbs, 88–89, 93
 strobes, 94, 97
 See also flash
author's gear list, 259–268
auto focus (AF) button, 159

Auto FP Sync. *See* High-Speed Sync
Auto White Balance (AWB) setting, 49, 65, 88, 89
automatic flash, 99–100
 experimenting with, 116
 fill flash as, 101
 fine-tuning, 102–103
Avenger C-Stand, 268

B

backgrounds
 brightness of subjects vs., 187, 212
 comparison of lighting for, 254
 seamless used for, 136–138, 190, 248–256
 separating subjects from, 223
 showing details in dark, 178–181
 white seamless, 248–256
backlight
 assignment on using, 143
 food photography and, 132–135
 sun used as, 230, 233
ballheads, 262
batteries, 265, 267
battery pack, 265
beauty lighting, 194–198, 223
black-and-white photography, 21
blue hour, 16, 62, 63, 65
blurring motion, 36, 199, 201
bounced light
 flash as, 109–111, 117
 sunlight as, 68–70, 182–187
brackets, 245, 264
brightness
 lightbulb comparison, 92
 subject vs. background, 187, 212
built-in wireless systems, 113–114
built-in/pop-up flash, 94–95

C

California Sunbounce panel, 182, 187, 265
camera gear, 261–262
camera modes, 46–47

Camera Raw, 49
camera settings, 29–53
 aperture setting, 37–40
 assignments on, 53
 camera modes, 46–47
 equivalent exposures and, 43–45
 examples illustrating, 30–33
 image stabilization, 36
 ISO setting, 40–42
 RAW vs. JPEG, 49–51
 shutter speed, 35–37, 53
 white balance setting, 48–49
 whole-stop increments and, 34–35
camera shake, 53
Canon cameras
 built-in/pop-up flash, 94–95
 EOS and Powershot, 261
 ETTL metering on, 100, 113
 lenses and filters for, 261
 second-curtain sync on, 198, 202
Canon Speedlites, 95, 96
 gear list, 263
 modifiers, 170, 263
 radio transmitters, 114, 212, 234, 263
 wireless sensors, 113–114
carbon filter tripods, 262
CFL bulbs
 home and office, 87–88
 photographic, 92–93
charger for batteries, 265
Chimera softboxes, 268
circular polarizer, 261
city streets, 27
clamps, 248
clamshell lighting, 196–198
Close-up mode, 46
clouds
 creating cloudy weather look, 125–126
 diffused sunlight and, 11–12, 76–77
Cloudy white balance, 49, 76, 235
CMYK color gamut, 18–20
coldshoes, 98–99
color balance. See white balance
color gamuts, 18–20

color gels, 238–241, 263, 268
 attaching to flashes, 241
 example of using, 238–240
 flash power and, 241
 sunset look from, 242–245
color of light, 15–20, 27
color temperature, 17, 48
column of light, 233
compact lights, 91
contrast, 21–24, 27
cool colors, 15–16
creative camera modes, 47
CTO/CTS gels, 244

D

daily cycle of sunlight, 61–65
daylight. See natural light; sunlight
Daylight white balance, 48, 75, 88, 89, 235
deep shade, 75–76
depth of field (DOF)
 aperture and, 32–33, 37–40
 assignment on manipulating, 53
 intensity of light and, 13
 pocket calculators of, 39
Develop panel (Lightroom), 52
DICCH mnemonic, 7
diffused light, 11–12
 clouds and, 11–12, 76–77
 making sunlight into, 66–68, 126
 reflected light vs., 169
diffuser panels
 experimenting with, 143
 reflectors combined with, 71–72
 softening light with, 66–68, 126, 169
digital noise
 ISO setting and, 41–42
 software for reducing, 42, 50
digital single-lens reflex (DSLR) cameras, 35
direct light, 11, 55, 66
directing your subjects, 247
direction of light, 7–13
 direct, diffused, reflected light and, 11–13
 lighting compass and, 8–10
disk holders, 196

distance
 apparent size and, 171
 intensity related to, 15
double truck, 217
Dubai twilight, 56–57
dynamic range, 21–23

E

Einstein E640 monolight, 97, 267
environments, conveying, 214–216
equipment. *See* gear list
equivalent exposures, 13, 34, 43–45, 53
ETTL flash mode (Canon), 100, 178
 cords for, 112–113, 202, 234, 246, 264
 radio triggers for, 234, 246
exposure
 equivalent, 13, 34, 43–45, 53
 post-processing and, 24
 workflow for lighting and, 151–154
Exposure Compensation (EC), 152, 163, 178
Exposure Pyramid, 43
exposure triangle, 43
eyes, focusing on, 159

F

fabric reflectors, 12
family portraits, 235–237
feathering light, 172, 203
fill light
 bounced sunlight as, 68–70, 182–184
 creating a column of, 233
 definition of, 9
 filling shadows with, 9
 flash used as, 23, 73, 101
 three-light setups and, 225
filters
 circular polarizer, 261
 neutral density, 232, 261
firing line arrangement, 218–221
first-curtain sync, 198–200
five-in-one reflector set, 71, 169
flags, 192–193, 203, 250, 251
flash, 94, 99–115
 alternatives to, 102
 ambient light and, 176, 178

assignments on using, 116–117
automatic, 99–100, 101
bouncing, 109–111, 117
built-in/pop-up, 94–95
color gels for, 238–241
daytime use of, 95
fill, 23, 73, 101
fine-tuning, 102–103
firing outside a room, 246
gear list for, 263–267
group shots and, 237
High-Speed Sync for, 108–109
hotshoe/speedlight, 95, 96
lightstand connections, 98–99
manual, 99, 100, 103–105
off-camera, 112–115
power settings, 104–105
radio triggers for, 114–115
shutter speed and, 37, 105–109, 176, 178, 181
strap-on modifiers for, 170
sunlight combined with, 182–184
triggering inside softboxes, 234
wireless systems, 113–114
zoom settings, 192
 See also strobes
Flash Exposure Compensation (FEC), 102–103, 178
FlashBender Large, 130, 170, 193, 250, 263
flat light, 8, 10
Flickr group for book, 27
floor boards, 250
fluorescent light
 home and office, 87–88
 photographic, 92–93
foam core, 137
 flags made from, 250, 251
 panels made from, 12, 68, 169
 used as softbox alternative, 214
 vee-flats made from, 137–138, 251
focusing
 on eyes in portraits, 159
 the viewer's eye, 212–213

food photography
 backlight for, 132–135
 reflectors used for, 132
 See also object photography
freezing motion, 36
f-stops, 37, 38, 39
 See also aperture settings
fully automatic camera mode, 46

G

gaffer's tape, 268
gamuts, color, 18–20
gear list, 259–268
 camera gear, 261–262
 flash gear, 263–267
 kit recommendations, 260
 strobe gear, 267–268
gels. *See* color gels
gold reflectors, 69, 70, 169
golden hour, 16, 62, 63, 64
grids, 130, 193, 268
group shots, 235–237
 example of setting up, 235–236
 tips for lighting, 237

H

hair light
 definition of, 9
 sunlight used as, 185, 186
 three-light portraits and, 225, 228
handhold shutter speed, 53
hard light, 25, 164, 165, 227
hardness of light, 24–26, 27
high key images, 135, 188
highlights
 blowing out, 24
 contrast and, 21
 dynamic range and, 22–23
 exposure decisions for, 24
 post-processing, 24
 spectral, 22
High-Speed Sync (HSS), 108–109
 ambient light vs. flash and, 176, 178
 syncing in broad daylight with, 229–234
home and office light, 86–90

home studio kit, 260
honeycomb grid, 193
Honl products
 gel kits, 241, 263
 Speedstrap, 263
hot lights, 91
hotshoe flash, 96
 bouncing, 109–111
 lightstand connections, 98–99
 off-camera, 112–115
 speedlights as, 95, 96

I

IDC Triple Threat, 264
image stabilization (IS), 36
Impact Quikbox, 133, 134, 263
incandescent light
 home and office, 86–87
 photographic, 91
industrial vapor lights, 89–90
intensity of light, 13–15
 assignment on, 27
 distance and, 15
 shadows and, 13–15
inverse relationships, 43
Inverse Square Law, 15
iPhone 5 camera, 261
ISO setting, 40–42
 creative use of, 41
 digital noise and, 41–42
 equivalent exposures and, 43–45
 exposure workflow and, 151
 whole-stop increments of, 40
ITTL flash mode (Nikon), 100, 178
 cords for, 113, 202, 234, 264
 radio triggers for, 234, 246

J

JPEG file format, 51

K

Kacey Pole Adapter, 265
Kamm, Zeke, 52
Kelvin temperature, 17
key light, 9, 225
kit recommendations, 260

L

label removal, 143
Lastolite Ezybox Speed-lite, 168, 170, 263
LED light bulbs
 home and office, 88–89
 photographic, 93
LED panels, 93
lens shade, 188
lenses
 gear list for, 261
 image stabilization, 36
 portrait, 155
light
 ambient, 60, 151–154, 174
 angle of, 8–9
 artificial, 60, 81–117
 bounced, 68–70, 72, 109–111, 182–187
 characteristics of, 7
 color of, 15–20
 contrast and, 21–24
 diffused, 11–12
 direct, 11
 direction of, 7–13
 feathered, 172
 fill, 9, 68–70, 101
 flat, 8, 10
 hair, 9, 228
 hardness of, 24–26, 164
 intensity of, 13–15
 key, 9, 225
 natural, 55–79
 obsession with, 6
 open, 159–163
 reflected, 12
 rim, 9, 130–132
 shadows and, 4–5, 7
 size of, 165, 166
 soft, 25–26, 164–171
 window, 77–78, 245
Light Right reflectors, 132
lighting
 background, 254
 beauty, 194–198, 223
 clamshell, 196–198
 group shots, 237
 objects, 124
 portraits, 150–151, 210
 selective, 127–129, 143
 sources for learning about, 26–27
 test shots for, 254–255
 white seamless, 251–255
 workflow for, 151–154
lighting compass, 8–9, 27
Lightroom
 Develop panel adjustments, 52
 post-processing photos in, 51–52
lightstands
 connecting flashes to, 98–99
 gear list for, 266, 268
 white seamless setup with, 248
low key images, 135, 188–191
L-Plates, 262
lumens, 92
LumoPro LP160 speedlight, 96

M

macro lenses, 261
macro photography, 125
magazine ads, 26
magnifier gear, 262
Manfrotto products
 Nano and Ranker stands, 266
 Reflector Holder, 196, 265
 Swivel Adapter, 98, 266
Manual camera mode, 47, 152, 175, 255
Manual flash mode, 99, 100, 103–105
mental photos, 6
metallic reflectors, 70
midday sun, 62, 63, 64
modifiers
 Speedlite, 263
 strobe, 268
 testing, 172
monoball swivels, 266
monolights, 97, 267
moonlight, 60
motion
 freezing vs. conveying, 31, 35–36
 second-curtain sync and, 198–202
 shutter speed and, 30–31, 35–36

motion blur, 36, 199, 201
movie lighting, 26
multi-flash brackets, 264

N

natural light, 55–79
 assignments on shooting in, 79
 blue hour of, 16, 62, 63, 65
 bouncing into shadows, 68–70
 cloudy days and, 76–77
 cycle of sun and, 61–65, 79
 deep shade as, 75–76
 diffused sunlight as, 66–67, 76–77
 examples of using, 56–59
 golden hour of, 16, 62, 63, 64
 open shade as, 73–74
 overhead and bounce for, 71–73
 white balance and, 64–65
 windowlight as, 77–78
 See also sunlight
neutral density (ND) filter, 232
Nikon cameras
 ITTL metering on, 100, 113
 second-curtain sync on, 198, 202
Nikon Speedlights, 95, 96, 113, 114
noise, digital
 ISO setting and, 41–42
 software for reducing, 42, 50
Noiseware Professional plug-in, 42, 50
nose-to-the-light principle, 219

O

object photography, 119–143
 annotated examples of, 120–123
 assignments on lighting, 143
 backlight used for, 132–135
 foam core vee-flats for, 137–138
 getting started with, 125
 overview of lighting concepts, 124
 rim light used for, 130–132
 seamless backgrounds for, 136–137,
 139, 140
 selective lighting for, 127–129
 shiny or reflective objects and, 140–142
 softening sunlight for, 125–126
OCF Gear ETTL/ITTL cords, 112, 264

off-camera flash, 112–115
 built-in wireless for, 113–114
 cords used for, 112–113, 264
 radio triggers for, 114–115
office light, 86–90
online auction photos, 135–138
open light, 159–163
overhead diffuser, 71–72

P

pCAM DOF app, 39
photo flood light, 91
photographic lights
 continuous, 91–93
 flash and strobe, 94–99
Photoshop
 expanding the frame in, 256
 Noiseware Pro plug-in for, 42, 50
 post-processing photos in, 52, 256
pixsylated.com website, 259
PocketWizard radio triggers, 115, 234, 267
polarizer filter, 261
poles, 265
pop-up flash, 94–95
portrait photography, 145–257
 accuracy of light in, 188–194
 advanced lighting for, 205–257
 alternate compositions in, 217
 ambient light for, 151–154
 annotated examples of, 146–149, 206–209
 assignments on lighting, 203, 257
 beauty lighting for, 194–198, 223
 color gels used in, 238–241
 concealing and revealing in, 211–217
 conveying persona through, 214, 215
 directing the subjects of, 247
 environmental clues in, 214, 216
 expanding the frame in, 256
 focusing on the eyes in, 159
 group shots as, 235–237
 guiding the viewer's eye in, 212–213
 hair and rim light for, 186
 high-speed sync used for, 229–234
 lazy situations for lighting, 156–158
 lens selection for, 155
 low key images in, 188–191

moving subjects in, 198–202
nose-to-the-light principle for, 219
open light used for, 159–163
overview of lighting concepts, 150–151, 210
second-curtain sync for, 198–202
showing details in shadows, 178–181
shutter and flash synergy, 173–178
soft light created for, 164–171
sunlight used for, 182–188
sunset look created for, 242–247
three-light setup for, 224–228
two-light setup for, 218–223, 229
white backgrounds for, 248–256
poster boards, 137
post-processing photos, 51–52
 adjusting exposure, 24
 expanding the image frame, 256
 reducing digital noise, 42, 50
 retouching images, 234
power gear, 265
power pack strobes, 97
product photography. *See* object photography
Profoto light system, 267
Program mode, 47, 175

R
radio transmitters, 114, 212, 234, 263
radio triggers, 114–115, 234, 246, 267, 268
RAW file format
 advantages of, 49–50
 Small RAW format, 51
rear-curtain sync, 198
rechargeable batteries, 265
reflected light, 12
 diffused light vs., 169
 sunlight used as, 68–70
reflective objects, 140–142
reflective umbrellas, 167
reflectors, 12
 5-in-1 set of, 71, 169
 gear list for, 265, 268
 pint-sized, 132
 rim light created with, 131
 size and position test for, 192
 squinting caused by metallic, 70
 sunlight bounced with, 68–70, 182–187

rim light
 assignment on using, 143
 definition of, 9
 sunlight used as, 185, 186
 tabletop photography and, 130–132
 three-light portraits and, 228
Rogue Flash Gel Kit, 241
Rogue FlashBender Large, 130, 170, 193,
 250, 263

S
scene-based camera modes, 46
Scrim Jim panels, 68, 70, 126, 127, 169, 265
seamless
 object photography and, 136–138
 portrait photography and, 190
 tips for using, 137
 white sets using, 248–256
second-curtain sync, 198–202
selective lighting, 127–129, 143
shade
 deep, 75–76
 exploring, 79
 open, 73–74
Shade white balance, 75
shadows
 beauty light and, 197
 bounced light and, 68–70, 182–187
 contrast and, 21
 creating interesting, 4–5, 7
 diffused light and, 11–12
 direct light and, 11
 direction of light and, 7–13
 dynamic range and, 22–23
 exposure decisions for, 24
 fill light and, 9, 23, 68–70
 fluorescent light and, 88
 group shots and, 237
 hard vs. soft, 25–26
 industrial vapor light and, 90
 intensity of light and, 13–15
 LED light and, 89
 lighting compass and, 8–9
 photographic importance of, 7
 post-processing, 24
 reflected light and, 12

shadows *(continued)*
 showing details in, 178–181
 sunset look and, 245
 tungsten light and, 87
shape of objects
 defining with rim light, 130–132
 shadows indicating, 7
shiny objects, 140–142
shooting modes, 46–47
shoot-through umbrellas, 166, 167
Shutter Priority mode, 47
shutter speed, 35–37
 ambient light and, 173–177
 aperture and, 38
 assignments on, 53
 equivalent exposures and, 43–45
 exposure workflow and, 151
 fast/short vs. slow/long, 106
 flash photography and, 37, 105–109, 176, 178, 181
 handheld cameras and, 53
 image stabilization and, 36
 lighting sources and, 37
 motion and, 30–31, 35–36
 second-curtain sync and, 201–202
 whole stops of, 34, 35
silver reflectors, 70, 169
size of light source, 165, 166
skylight, 73–74
Small RAW file format, 51
snoots, 130, 194
soft light
 creating in direct sun, 126
 group shots and, 237
 options for creating, 164–171
 shadows created by, 25–26
 three-light setup and, 227
softboxes
 clamshell lighting and, 196, 198
 gear list for, 263, 268
 object lighting and, 134
 portrait lighting and, 168
 stacking for column of light, 233
 triggering flashes inside of, 234
solid overhead, 71–72
spectral highlights, 22

Speedlights. *See* Nikon Speedlights
Speedlites. *See* Canon Speedlites
Spiderlites, 93
Sports mode, 46
stands. *See* lightstands
ST-E3-RT Speedlite transmitter, 234, 263
stops, calculating, 34–35
strobes, 94, 97
 daylight use of, 232
 gear list for, 267–268
 See also flash
Strobos system, 130, 193, 194, 263
sunlight
 blue hour of, 16, 62, 63, 65
 bouncing into shadows, 68–70, 182–187
 brightness of backgrounds in, 187
 clouds and, 11–12, 76–77
 contrast and, 23
 daily cycle of, 61–65, 79
 deep shade, 75–76
 diffused, 11–12, 55, 66–68, 76–77
 direct, 11, 55, 66
 flash used with, 182–184
 golden hour of, 16, 62, 63, 64
 high-speed sync in, 229–234
 lens shade for, 188
 midday, 62, 63, 64
 open shade, 73–74
 portraits in, 182–188
 reflected, 12, 68–70
 softening, 66–68, 126
 solid overhead for, 71–72
 strobes used in, 232
 white balance and, 64–65
 windowlight, 77–78
 See also natural light
sunrise
 color of light around, 16
 golden hour after, 16, 62, 63
sunset
 creating the appearance of, 242–247
 golden hour before, 62, 63, 64
Super Clamp, 248
surrounding light, 135, 137–138
swimming pool analogy, 39
swivel adapters, 98, 266
sync speed, 37, 105–109, 116, 181

T

tabletop photography, 125, 127–142
 annotated example of, 120–121
 backlight used in, 132–135
 foam core vee-flats for, 137–138
 rim light used in, 130–132
 seamless backgrounds for, 136–137,
 139, 140
 selective lighting in, 127–129
 shiny or reflective objects and, 140–142
 See also object photography
testing
 lighting, 254–255
 modifiers, 172
three-light portrait setup, 224–228
 positioning lights for, 227–228
 two-light alternatives to, 229
 workflow used for, 226
tile board, 250
trees, shooting under, 75–76
tripods, 125, 172, 181, 262
TrueDOF app, 39
tungsten light
 home and office, 86–87
 photographic, 91
Tungsten white balance, 48, 87, 88, 89
twilight, 62, 63
two-light portrait setup, 218–223
 firing line arrangement, 218–221
 strategies for using, 222–223, 229

U

umbrellas
 gear list for, 263, 267, 268
 soft light created with, 166–167
 swivel adapters for, 98, 266

V

Vari-ND filters, 232
vee-flats, 137–138, 251

W

warm colors, 15–16
Westcott products
 Apollo softbox, 4, 168, 233, 263

 CFL lights, 92, 93
 reflectors, 265
 umbrellas, 263, 267
Weston, Edward, 21
White, Minor, 21
white balance, 48–49
 Auto setting for, 49, 65
 color temperature and, 17, 48–49
 cycle of sunlight and, 64–65
 experimenting with, 116
 fluorescent light, 88
 industrial vapor light, 90
 LED light, 89
 tungsten light, 87
white reflectors, 69, 70, 169
white seamless, 248–256
 lighting, 251–255
 set creation, 248–250
 shooting, 255–256
whole-stop increments, 34–35
 of aperture, 37
 of ISO, 40
 of shutter speed, 34, 35
windowlight, 77–78, 79, 245
wine bottles
 annotated photo of, 120–121
 lighting setup for, 140–142
 removing the back label from, 143
 steps for photographing, 141–142
wireless flash, 113–115
 built-in system of, 113–114
 radio triggers for, 114–115
 second-curtain sync and, 202
Wizard Bracket, 245, 264
workflow
 exposure and lighting, 151–154
 Lightroom-based, 51–52
 three-light portrait, 226

Y

Yongnuo radio trigger, 115, 234, 267

Z

Zacuto Z-Finder Pro, 262
zoom button on flash, 192
zoom lenses, 261